*INDIAN ARTS
IN NORTH AMERICA*

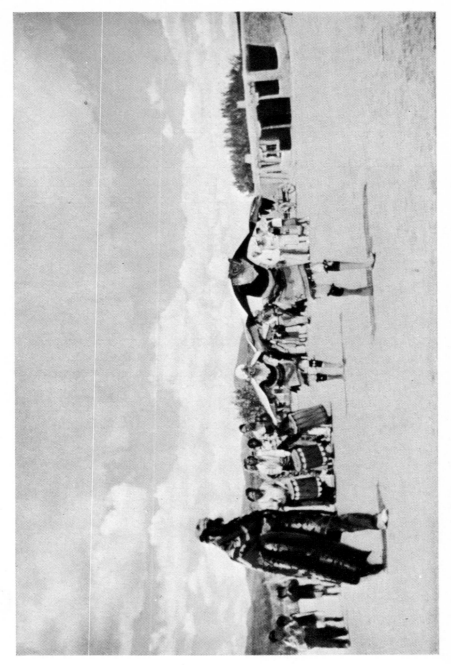

PUEBLO EAGLE DANCE, SAN ILDEFONSO, NEW MEXICO

INDIAN ARTS IN NORTH AMERICA

~~~~~~~~~~

*By*

GEORGE C. VAILLANT

*ILLUSTRATED*

~~~~~~~~~~

COOPER SQUARE PUBLISHERS, INC.
New York
1973

Originally Published 1939 by Harper & Brothers Publishers
Reprinted by Permission of Harper & Row, Publishers
Published 1973 by Cooper Square Publishers, Inc.
59 Fourth Avenue, New York, New York 10003
International Standard Book Number 0-8154-0469-7
Library of Congress Catalog Card Number 72-97071

Printed in the United States of America

Z 8/15 4021

Table of Contents

vi

LIST OF PLATES

MODERN PUEBLO EAGLE DANCE, SAN ILDEFONSO,
NEW MEXICO *Frontispiece*

The plates listed below will be found as a separate section following page 54

viii

FOREWORD

THIS BOOK is a cooperative endeavor in the true sense of the word. It is the work of many agencies and many people. It is almost an impertinence for the writer, who served merely as agent, to express his deep thanks and appreciation to all those who made the project a success.

Mr. René d'Harnoncourt, General Manager of the Indian Arts and Crafts Board of the Department of the Interior, conceived the idea of amassing a collection of photographs to illustrate the artistic attainments of the North American Indians. The Rockefeller Foundation approved this plan and granted money for a preliminary survey in 1937 and, later, additional funds to carry the project further during 1938 and 1939. The American Museum of Natural History administered the grant and the writer exercised a general supervision over the work. Important additional backing was given by the Indian Arts and Crafts Board and Miss Phillipa Gerry. Miss Gerry, with the utmost taste and diligence carried out the exhausting task of recording and selecting specimens. Mr. Konrad Cramer, who did the photographic work, combined an extraordinary technical talent with a deep sensitiveness to the form and content of the examples recorded. 872 specimens were photographed, enlargements were made of 370, and 111 color plates were taken. Miss Phyllis Brewster capably and cheerfully carried out the final cataloguing of the negatives which are on file in the Photographic Department of the American Museum of Natural History.

The success of Miss Gerry and Mr. Cramer was ensured by the generous assistance of the institutions which they visited. The indi-

vidual members of the various museum staffs, who gave so freely of their time and knowledge to help the project, placed us under obligation too deep for us ever to repay, but we can hold up their unselfish attitude as as fine an example of institutional cooperation as it has been our pleasure to encounter. The Museum of the American Indian, Heye Foundation, The Peabody Museum of Harvard University, the Peabody Museum of Phillips Academy, Andover, the Peabody Museum of Yale University, the University Museum of the University of Pennsylvania, the United States National Museum, the Rochester Museum, the Field Museum, the Denver Art Museum, the Laboratory of Anthropology in Santa Fé, the Museum of Northern Arizona at Flagstaff, Gila Pueblo at Globe, in their institutional capacity and in the goodwill of their staffs, made the collection of this material a real joint endeavor to portray the art of the Indian. The same kindness was shown by Dr. Edgar L. Hewett, Mrs. Amelia Elizabeth White, Mrs. Charles Dietrich, and Mr. C. T. Wallace in offering us the freedom of their private collections. We are also individually indebted for friendly counsel and aid in selecting specimens to Mr. Kenneth Miller of the Museum of the American Indian, to Dr. Cornelius Osgood of Yale, to Mr. Donald Scott of the Peabody Museum at Harvard, to Mr. Douglas Byers and Mr. Frederick Johnson of Andover, to Dr. J. Alden Mason of the University Museum, to Mr. H. W. Krieger of the National Museum, to Dr. A. C. Parker and Mr. William Ritchie of Rochester, to Dr. Wilbur of the Field Museum, to Mr. Frederick Douglas of Denver, to Dr. Scudder Mekeel, Mr. Kenneth Chapman, and Dr. Mera of Santa Fé, and to Dr. H. S. Colton of Flagstaff, all of whom gave up ill-spared hours of their busy days to help us.

Publication was not contemplated in terms of the original grant. However, Mr. Cass Canfield and Mr. E. C. Aswell of Harper & Brothers saw the importance of bringing out an introductory work on the subject of American Indian Art. The Fine Arts Committee of the

xii

American Council of Learned Societies generously underwrote half the manufacturing costs, a contribution which enabled Harper & Brothers to bring out this volume with an adequate corpus of illustrations.

The writer also owes much to those kind people who supervised the final selection of photographs. He is especially indebted to Miss Bella Weitzner, Mr. Clarence Hay, Dr. Clark Wissler, Dr. H. L. Shapiro and Mr. Paul Richard of the American Museum, Dr. Duncan Strong and Dr. Ralph Linton of Columbia University, Mr. J. J. Sweeney of New York University, and Mrs. Thomas Fansler of the Metropolitan Museum of Art.

Thus this volume is freighted heavily with good will. The writer hopes that all those who helped to make this project a reality will find that their efforts did not fall on barren ground.

≈≈≈≈≈≈≈

*INDIAN ARTS
IN NORTH AMERICA*

≈≈≈≈≈≈≈

CHAPTER I

The Social Significance of Indian Art Today

INDIAN ART in North America, to borrow an aviation term, suffers from a "low ceiling." The impenetrable clouds of white domination prevent its reaching very great heights. Anyone not a sentimentalist may forgive the seventeenth and eighteenth century British and French colonists for not pausing to cherish Indian arts and crafts. Neither by tradition nor by economic circumstance were they disposed to pay much heed to aesthetic considerations in their own culture, let alone that of the Indian. The method of colonization by the infiltration of people impelled by personal initiative did not tend to respect Indian rights.

However, the nineteenth and twentieth centuries saw the development of conservation and the rise of the museum. Masses of material were housed and studied under three rough divisions, art, history, and science. The social "ceiling" operated again, since art collections were confined usually to European cultures and those historically antecedent to them, while Asiatic art balanced precariously between this category and the limbo of the "natural history of man" into which fell African, Polynesian, Melanesian, and Indian collections. Such a segregation was logical and necessary, but it meant that as the study and practice of "Art" as an intellectual and cultural discipline began slowly to strangle the craftsman with his answer to a social demand, great quantities of useful and significant material escaped the notice of students and connoisseurs. It is obvious that one studies art in art museums and not in museums of natural and social science. Thus the art of the Indian is difficult to contemplate or to study in a

1

properly aesthetic aura, since the exhibition of ethnological collections shows the general equipment of a tribe and does not emphasize or dramatize examples of high artistic merit according to white standards.

Yet it seems remarkable that it was not until 1931 that the Exposition of Indian Tribal Arts Inc. made the first concerted attempt to gather together and to exhibit specimens illustrating the beauty of North American Indian Art.[1] The two pamphlets brought out by the Exposition contain excellent articles on Indian aesthetics, but these are now most difficult to obtain. Thus a fully illustrated reference book on North American Indian art has never been submitted to a wide public, and the potential aesthetic interest of the various tribal styles has not been made accessible except in some specific instances.

The labors of Doctor Clark Wissler, Mr. Kenneth Chapman, Mr. Eric Douglas, and Doctor H. J. Spinden have stimulated interest in Indian design, and many students have availed themselves of the varied patterns exhibited in the museums in New York, Brooklyn, Santa Fé, and Denver. These men have tapped one of the best available sources for active interest in Indian art, that of the designers and commercial artists.

Mr. Chapman has also worked long and ardently in the Southwest to stimulate the Indians into developing their own arts. Mr. Collier and Mr. d'Harnoncourt of the Indian Arts and Crafts Board are laboring earnestly to find some means of enabling the Indians to supplement their livelihood by utilizing their past traditions of excellent craftsmanship. This scheme necessitates an interest in Indian art on the part of the buying public and enough pride and hope on the part of the Indians to revive an energetic interest in their own crafts. Dead

[1] The exhibition arranged by Dr. H. J. Spinden in 1919 at the American Museum of Natural History showed how modern design could be enriched by using American Indian and other aboriginal design motives. It was not primarily an exhibition of American Indian Art.

2

work in slavish imitations is as fatal to a tribal art as making gimcrack souvenirs.

The possible effects of Indian art on modern American culture are impossible to estimate. It seemed to the writer a great wastage that modern artists availed themselves so much of pioneer themes, to the neglect of the Indian background. A strong thrust toward a national art should avail itself of all conceivable regional roots. Yet a moment's reflection will disclose that American artists have an abundance of pioneer material at hand as part of their elementary education, but they have no place to turn for Indian material except in the technical anthropological literature. The mingling of styles and the adoption of Indian techniques is probably unsuitable and genetically unsound. Yet in this era there is a definite place for the emotional principles back of American Indian art. The idea of the group working together for the common good certainly is reflected in the unity of the tribal styles. That communal work does not submerge initiative may be seen in the infinite variety of design and form. Personal emotions affecting the individual in his relations to other individuals are conspicuously absent from North American Indian art. Rather there is a balanced harmony of presentation like the natural laws to be obeyed in adjustments to the finite and the infinite. Balance, order, repose, awe, majesty, naturalism, are terms for Indian art instead of the love, mercy, hate, mysticism, of the personal European religious art. Perhaps such attitudes are impossible to reconcile, but in a great technical age where, more than ever before, mass cooperation is essential to survival, such emotional ideas as are depicted in Indian art are not lightly to be dismissed. In this twilight of individualism, perhaps we may draw some satisfaction from the group arts of America.

The Nature of Indian Art in North America

THE arts of the North American Indians have been little explored except as an aspect of anthropological research. In consequence, public attention has lacked the stimulation to investigate the significant art forms achieved by the North American tribes. Publication and illustration of important examples, with a few notable exceptions, chiefly in detailed fields, have tended to conform to the needs of anthropologists instead of catering to the demands of art students. The purpose of this volume is to try to present pictorially a sample of the range of material available to supply this deficiency. The accompanying text will give a short exposition of the nature and condition of the Indian groups who created these arts. Ultimate aesthetic criticisms do not fall within the scope of this book, which is to introduce the arts of the American Indian and not to expound their significance in terms of modern art appreciation.

However, a few generalizations are necessary to set the scene and to establish a point of view. The general technical and sociological plane of the Indian arts corresponds to the earlier levels of European and Asiatic development. The aesthetic principle, consciously expressed for its own sake as in the modern European and American intellectual pattern, is not prominent in aboriginal North American art. On the other hand, those aesthetic formulae, which so strongly govern decoration and shape in the anonymous arts of the past and present are very definitely in evidence. Conventional treatment is the rule in North America, since artistic motives are used to enhance

or embellish objects of practical or ritualistic use. Yet naturalism, when it does appear, often reproduces life forms with a dramatic fidelity.

Relatively few of the Indian tribes were advanced enough technically or socially to have an abundant life under settled conditions. Many of them were semi-nomadic, changing their settlements as the soil became too exhausted for agriculture and as the game was killed off. Thus there was little opportunity for the leisure and security which contribute to the training of generation after generation in the techniques and traditions productive of a great art. Nor was the social structure of most groups so organized that the craftsmen banded into a guild with its implications of traditionalized standards. There were rules which governed the functioning of a craft, but the worker in one was not confined to that alone. He might have exercised his talents at several.

It is conceivable that only familiarity with an art reveals individual practices, and that to a foreign eye the works of the greatest European masters might sink back into the anonymity of a national or regional school. It is possible that one may therefore underestimate the importance of the individual in primitive arts, such as those produced in North America. Yet the arduous conditions of life in aboriginal North America tended to suppress individuality, since it was so essential to maintain social solidarity against the hostile forces of nature and man. Such social strictures, habitually enforced, would set a premium on custom and standardization in production. Thus speaking very roughly and generally, where in a European art the range of skill exhibited by the artist at one extreme and by the ordinary member of society at the other might be expressed by an arc of ninety degrees, perhaps fifteen degrees would cover the range between supremely skillful and ordinary work in an Indian group.

Technical equipment of North American Indian tribes was rude, to say the least. They had no metal tools until the time of European

contact, so that according to those rough criteria of cultural development, the American Indian was in a neolithic stage. Yet his products both in North America and in the high civilizations of Middle America, reveal a skill, feeling, and mastery over material that far transcend the equivalent levels in the Old World.

The preoccupation of the American Indian with religion and ritual is another point to be considered. This situation is common in other parts of the world, but it seems especially true of the native cultures and civilizations of North and South America. The highest achievements of man in the New World, as represented in the civilizations of the Aztecs, Zapotecs, and Mayas, evolved through religious channels. Art, mathematics, architecture, philosophy, all served religious ends. It is as if the current of intellectual development in the New World worked toward a perfect religious expression wherein the supernatural forces could be constrained to work for the benefit of man.

Many things, lovely in terms of our own aesthetics, have emanated from this anonymity of production, so that the author has tended to select with a European eye rather than to try to recapture the inner significance of Indian psychology, an elusive process at best. Yet the objects selected for illustration have been themselves the final arbiters, for an outstanding work is pre-eminent in any civilization or culture. Let us pass now to a consideration of the people themselves, to understand better the background of our subject.

CHAPTER III

The Social Background of Indian Art

THE aboriginal arts of North America were produced by American Indians. This term is a general one and has no more implication of cultural, linguistic, and racial homogeneity than the blanket terms, European, African, or Asiatic. In hair color and pigmentation of skin and eye the Indians have a rough resemblance to each other and to the eastern Mongoloids of Asia, but Indians also disclose great variability between tribes in stature, head form, and proportion of features. The North American Indians show as great a diversity in language as in physical type. More than fifty mutually unintelligible linguistic stocks have been recorded, and only by the most sweeping generalization may these be reduced to six great families. A further division of the North American population, before the white penetration, results from the numerous independent bands or tribes, which, although occasionally linked in loose confederacies, more often operated in complete independence of each other.

This racial, linguistic, and political diversity probably arose on the one hand from the manner of population of the New World and on the other from the isolation of the established colonies. The best current opinion believes in an infiltration of many small nomadic groups of immigrants. These wanderers from Asia must have contained elements split off from many Old World peoples, and since a vast terrain is necessary for even a few people to live by hunting, they must, after arrival, have lived sufficiently separated to accentuate still further these linguistic, social and biological differences.

The major problem these groups had to face was adjustment to

7

their environment, and the North American continent exhibits wide extremes in climate and terrain, all of which were occupied by man. In the north extended the inclement reaches of the Arctic Circle, flanked by the forest country of the northwest and northeast, with the barren lands of Hudson Bay stretching between. The Rocky Mountain chain walled the hospitable valleys of the lower Pacific Coast from the Great Plains which reached down through Texas to the Gulf of Mexico. At the south of the Rockies was the great arid area embraced by the southwestern states of today. The country east of the Mississippi to the Atlantic Coast was shrouded by forests ranging from the pines of the cold north to the sub-tropical woods of the deep south.

To survive in such different environments required delicate adjustments in the techniques of living. In consequence, methods of hunting, fishing, food-gathering or agriculture varied from area to area, even as did the manner of life in relying on one or all of such practices. The measure of a tribe's success in supporting itself is closely correlated with the skill and development of its arts and material culture. The direction of a tribal art depends closely on the tribal life.

Thus wretched nomadic groups forced to live in barren land would have too little surcease from the search for food to produce any art, whereas successful hunting groups whose food supply was ample, would have leisure to express their artistic energies. One would not expect major sculpture to be produced by people whose possessions must be kept at a transportable minimum. On the other hand, groups whose chief food supply was an abundance of fish from coasts nearby, could maintain semi-permanent settlements with the accompaniment of a great range of possessions. This situation would be reflected in a wider expression of artistry and technical achievement.

Good hunting makes for a higher standard of life than poor farm-

8

ing, but successful agriculture in North America, as in other parts of the world, has enabled man to produce a more developed culture and a higher art than the most plentiful game supply.

The Indian arts of North America provide material for a case history of artistic expression and development. The number of forms and designs is enormous and the individual objects are pleasing and important. Yet there is no group in North America which can be said to have achieved that developed mass of social and technical excellences which we associate with the term civilization. To the south, in Middle America and Peru, there existed tribal cultures which can be called civilized, but they do not fall within the scope of this book. The exclusion of such material does not affect the presentation of North American art. Whatever influences may have passed from the south were more probably technical and social traits than direct artistic inspiration.

The history and development of the North American Indians and their cultures require a continental survey in respect both to time and to geographical distribution. A comprehension of Indian art must also take into account the curious peaks, plateaus, and valleys of human culture. Some of these may be directly attributable to environment, but others seem to depend on those innate psychological strengths and weaknesses so difficult to explain in human activity. A review of such history as has been recovered will indicate some of the steps by which Indian culture developed. A survey of the modern Indian groups, now restricted to reservations, will give us some insight into the social functioning of artistic techniques. The next two chapters will take up some aspects of the Indian, past and present.

CHAPTER IV

The Origins of Indian Culture

THE origin of the Indians and of Indian culture and civilization has received much attention from seekers after fact and from indulgers in fancy, but the latter in recent years have tended to focus their interest on the richer field of Middle America. The gross resemblance of the Indians to Mongoloid groups strongly indicates an Asiatic origin, and to derive the population of the New World from Asia by way of the Bering Strait and the Aleutian islands is a hypothesis demanding less tax on the imagination than to import the American population from more distant sources. The geological age of the Atlantic and Pacific ocean floors precludes the presence of man before the subsidence of former land masses. It seems most unlikely that highly civilized colonists from the Old World could have had an appreciable effect on American culture prior to 1492, since no specific Old World culture has a sufficiently close resemblance to a New World group. Nor does it seem likely that man himself could have originated in the Americas, since the fossil apes and fossil men, which point the evolutionary road in the Old World, are conspicuously lacking in the New.

Man was living in the New World at the end of the Pleistocene era, a score of millennia ago. He was in contact with types of animals that are now extinct, like the early horse, camel, sloth, extinct bison, mastodon, and mammoth. We know that there were two types of human culture at this time. One, the Folsom, was based on hunting needs as disclosed by the presence of stone projectile points, knives, scrapers and the like. The other, the Cochise, had grinding stones as

10

if its makers lived principally on seeds and berries, gathering their food rather than hunting it. Both groups seem to have been nomadic, and remains of hearths alone represent their domiciles. Their stone tools have survived chiefly, and a few projectile shafts found in dry caves offer a remote testimony to their perishable material. Nothing approaching art has survived on this horizon.

The close of the Pleistocene was a good period for immigration. The retreating ice sheets set the cold weather animals migrating, and the tribes which lived on them naturally followed their source of food supply. Yet the glaciation probably reduced the flow of waters into the Bering Sea so that it was lower than now and communication between islets more simple.

The people living now who most closely approach such rudimentary cultural stages are the Alakaluf in the southernmost tip of South America. Their life is extremely simple, their culture is as little developed as any known, except that of the Australians, and they have no art worthy of the name, even in an anthropological sense. Thus combining the ancient archaeological with the modern ethnological data, we may postulate an original immigration on an exceedingly low culture plane a long time ago. Probably enough groups came over in this long stretch of time to lay down the basis for the linguistic and possibly for the physical complexity of the American Indian.

Archaeology, in the complete absence of adequate historical or traditional records of the past in North America, is a very inadequate tool. Except under very exceptional circumstances, only the imperishable objects like stone and, less commonly, bone, shell, and pottery, remain. Therefore it is possible completely to underestimate, on archaeological evidence, a culture like that of the modern Indians of the Northwest Coast, which has no pottery, rather poor stone, and an elaborate development of wood carving and basketry. After a

couple of centuries the fine carving and weaving would have disintegrated, leaving the inferior stone implements as cultural remains.

Consequently, it is possible that some of the groups who later made their way across the Bering Strait had more developed types of hunting culture than others. How much of Asiatic influence crept in with these early nomads we can never know, but it can be stated with some confidence that their culture was not a product of the high Chinese civilizations. The closest cultural connections now evident exist between the relatively recent Northwest Coast culture and those of northeastern Asiatic tribes who are survivals of more primitive stages of human development in eastern Asia.

While some hunting groups never passed beyond the stage of developing their arts and techniques in that direction, other tribes began to domesticate and utilize the native plants found in the New World. Especially important to North American agriculture were corn, beans, and squash, but the actual steps toward domestication may have been taken further south in Middle America. In South America, on the Highlands, the potato, and in the Amazon basin, manioc, were cultivated to form staples of diet. It is of some interest to note that New World agriculture comprises the cultivation of plants not one of which was known in Asia or Europe until after the first white contacts. The invention of agriculture brought a stable food supply, but also demanded the invention of new techniques for storage.

The state of the arts during this period is difficult to estimate. There are many living tribes who created, up to very recent times, interesting art forms in perishable materials and in some cases continue to do so. On the basis of their archaeological remains no hint of their attainments would exist. These modern perishable arts are made both by hunting and farming peoples, but on the basis of time we do not know when the first primitive hunters and the first farmers began to turn from strictly utilitarian concerns to take a few side

12

glances at aesthetic considerations. However, in several localities basketry and wooden objects have been preserved either through arid conditions or through deposits under water where the remains were so coated by mud as to resist destruction. As a result of these investigations we know that aesthetic impulses became manifest at a relatively low culture stage, in some cases of considerable antiquity. A few examples will illustrate this conclusion. In the southwestern United States the Basket-Maker culture fortunately often occurs in dry caves, so that we may reconstruct much of their life as their equipment is well preserved. The Basket-Makers depended on corn, on game, and on seeds and berries. They wove fibers into cloth and into baskets and embellished their products with simple but handsome decorative patterns. After attaining considerable excellence in weaving, they either invented or acquired the idea of making pottery vessels, first sun-dried, and later, fired. To these new products they applied designs developed in their weaving. Free drawing was confined to highly conventionalized figures on the walls of their caves, sculpture to crude little images of sun-dried clay.

The fusion of roundheaded immigrants with the original long-headed group seemed to invigorate the culture and there followed continuously and gradually the development of a sedentary agricultural life which still exists among the Pueblo of today. Yet the art in general never broke the dominance of design imposed in their first steps.

The Indians of the southeastern states also had a Basket-Maker stage, differing in style from that of the Southwest, but showing a transition from food-gathering into agriculture. They, too, learned to make pottery and elaborated their weaving technique. Their stone work extended from the manufacture of simple implements to the creation of ceremonial objects of real artistic merit. In some localities these tribes worked up to a ceremonialized culture with temples and

13

priests, on the economic basis of a corn agriculture which produced a secure food supply.

Again on the Northwest Coast, because of the abundance of fish and shell foods, and the cycle of salmon runs, some tribes were able to work out a rich ceremonial culture, the peer of those in the Southwest and Southeast. Yet agriculture they had none, except for the growing of a little tobacco.

The Eskimos started out with a well-equipped technique for living by hunting and went through a gradual development, culminating in an adjustment to a severe environment that was practically without equal in the annals of man. The arts here are expressed in decorative motives and in the creation of a minor ivory sculpture that exhibits the most lively naturalism.

Some of these archaeological sequences must represent a couple of thousand years of human history and show the development of simple stages of human culture. In such sequences as we have, there can be detected a gradual advance in general technical ability to which is added the accretion of new crafts and skills, sometimes invented and sometimes borrowed. Until the advent of the whites there is little evidence of the sudden influx of newcomers bringing high culture elements, with resultant transformations in the local life. Thus the adoption of the horse culture on the Plains, the sheep herding of the Navajos in the Southwest, and the politico-military craft of the Iroquois, arising from European contact, seem to have wrought more violent and sudden change in local culture habits than did the spread of corn agriculture and the introduction of ceremonialized religion.

The arts of North America attained a high excellence with a low technical equipment according to Old World culture patterns. Without effective metal tools, without domesticated animals for food or transport, except the turkey and dog, the Indians worked out various types of economy productive of art forms which, on a comparative basis, belong to more technically advanced culture planes in the Old

14

World. There is a strong impression of mass life, mass art, and a submergence of individualism. The Indian arts in their impersonality are like our hills and forests, and like our physical background, should not be ruthlessly destroyed for our modern needs. Conservation might just as well be applied in the direction of Indian arts as to the establishment of parks to save aspects of our national resources. A summary of Indian art in terms of time and tribe will show a neglected but nonetheless rich heritage from our predecessors on this continent.

CHAPTER V

Indian Art Before White Contact

SECTION 1—*Steps in Development.* Archaeological methods must be used to recover the historical stages in North American Indian art, since documentary history is lacking and tradition vague. Unfortunately, this branch of research is still in its preliminary stages, so that the record of Indian art in the past is far from complete. Excavation is the chief tool of archaeology, and in view of the great size of the North American continent, it is not surprising that neither man power nor funds have been sufficient adequately to sample this enormous area. Thus the element of chance enters, so that an excavator's lack of success in finding a site rich in objects may give an erroneous impression that a region produces a negligible art.

Another factor hindering the study of ancient art arises from the element of preservation. In sites open to the weather the perishable objects soon disintegrate so that only pottery, bone, and stone are left, amounting to as little as five per cent of the total possessions of a people. Under such circumstances it is obvious that estimates of Indian culture in the past must be very imperfect, since they are restricted largely to artifacts of stone, pottery, and bone; but we know from the work of modern tribes that wood, woven materials, and leather were important media for artistic expression.

When examples of human handiwork are recovered by excavation, there arises a series of questions as to the identity of the makers, the age of the specimens, and their relationship to the art development of the Indian in general. Without calendars, without inscriptions,

16

such a task is almost impossible. However, relative time may be established by the superposition of objects in the ground, since under normal circumstances, in a human deposit like a refuse heap, the older objects would be found at the bottom of the accumulation, the later at the top. Then, too, certain types of specimens and certain styles of decoration are found associated and frequently confined to specific geographical areas. These may frequently be interpreted as the work of a single tribe, and are the tangible remnants of what the anthropologist calls a culture, in Linton's definition, "a strain of social heredity." Since we often cannot identify the tribes producing these archaeological cultures, for the purposes of distinction they are frequently named after sites where they are best represented or were found first.

Broad similarities attend the culture traits in different parts of North America. Many regions produce no significant examples of art either from the point of view of the ancient Indian or of the modern observer. Yet to obtain a perspective let us examine the archaeological culture areas of North America, commenting briefly on the arts found in each zone. For convenience, let us begin with the Eskimo and pass southward to the Northwest Coast and California. Then we shall consider in succession the Plains, the northern Woodlands, the middle Mississippi and Ohio region, and after analyzing the art of the southeastern United States we shall conclude our survey with the Southwest. (Plate 1)

Section 2—*Ancient Eskimo Art.* (Plates 2 & 3) The struggle for existence in the inclement north thrust most of the creative energies of the ancient Eskimos into devising techniques for maintaining life under hunting conditions. The ingenious and practical inventions of characteristic houses, boats, skin clothing and hunting instruments attest conspicuous abilities that in a more favorable environment might have developed into important cultural attainments. The search for food involved frequent changes in residence, so that emphasis had to

17

be laid on the portability of objects. The very considerable archaeological research in Greenland and along the Alaskan coasts and islands discloses a steady development of practical things, with the artistic impulse largely confined to perfection of manufacture. The tentative definition of six culture periods, known as Old Bering Sea, Birnik, Punuk, Thule, proto-historic, and modern, show a long occupation of the northern region, maintained by very similar adjustments to the environment.

Ancient Eskimo art does not approach the lively freedom of the modern. The earliest levels produce evidence of a fine sense of design, which has tantalizing suggestions of an Asiatic source. This early art, seemingly engraved with iron tools which likewise point to Asia, completely disappears in the middle periods. Ornamentation of bone and ivory objects is the chief decorative expression, but ceremonial masks reveal a simple grasp of anatomical essentials, suggestive of a strong aesthetic sense. Minor figures of animals and men also disclose this latent ability which never fully attained fruition. A few carved ivories and bones give a foretaste of the brisk action of modern Eskimo draughtsmanship, although such work in general is far inferior to that of modern times. Whatever ideals of craftsmanship the ancient Eskimos had are expressed in the careful manufacture of practical things. Those objects like figurines and masks, which would seem to us the logical outlet for such attitudes, apparently were by-products of the essential manual industries, receiving no more, but definitely no less, of that dexterity in manufacture so characteristic of every ancient and modern Eskimo product. It is in the modern art that we have opportunity more justly to appraise the talents of these modern peoples, a task which we shall defer to the next chapter.

Section 3—(Plates 4 & 5) *Ancient Arts of the Northwest Coast and Columbia Basin.* This region, which was the seat of such very high culture in modern times, is baffling to appraise from the archaeological evidence. There are ancient remains of summer houses and semi-

18

subterranean winter dwellings; and competently-made tools of antler, bone, and chipped stone turn up in the excavations. Nothing indicative of the antecedents of the rich wood carving of the historic period is preserved, nor does the mute evidence of human occupation reveal anything of the complicated social organization and rich mythology of the modern tribes. Yet it is hard to see how the modern art could have developed without years of folk apprenticeship.

Stone figures and heads found on the upper Columbia River suggest that prehistoric peoples might have had considerable skill in sculpture. The other remains of human handiwork associated with the Columbia River sculptures approach in general type and style the norm for the material culture of the prehistoric Northwest Coast tribes. Consequently, we may assume a relatively long development in this direction.

The Columbia River sculptures are ceremonial and ritualistic in flavor, with naturalistic considerations occupying a secondary position. The technique in shaping these forms consists of beating or pecking out the lineaments of the head and body with another stone tool. This process gives a massive quality to the sculpture, irrespective of its actual size. This monumental effect runs through all the New World sculptures, which have been wrought from stone with stone tools, so that even the smallest amulets, when enlarged upon a screen, have all the dignity of major monuments. There is an intrinsic sense of proportion, abstract rather than naturalistic, which seems to govern the formation of the smallest figurine, as well as the largest sculpture in the round, no matter what the tribe or its scale of civilization.

The stylistic affinities of this Columbia River sculpture present an irritating problem to students of aboriginal American art. Although the treatment of the figures shows a tenuous connection with the later Northwest Coast wood carving, the quality of workmanship is best matched with the Guetar Culture of Costa Rica, far to the

19

south. Yet the distance is so great, the intervening tribal cultures so many and diverse, that direct contact or influence seems impossible.

Section 4—*Ancient Arts of California.* (Plates 6 & 7) The modern Californian Indians showed their most conspicuous artistic attainment in the weaving of basketry, but climatic conditions have effectually obliterated any trace of such art in the past save for some material found in caves. That California was inhabited for a long time is shown not only by the occurrence of human artifacts of substantial antiquity, but also by the continuous record of human habitation as shown by the shell-heaps formed from the discarded inedible parts of shell fish.

The environment of California provided such an abundance of natural food products that no serious agriculture was developed. Hunting implements and equipment for grinding berries were competently made. Pictographs were occasionally scratched on rocky outcrops, and the presence of shell ornaments in archaeological sites might be construed as a form of aesthetic idealism. However, the most conspicuous artistic creations are the steatite bowls made for cooking, which in form and finish reveal the exercise of an accomplished taste. Sometimes these vessels are further embellished by incised designs or by inlay work with shell set in asphaltum. A few animals pecked from stone show a grasp of essential form that is comparable to our best modern attainments. It is a curious contradiction to find such exquisite stone work among tribes who made no pottery, or an inferior kind at best, since such workmanship is usually associated with a much higher scale of living.

Section 5—*Ancient Arts of the Plains.* The peoples of the Plains lived in a region unsuited for agriculture except along its eastern borders. Just as in the far west, there is little evidence of artistic attainment in the stone and bone tools harvested by archaeologists. Yet the discovery of implements associated with such extinct animal forms as the bison and the elephant proves that hunters roamed the

20

plains as early as ten or twenty millenia ago. In spite of this long span of time, little was developed in the way of important art.

The rich panoply of the nineteenth-century Plains Indians may well have been a recent development, for the introduction of the horse from European sources undoubtedly improved hunting techniques and brought about the achievement of a richer life. Furthermore, ownership of sizeable pack animals made it possible to accumulate more possessions. Finally, there is good evidence for believing that the best exponents of modern Plains culture were former sedentary agriculturists converted to nomadism by the introduction of the horse. As farmers, they were susceptible to waves of high culture from the south and east. While from the historical point of view we may lament our imperfect knowledge of Plains archaeology, it does not seem very probable that we have lost a great deal artistically.

Section 6—(Plates 8-16.) *Ancient Arts of the Northeastern United States.* The ancient cultures of the northeastern United States abound in significant art forms in contrast to the povery of the prehistoric tribes of the West. Unlike the nomadic hunting groups of the West, the eastern tribes were sedentary farmers, relying upon corn, squash, and beans as food staples. Permanence of abode, predictability of sustenance, relative regulation of hours of work, growth in population, all contributed to release more energy into inventions of new tools, new social conventions and new art forms. There is throughout the northeastern and culturally closely allied southeastern United States a close correlation between a favorable environment and a high culture.

The historical picture is not yet complete and we lack much data on the origins of many culture traits. Yet the general planes of human development may be defined. Some of the earliest groups lived largely by hunting and fishing and worked out material cultures of various degrees of excellence. One such manifestation, the "Red Paint" cul-

21

ture of New England, has stone implements of such fine workmanship that some might almost be considered art objects. Other groups relied on available supplies of native plants, like wild rice, gourds, sunflower seeds and the like. At some distant time in the past, the cultivation of corn was introduced, and the sedentary life followed gradually. At a later date pottery was introduced or invented, and its value for storage and cooking can hardly be overestimated. The process of agricultural diffusion must have been a slow one, for the clearing of the forests offered to these stone age peoples an even more formidable task than it did to the early European colonists. Furthermore only such varieties of vegetables could be grown as would complete their growth in the short northern summers, and the necessary experimentation and selection must have taken some time. Eventually in southern Ohio a fairly sophisticated culture, called Hopewell after the type site, came into being.

Various tribes in Wisconsin, in Minnesota, and in the rich river valleys west of the Mississippi borrowed elements of this complex. Others in northern Illinois, Indiana, and Michigan did the same. The peoples east of the Appalachians were likewise influenced, but these peripheral groups never seemed able fully to absorb all the traits of the Hopewell culture, or to attain the great artistic skill of its makers. On the other hand, they developed local styles distinctive for their respective regions.

A characteristic feature of the culture is the erection of mounds of earth, so that the term Mound Cultures is often applied indiscriminately to the prehistoric inhabitants of the eastern United States. These mounds served many purposes. One very common structure first consisted of a wooden framework covered by a thatch and walled by wattlework. In this building the dead and their cherished possessions were laid out. Later the structure was set on fire and baskets of earth were piled up into a mound over the ashes. The objects found with these burials are superior to those occurring in village refuse

22

heaps, so that we have a means of determining what the aboriginal people valued. However, not all the mounds were used for burials. Other mounds seem to have been foundations for temples or palaces, and still others were made to resemble animals, birds, or snakes. Sometimes circular mounds were constructed, as if to form a rampart or to mark the limits of a ceremonial enclosure.

The most notable art forms of the Hopewell culture center in the stone pipes, the bowls of which were often carved to represent men, animals, and birds. The small size of the figures in no way detracts from the accurate and often lively presentation of the animals, and the human examples are gauged to Indian physical proportions. Action is almost never shown, but there is nothing lifeless or inert about the passive positions. Small clay figurines have been found at rare intervals. A notable group from the Turner Mounds in Ohio discloses the detailed presentation of clothed male and female figures, revealing a highly developed anatomical sense. (Plate 14.) Paramount among examples of Hopewell sculpture is a pipe in the form of an erect figure, who seems almost to be dramatized as a chief chanting his song of prowess. (Plate 11.) Occasionally small limestone heads are found which reveal the same gift of expression and perfection in execution.

We have no way of knowing whether there was a wooden sculpture commensurate with these stone examples, but such a possibility is by no means remote. There does not seem to be enough work in clay to allow for a period of practice and development to take place in that medium, nor does the stone sculpture produce a developmental series suggestive of the complete evolution of such forms.

Draughtsmanship and pure design are found well developed in plaques and gorgets of beaten copper and shell, which seem to be trade pieces from further south. The surviving examples show a strongly developed sense of balance and rhythm with a lively sense of invention. In this northeastern region the application of pure

design did not develop strongly in the direction of ceramic ornament, although there are a few examples of a crafty balancing of designs in ceremonial vessels.

In a survey such as this, there is not space to point out the variations in cultural manifestations. We have concentrated on the Hopewell culture to the exclusion of others as illustrative of the first competently developed art that we have thus far met. South of this region in the lower Mississippi drainage and as far east as Georgia there are many notable artistic developments, a few of which will be described in the following section.

Section 7—(Plates 17-29.) *Ancient Arts of the Southeastern United States.* The erection of mounds was a customary procedure in the southeastern United States, but platforms for temples were far more common in the South than in the North. In many instances these platform mounds were coated with clay so that a smooth and shining surface would result.

Pipes, which, in contrast to the North, show men more commonly than animals, are not the only stone sculptures in this region. In addition, several larger human figures have been found, that could only have been used as idols. A notable development in the lower Mississippi-Tennessee area was the manufacture of clay vessels in the forms of men and animals. Occasionally, as in the case of vessels modeled into the form of human heads, real heights were reached, showing not only anatomical and decorative details, but also varying expressions. One of the most lovely examples in the entire field of North American Indian art is a diorite vase from Alabama. (Plate 20.) This gracefully conceived bowl is surmounted by the head of a wild duck. There is superb blend here of the functional purpose of the bowl with a vivid reproduction of a natural form.

Some wooden sculptures were recovered from Key Marco in Florida that reveal a lively observation of nature as well as that balancing of elements of pure design that is so characteristic of Indian art.

24

This virtually unique case of the discovery of ancient wood work makes one lament the remorseless action of time and weather, but it is an extremely important confirmation of the former existence of competent wood carving.

The graphic arts reach their peak in the ornamentation of shell gorgets and trumpets. That these were highly esteemed is shown by their presence in the northern mounds and in others far to the east. The Spiro Mound in Oklahoma produced a superb series of these, depicting elaborately accoutered individuals in various postures suggestive of ritual dances. (Plates 18 & 19.) Sometimes these figures are etched and at other times cut out from the shell. The Etowah Mounds in Georgia yielded magnificent examples of this drawing style, which was expressed upon beaten copper rather than shell. The homogeneity of the drawing in spite of the wide diffusion of the specimens suggests a single center for the practice of this art. While there are elements in the dress of the figures which, to some authorities, suggest Mexican influence, I feel that the very specialization of the drawing contradicts that theory, since the style cannot be matched specifically to the graphic arts of any defined Mexican culture now known.

The pottery of the southeastern States which we have seen attracting the sculptor, also drew the draughtsman's attention as a field for expressing design. To incise the pattern was a much more common practice than to paint it. Often continuous running patterns extend over the shoulders of the vessels and sometimes are carried out over the entire surface. To plan and execute such patterns must have required a very acute sense of design, combined with great dexterity. Furthermore in some areas these designs are applied even to the ordinary pottery, a practice indicating a very high order of skill in the humblest potter.

Western Arkansas is the source of lovely examples of incised design carried out in panels and in all over patterns. Moreover, this selection of varying types of design, and the invention of ways to ex-

25

press them are balanced by an enormous versatility in creating new forms for the pots themselves. These vessels are usually built up with strips of clay, since the potter's wheel, ubiquitous in the Old World, was unknown to the Americas. Under such conditions of manufacture the solid proportions of architecture result, rather than the gracile elongations of Greek pottery.

A sparing use of painted design is to be found which seldom attains the richness of the incised patterns. There is, however, one ware with carefully executed designs, evidently produced by lost-color painting, which is the same process as batik applied to a hard surface instead of to a textile. (Plate 28.)

The closest connections with the high cultures of Central America are to be found in the eastern Arkansas region, where one group of forms suggests a number that occur very early in the Maya area. Again the incised designs from western Arkansas recall techniques used in Central Mexico during the early middle centuries of the Christian era. Nonetheless we are still unable to appraise how much the Southeast owes to Central America, and the interrelationships of cultures in the whole eastern United States is far from correlated.

We do find cultures apparently specializing in certain types of arts and crafts which were traded mutually. One also sees a distinction very evidently maintained between ceremonial objects and implements of daily use. The artistic talents seem to be largely directed into this religious channel. In the ceramics of the southeastern States, conceivably a distinction between secular and religious art exists, but the use of fine design seems, according to the bulk of the specimens, to have extended to ordinary vessels. Possibly the high general culture of these peoples brought up the level of the domestic crafts.

When we examine the arts of the ancient Southwest we shall see a very definite contrast with the East. In the Southeast and more specifically in the Northeast there is quite a wide gap between cere-

26

monial form and the domestic expression of the arts, whereas in the Southwest the domestic arts seem to receive the maximum emphasis.

Section 8—*Ancient Arts of the Southwest*. (Plates 30-38.) In no place in the Americas have we so much tangible archaeological information as in the Southwest. There are sites with deep deposits resulting from many years of occupation, there are caves which keep the rain from attacking the perishable remains of human culture, and finally, it has been possible to tell by the tree-rings in the beams of ancient houses the exact time when they were built, so that from A. D. 700 on we have good dates. The living people furthermore are culturally the lineal descendants of the ancient population and maintain in many basic elements the same sort of life as in the past. A serious lack in this superb structure for studying artistic evolution, is the paucity of striking examples of sculpture or draughtsmanship. Essentially we are dealing with an evolution expressed through purely domestic arts.

In geologically ancient times, there have been found the remains of hunting and food-gathering groups, which, so far as we can judge from the archaeological evidence, were without an art. However, in the early centuries of the Christian era, a group called, for want of a better name, the Basket-Makers, lived in northern Arizona. These people resided in small communities located in caves and in the open. While they had begun to practice corn agriculture, they still depended extensively on collecting wild seeds and on hunting. Yet they had an amazing variety of domestic articles, of which very few would survive in open sites but which are fortunately preserved in the dry caves.

These people had a tremendously developed skill at weaving, making all kinds of baskets, including waterproof ones for keeping a drinking supply. They wove bags, nets, string, robes of fur cloth, ponchos, and even sandals. They had all kinds of implements and containers for every conceivable purpose. As Mr. Charles Amsden

27

says, the material culture of the Basket-Makers seems to reveal interests mechanical rather than spiritual. Objects indicative of ceremonial use seem to be very rare. Their art is chiefly expressed through designs woven into their textiles. These consist of harmonious arrangements of geometrical elements and are used to adorn not only bags, tump-lines, and ponchos, but also to ornament the soles of their sandals. A few crude little effigies in unbaked clay seem to be the only expression of plastic interest. Some highly conventionalized but primitive paintings found on the walls of caves comprise the chief graphic art.

Finally, these people either invented or acquired the art of pottery-making. The vessels came to be competently made and, interestingly enough, the old textile designs were at first somewhat fumblingly applied to the new forms.

At about A. D. 700 new peoples with round heads began to penetrate into New Mexico and Arizona. Houses were developed, cotton was introduced, and pottery design began to be elaborated, although in the geometric tradition. The kiva or men's house as a religious center was developed. Agriculture was the chief means of subsistence. Different communities began to adopt distinctive ceramic styles and the standard Anasazi or northern Southwestern culture took its form.

Contemporaneously with the Basket-Maker in the North, another culture, the Hohokam, was flourishing in southern Arizona. These people were living in more or less permanent houses, which were semi-subterranean. They were making pottery, which they painted with simple designs, adhering in general to such conventional motives as might well have been derived from textile decoration. At a later date the figures of little men, birds, and animals are used sparingly but attractively. In contrast to the Anasazi or northern Pueblo groups, these Hohokam consistently made clay figurines representing human beings. The evolution of this art followed a long and crabbed course, without ever reaching any pronounced success. In stone, on

28

the other hand, a subsidiary decorative sculpture was worked out as an adornment for palettes and the backs of mosaic mirrors. These little carvings have some of the fresh vitality to be observed in pre-dynastic Egyptian stone work. Work in shell and in mosaic was also indicative of a strong sense of decorative art.

The northern Pueblos, the Anasazi, reached their height in the Eleventh to Thirteenth Centuries, but they were an essentially practical people. Ceramic decoration seems to have been the chief artistic outlet, and an amazing skill and inventiveness were achieved in laying out geometrical designs over the convex and concave surfaces of the respective exteriors and interiors of vessels. In southeastern Arizona, a special ceramic development in the Mimbres Valley led to a delightful development of naturalistic forms coupled with pure design. The decoration of these Mimbres vessels is one of the most vital expressions of draughtsmanship to be found in the pre-historic Southwest. (Plates 30-32.) Another style, attractive not only because of the design, but also on account of the charming yellow tones of the base clay, emanates from the early Hopi in central Arizona. The drawing of the design is bolder and less finical than in the Mimbres product. (Plates 33-34.) Cave drawings, however, show a crabbed conventionalization.

Stone sculpture is very rare in Anasazi art. Occasionally small stone figures used as fetishes reproduce something of the character of the animal represented, but in the main they are far below the general level of the rest of the elements of the culture. As in Mexico, there was some skill in mosaic work, inlaying turquoise, jet, and shell on pottery, wood, or another shell. Weaving, to judge from the specimens preserved, adheres to a few simple patterns without reflecting a great interest in design.

There is, however, an architectural development in the ancient Southwest that exerts a considerable fascination, even though aesthetic conditions did not govern the construction. The large communal

29

dwellings like Pueblo Bonito arise in steps from the level open country. The proportions of the dwelling rooms are peculiarly suited for a harmonious cluster of rooms of this type; and the circular shape of the kivas or ceremonial rooms breaks the rigid rectangular massing of the living quarters. The cliff houses or cave dwellings, set high above the valley floors in shallow lofty caves are more irregular in plan. The rooms are set on the sloping cave floors and conform to the natural irregularities of these great hollows in the cliffs.

Southwestern art is not expressed in sculpture nor in naturalistic drawing. It flows through the channels of design; even the forms of the ancient pottery vessels are held down to a standard minimum. Just as the early and undeveloped Basket-Makers seem to have been motivated by the desire to equip themselves rather than to express themselves, so the later Anasazi and Hohokam carried on the same process, the better to maintain life. However, the smooth surfaced pottery vessels offered a field for decoration that not even these practical people could overlook. In this decoration they expressed the major part of their artistic impulse, with rhythmic, skillful, heavily conventionalized designs. That random fancy which we find so vividly represented in the art of eastern Indians, here seems to be non-existent. Yet the living techniques of the Pueblo groups seem to surpass those of the eastern peoples.

Section 9—*Conclusions on the Development of Indian Art in the Past*. This brief review shows how before the European Conquest various types of art were associated with certain types of culture, and how these types of culture were related to specific kinds of environment. Yet weighting the equilibrium between man and nature, first on one side and then on the other, were three factors, the ability of some groups to be more inventive than others, the ability of some groups to absorb the inventions of other tribes, and the apparent lack of desire or ability on the part of some units to improve their condition by borrowing.

30

All in all, however, the well-watered lands of the sedentary peoples of the Southeast enabled them to establish a rich agriculture with a consequent leisure to invent new forms in techniques and art. The peoples of the southwestern country, possibly because lack of water entailed more work in order to live, did not, perhaps, attain so high an artistic development as did the southeastern tribes, although they surpassed them in technique of living. The northeastern groups, while relatively low in the development of their material culture, nevertheless, in a restricted field, produced highly significant forms.

Westward across the plains neither environment nor association with higher tribes could produce more than a bare maintenance of life, even if to do so required the greatest possible skill in hunting. The fishing communities of the Northwest Coast, with a food supply almost equivalent in reliability to farm products, may well have had an art of considerable interest. Yet the Eskimos, though having a relatively abundant food supply from the sea, seem to have followed the Pueblo idea of mastering technique.

As a general rule, however, the North American types of culture are closely associated with geographical conditions. The preceding survey is based on Dr. Clark Wissler's conception of the culture area, which so vividly contrasts the various states of human groups when they are fighting their way the more successfully to maintain life. To some extent, these geographic limits may be seen to affect our modern American culture in the technical sense, although up to very recent years, the intellectual and artistic distribution depended on relative proximity to the European sources of our culture borrowing.

To the primitive man, all crafts are arts and the manufacture of a serviceable weapon, the invention of a new method of stalking, are just as much arts as the creation of a design, or the portrayal of a figure. Thus the evolution of an art is more easily traced in terms

31

of a single culture than on the basis of a world development, because the definition of the ultimate forms is so difficult truly to formulate.

The two chief regions where the archaeologists have been able to secure good evolutionary series are the southwestern United States and the Eskimo area, where the abundance of life depended quite definitely on the development of techniques. In pre-Columbian times the social customs of neither area provided an outlet for a rich art in the European or Asiatic sense. There was an artistic feeling, especially in the Southwest, but it was directed toward embellishing articles essential to maintaining the group life.

In the southeastern United States, on the other hand, archaeology has brought to light a quantity of forms which may be considered as artistic, to our eyes, if not so to their makers', and which were certainly of great ceremonial significance. The evolutionary picture is very incomplete, but it seems possible to detect stages equivalent to the technical evolutions we have just mentioned. However, at a somewhat lower point in the development, as compared to the Southwest, a new factor is introduced, an intricately and objectively expressed ceremonialism. To implement this, very evidently the people had both to develop themselves and to borrow from others styles of carving and methods of representation that called into play major considerations relative to form and presentation. To hands trained in fabricating their every article of daily use, adaptation to a new outlet of this sort might be very rapid. While we predicate a southern origin, possibly Mexican, for some of these traits there is much left to find out before we get a true picture.

The following section on the modern arts will give a somewhat clearer picture of the social forces affecting the Indian arts like the transformations of ancient attitudes under European influence. Possibly the most significant change is an increased emphasis on social values as opposed to ceremonial or technical worth. Thus art and design were applied to personal or family possessions instead of being

32

chiefly employed for objects used in religious ritual. Just as in our modern society, a tangible and visual means of expressing social prestige lay in the excellence and beauty of workmanship of individual as opposed to tribal property. The influence of the white trade in furs may well have accentuated this tendency, already latent in the Indian communities.

CHAPTER VI

Indian Arts After White Contact

SECTION 1—*Introduction.* The Indian arts of the present are rarely fully expressed, but remain dormant, waiting for some stimulus to call them into being. In some places the old feeling for ancient forms has been completely obliterated, in others there exists an unbroken continuum from the past. The cultures of the southwestern United States still display many of the elements of the past and it is here that one may best begin to sketch the essential details of the retention of old and the absorption of new elements from European sources.

Section 2—*The Arts of Modern Pueblos.* (Plates 39-50.) The modern Pueblos live in a number of independent towns, and, in spite of more or less cultural unity, speak several different languages. They retain much of the ancient economy, but have added such characteristic innovations as glazed windows, livestock, wagons, metal tools, and the like. A veneer of Catholicism coats, but does not permeate, the ancient religion. They retain much of their old social organization.

Their ancient crafts, in large measure, persist in several towns. The weaving of garments has benefited enormously from the use of wool which followed the Spanish introduction of sheep. The form of the clothes and the designs on them are still pre-Columbian. Pottery follows largely in the ancient tradition, but new designs, following indigenous developments, distinguish the work of one town from another and designate the change of fashion through the years. In some towns there has arisen a considerable trade in selling these products to whites and the friendly counsel of interested Americans

34

has throttled a tendency to pervert the old handiwork into drug-store Indian forms. In other towns, notably San Ildefonso, a ware has been developed especially for whites, which although pleasing to some is not made for hard use, and lacks the integrity of a genuine product for tribal consumption. Silver work is a direct borrowing from Spain, but has become more characteristic of the nomadic Navajo.

A baffling development, that of masked dancers or kachinas, is hard to evaluate as a Pueblo invention, a Spanish adaptation, or something learned from the Mexican allies of the Conquistadores. There is little evidence for the trait archaeologically, but the form of the headdresses is distinctly Pueblo. The painting of the body in connection with the wearing of the masks creates a unity that is like a living sculpture. It would seem that the plastic sense so lacking in pre-Hispanic times blossomed out in this series of dance costumes. A minor art of wood carving reproduces the elaborate costumes of the dancers in stylized forms which combine, in a peculiarly fascinating manner, the abstract with the concrete.

Modern Pueblo painting has proved a most interesting acquisition from white contact. This art was carefully fostered by white friends and designed for sale. There is a fresh charm about the paintings, and the drawing is unmistakably Indian in feeling, however European the technique. Examples of paintings utilizing ceremonial abstractions are very rare. A small group of carved turquoise animals constitute an interesting biological sport in the development of Pueblo art. They do not seem to bear the marks of ancient sculpture, yet they make one wish that the Pueblo had done more with this medium.

One might be tempted to conclude from this cursory survey of modern Pueblo art, that the coming of the whites and the provision of a commercial market provided a stimulus toward artistic production, which was lacking in the ancient culture. On the other hand, the introduction of the Kachina cult seems a response to some re-

35

ligious urge and certainly it led to the development of highly interesting sculptural conceptions. However, on the whole, the sedentary populations of the Southwest adhered to their purely technical development beyond the point where most peoples start to work out art forms in answer to religious or aesthetic needs.

Section 3—*The Arts of Southwestern Nomads.* (Plates 51-58.) The life of a modern nomadic tribe, the Navajo, illustrates beautifully the process of culture assimilation or borrowing. These peoples filtered into the Southwest in late prehistoric times and seem at first to have led a precarious life, hunting, farming, and raiding the sedentary groups. When domesticated animals were acquired by the sedentary Pueblo from Spanish sources, they became first a prime article of loot and later a means of subsistence for the Navajo. Gradually, this group became more and more pastoral until now their flocks and herds are their chief means of subsistence. This method of life seems to have been well suited to the Navajo, since of all the Indian groups in North America, the population of this tribe has increased the most.

The Navajo are distinguished for three artistic products, two of recent introduction and one aboriginal. These are weaving, silver work, and sand painting. Wool from the herds is used to make blankets, and the technique seems to have been derived from the Pueblo who in turn may well have taken it over from the Spanish Mexicans. A beautiful talent for design has persisted in spite of abundant opportunity for the patterns to break down into the most vulgar "novelty" work for the souvenir trade. Silver work is rich and satisfying, being formed in bracelets, belts, bow guards, necklaces, and horse equipment. The designs and forms give forth a definite Navajo flavor, but until recently the source of the metal was largely Mexican coins, and the techniques of working the silver were probably learned from the Pueblo who in turn acquired the art from the Spaniards. An attractive use of turquoise inlay points up the jewelry of the Navajo. At first pendants found on ruins were used, or else

36

bits traded from the Pueblo; but now, unfortunately, cut stones of white manufacture detract from, rather than enhance, the original work.

The sand paintings, possibly an expression borrowed from the Pueblo, are a beautiful example of aboriginal art. The designs, highly conventionalized and symbolic, are worked out in different colored sands and are destined for use in curative ceremonies. The skill shown by the draughtsman in pouring the grains into the desired patterns is miraculous. It seems hard for us to realize that the paintings are intended for a single ceremony and are obliterated after use. Sand paintings can be copied, but are virtually impossible to preserve. From sheer balance of element and contrast of color, they constitute one of the richest developments of abstract art in North America. A quaint by-product, informal in character, is composed of the random drawings found in various caves, which vary from the stilted portrayal of an Indian-hunting posse of the Spanish Colonial period to lively depictions of a bucking horse in the best modern rodeo style, or a deer in the best spirit of the palaeolithic cave paintings of Europe.

In contrast to the adaptability of the Navajo, we find the primitivism of the Apache. This tribe, one of the last to succumb to white penetration by force of arms, has assimilated little of the new culture. However, they still maintain the craft of basket-making, with an honest fidelity to old technique and practical function.

The comparatively large reservations, the lack of a heavy white immigration, the contact with church and government rather than with masses of immigrants, have given the southwestern Indian, relatively speaking, time to take breath. At present, his artistic abilities are jealously husbanded both by federal and private agencies. Thus of all the North American Indian groups, those in the Southwest have the best opportunity to build on their aboriginal foundation. We have seen how the Pueblo and Navajo have grasped the chance of-

37

fered and actually are working out a native art composed of elements from the two conflicting cultures.

Section 4—*The Arts of Modern Southeastern Tribes.* The rich arts of the past have not survived among the modern southeastern tribes. From the time of the first white penetrations, the Creeks, Cherokees, and Natchez suffered from the relentless pressure of north European colonization, which involved the actual occupation of land. Well into the Nineteenth Century the southeastern tribes, though forced to yield land, were considered to have an individual autonomy and entered into treaties with the United States as political entities. Their cultural borrowings seem to have been militaristic and mechanistic; and ceremonialism, as mirrored in the ritualistic designs of the past, apparently disappeared before the demands which were made on the surplus energy of the populace. Yet, this break-down of the tribal arts cannot entirely be blamed on the whites. The rise in power of the Iroquois in the North appears symptomatic of a general restlessness among the eastern tribes, which brought about a dislocation of settled groups from their homeland. Such migrations and invasions may have had very definite effect on the disintegration of the Hopewell culture.

Out of this collapse of tribal culture came one very significant achievement, Sequoyah's invention of a special alphabet to reproduce the sounds of the Cherokee language. While crude systems of writing had long been known in Middle America, this was the first attempt in the north, and, though borrowed from European sources, must rank as one of the most sophisticated Indian writing systems. Statecraft and warfare are both ephemeral arts that we may presume developed weedily under white contact, but the growth killed itself. Previous to 1840 these tribes were transported bodily to Oklahoma with a consequent breakdown of old tribal patterns. A false economic revival from oil royalties did nothing to stimulate a functional culture, but the future, with its improved attitude toward Indian integrity, may offer some stimulus to latent creative abilities. Indeed,

38

some advance has been made in stimulating such old industries as weaving.

The Southeastern culture, expressed through ceremonial channels, seems to be less hardy than the practical techniques of the Southwestern groups. An absolute evaluation is out of the question, since white pressure was undoubtedly stronger in the Southeast. Furthermore, there is evidence that redistribution of the aboriginal populations before and during the colonization period had begun to sap the foundations of the aboriginal culture.

Section 5—(Plates 59-64.) *The Arts of the Modern Northeastern Tribes.* The northeastern tribes never produced the general plane of high culture that we have noted for the Southeast. We are familiar with the remorseless pressure of the French and English colonists that ground into dust whatever elements remained of Indian culture. However, this obliteration must not entirely be assigned to European causes. It seems certain that the more striking aspects of the Hopewell culture had been destroyed before the advent of the whites; and the rise of the Iroquois league shows how a vigorous tribe, well led, can dominate a very wide area. The Iroquois had the political sense to form a confederation of tribes, and the strength of the league was maintained into the Nineteenth Century through the astuteness of the tribal leaders in playing off the English against the French, and later the American Revolutionists against the English, as bidders for their services as allies in war. This political skill enabled the Iroquois to retain some land as a reward for political services rendered, and continue living in their original homeland. Some of their tribal arts still exist albeit in a pallid form. Outstanding is the manufacture of grotesque masks for use in ceremonies. These masks have a leering quality which is truly dynamic as opposed to the static impressions given by most ceremonial art. Their little buckles of silver, a technique taken over from the Europeans, are less significant, and their originally attractive and ornamental pottery and pipes yielded

39

to European substitutes certainly by the early Nineteenth Century. An attempt to revive wood carving resulted in some little statuettes that retain a strong Indian influence despite the white inspiration.

The Ojibway or Chippewa, west of the Iroquois, developed important designs under white contact. Originally they, like many other northeastern tribes, ornamented their dress with porcupine quills, dyed and arranged in harmonious patterns. This technique also extended to birchbark vessels, which were ornamented as well with curvilinear patterns etched into the bark, an interesting variation from the rectilinear designs so prevalent in primitive design. When the fur trade with the whites began, the Indian received an abundance of glass beads, which had much greater decorative possibilities than the porcupine quills. Also, the French provided new designs involving floral and other motifs with the freedom of European design. These patterns were reproduced in beads, with a retention of various aboriginal elements, so that a pleasant and imaginative decorative art was created. Other designs were worked out by mosaics of silk and cotton ribbons, that created from European materials characteristically Indian patterns. Draughtsmanship extended also to the keeping of pictorial records.

In recent years these native arts have fallen away, since European manufacture can reproduce Indian designs on goods more suitable for white consumption. Furthermore, commercial methods can furnish consumers with these goods at cheaper prices than those which the reservation-bound Indians must charge. It is a competition between the Indian's handwork and the white man's factory products. A little basketry, a few pairs of moccasins, a scant quantity of beadwork, a few canoes, and some gimcrack souvenirs provide a precarious outlet for the old arts and skills of the northeastern tribes.

Section 6—(Plates 65-71.) *The Arts of the Modern Plains Tribes.* The peak of the art of the Plains tribes came about in the Nineteenth Century. During the previous hundred years, the Plains tribes had

40

been acquiring and mastering horses from among the wild herds composed of strays from the Spanish settlements in the Rio Grande drainage, and from booty obtained in raids on Indians and whites. Saddles and equipment were thus based upon Spanish models.

Coincidentally with the acquisition of this new animal which so improved their mobility, the Indians were subjected to enormous pressure from other tribes dislocated by the whites immigrating from the East. Thus groups who were originally sedentary farmers, with techniques and arts derived from northeastern and southeastern sources, found themselves equipped with a means of life which would enable them to push out on the Plains and take full advantage of the enormous herds of buffalo. A number of native arts like pottery-making and stone-chipping were gradually abandoned, as revenue from the fur trade provided a means for acquiring better tools of white manufacture. This nomadic life, coupled with the pressure that forced more and more tribes out onto the Plains, made the horse an article of value and an object of booty. Constant conflict set a premium on prestige, while trade with the whites must have created a keener emphasis on value. Therefore, a successful warrior and hunter had at his disposal means of showing his social eminence and wealth by the number of his horses and the splendor of his trappings. Weapons, moccasins, leggings, shirt, war bonnet, saddlery, became media for the expression of ornament and in consequence, design. Moreover, the power of a man could be reflected in the dress of his wife or wives, so that woman's dress also became a field for design. In full dress, a warrior and his household must have made a glittering display. Patterns in beads and porcupine quills were embroidered on every visible surface; and elk teeth, bears' claws, feathers, and scalps, were used decoratively even though they were badges of honor for prowess in the hunt and tribal foray.

A concomitant of this emphasis on prestige was the need to retail and record exploits. A lively school of drawing developed to retail

41

the incidents of an important life. Many of these records were kept on hides, but with the compression of the Indians onto reservations and their consequent accessibility to white supplies, notebooks and ledgers were employed to record these rugged annals. The fresh observation of animal forms is reminiscent of the cave paintings of the late European palaeolithic age. Both arts give the impression of spontaneous evolution, which we know to be the case in the Plains drawing.

Ceremonial art was less vivid. Pipes carved from catlinite, a soft red stone, are often beautifully executed in the harmony of their proportions, while the subsidiary decorations of feathers and the like enhance rather than obscure the beauty of the form. An occasional picture of a sun shield on a buffalo robe indicates that the old harmony of abstraction in the ancient art had by no means disappeared. Some drawings of ceremonies recorded in a notebook reveal a style of drawing human figures that has the rude vitality and curious divorce from reality of the palaeolithic cave drawings of Africa and Spain.

By the close of the Nineteenth Century, most of the old outlets for the artistic talents of the Plains Indians had died out. The inherent talent must still exist, awaiting some opportunity for expression. There are still old people to teach the young, old people who have tasted to the full the wild glories of this sudden eruption of Plains culture. The Peyote cult, a religion involving the consumption of a vision-inducing plant, is very strong through the Plains tribes and those eastern ones exiled to Oklahoma, and has certain ceremonial requirements involving a retention of Indian designs and costumes. This cult, although introduced in the latter part of the Nineteenth Century, is growing in strength and possibly may provide an outlet for the ancient arts.

Section 7—*Modern Arts of the California Tribes.* (Plates 72-74.) California in the past produced little evidence of high culture, and under the period of white observation the tribes show no conspicuous

attainments, save in one direction, basketry. The Pomo and other northern units had an extraordinary mastery of this craft, in fineness unequalled anywhere in the world. There was a great variety in size and form, and in some of the tiny baskets the weaving approached the delicate threading of a textile. Patterns were relatively simple, involving, of necessity, geometric elements. However, one class stands out paramount, where, instead of weaving the design into the wall of the basket, shell discs and pendants or, more often, the multicolored feathers of birds were applied to it, bringing out a shimmering, variegated decoration.

Section 8—*The Modern Arts of the Northwestern Tribes.* (Plates 75-92.) The richest art in North America flourished among the tribes of the Northwest Coast. Spectacular, subtle, conventionalized, realistic, it runs the full range of the sculptor's art. Like the art of the Plains its fullest expression seems to be relatively recent, but its roots must extend deeply into the past. The most striking feature of Northwest Coast art is the totem pole. This is a towering, involved series of conventionalized figures, which serve to recall a myth or to record the crests belonging to a man and his wife. No traveller reports these prior to 1830, but the earlier observers do tell of carved house posts and painted house fronts, indicative perhaps of a more substantial antiquity.

It would seem more than probable that a fairly developed wood carving had had a chance to flower brilliantly when white contact provided steel tools, which rendered the task in hand much more easy. Wood is a very difficult material to work with stone tools, since their blunt edges do not allow the shaving and delicate undercutting necessary to a skillful development of wood carving. In fact, in many respects, it is easier to produce stone sculpture with stone tools than to create a similar art in wood.

Two social conditions directed the form of the art. One was the idea of rank, wherein society was divided into chiefs, nobles, com-

moners, and slaves. The other was the religious conception of a totemic or guardian spirit which protected members of a clan. Complex ceremonies involving impersonation of the divinities took place whenever an individual was initiated into his proper relationship with the clan and its spirit. This combination of social prestige with a religious attitude toward mythical animals and birds led to a rich art expressed by the masks used in ceremonies and the great totem poles and house posts which retailed the spiritual descent of the head of a family. Interwoven into this fabric were ideas of wealth invested in visible possessions so that the elegance of what one owned attested to one's prestige, a happy situation for the free development of art.

Representation fell into two divisions, the more or less direct copying from nature and the presentation of the elements necessary to the definition of the original form. Human figures, and masks for impersonators of mythological characters show an exceedingly fine grasp of the essence of naturalism. One group of masks, in particular, depict the face contorted as in a cataleptic fit, the state in which the closest rapport with the guardian spirit was established. The contorted mouth, the open but unseeing eye, the general air of suspension of life are portrayed with a fidelity both spiritual and physical.

The symbolic art arose, perhaps, from the desire to portray the guardian animal on a chest or house front, on which exact reproduction in three dimensions was impossible. The sense of design, so strongly developed in Indian tribes, easily overcame inherent difficulties. The animal was reduced to certain diagnostic symbols and these were laid out according to the requirements of design. All the parts of the animal were included without suppressions of elements unseen when observed in plain view. To an uninstructed observer, there is an almost bewildering combination of unrelated elements. To one who has mastered the symbols for the Killer Whale, Raven, or Bear, the design breaks down into a lucid presentation.

44

Painting followed the system laid down in this type of decorative carving, and the designs woven into the very charming Chilkat blankets likewise obeyed these laws. The same designs, the same approach, governed both religious and secular art. If one picks out the masks, house posts, house fronts, canoes, and totem poles as the major field of expression, one can recapture the same approach and content in such minor objects as hats, rattles, spoons, chests, and containers. Moreover, the carving of substances other than wood, like ivory, bone, copper, and slate, as well as painting and weaving, all show the same tradition extended to the embellishment of the total material content of human possessions. Minor stylistic variations exist from tribe to tribe, and excellence of manufacture is far more common at the center of distribution than at the extremes. Yet the art gives every evidence of having been a typical New World evolution, created under neolithic conditions, guided by ritualistic requirements, but an art, nonetheless, achieved and defined, far from the inchoate strivings of the primitive. The introduction of steel tools, instead of breaking down and perverting the Northwest Coast art, liberated it in the direction of more universal application rather than defiance to tradition. To this increase of output the museum and private collectors possibly contributed, by setting standards of excellence in their buying and by taking out of use a quantity of implements, but this market is now fairly well glutted. Consequently, this art languishes today, with the dwindling of the economic utility of the Northwest Coast Indian groups and their consequent subsidence to reservation life. Yet this decline is so recent, that knowledge and practice of the old techniques exist in living men.

Section 9—*The Arts of the Modern Eskimo.* (Plates 93-96.) A lively naturalistic art both in sculpture and drawing existed in recent years among the Eskimo. This art, originally a subsidiary activity in leisure hours, may have been given a fillip by white collectors, who provided economic sanction for an original pleasure activity.

45

Contact with white whalers and hunters provided steel tools, and their interest possibly stimulated experiments in the direction of art. Like the pictorial art of the Plains, this sudden outburst takes a highly naturalistic and realistic form. Activity and fidelity may be the best terms to describe it, for animals and scenes of daily life like hunting or driving dog teams, are reproduced with a lively regard for essentials. Presentation seems to be the major interest, rather than obedience to custom, tradition, and other similar aesthetic controls.

This art flourishes most strongly among the northern and eastern Eskimo. In the Aleutian islands there is a strong tinge of Northwest Coast art. Still persisting, albeit pallidly, is an ancient tradition governing the carving of crude grotesque masks, which have a very definite character, as is usual among most long-practiced arts.

The collapse of whaling and the decline of trading for furs with the Eskimos and Indians have undoubtedly reduced the outlet for this kind of art. As yet, the tourist trade is insufficiently educated to be a satisfactory substitute and at best the market is extremely limited geographically. Yet here as elsewhere in so many Indian communities there is a reservoir waiting to be tapped.

Section 10—*Conclusions.* The arts of the American Indian flourished under white contact and stimulation so long as the essential social direction of the art remained the same as under aboriginal conditions. In the case of the early fur trade, when the Indian communities were a contributive factor to white economy, the arts prospered and made a rapid advance, due to the increased prosperity of the favored communities. However, when the whites began to hold territory and to enclose the Indians on reservations, the tribal communities were lost, since they could not adapt themselves to the competitive economy of the whites. Their roles were cast in a different type of drama. Without a means for expression, their very considerable artistic experience is being lost.

46

During the latter decades of the Nineteenth Century, it seemed as though the remorseless action of lowered birth-rate and disease would obliterate the Indians as well as their art. Now, however, they are rapidly increasing, having immunized themselves to our diseases and being insulated by the reservations from many of the hazards of competitive life. The reservations are becoming crowded, and some people believe that there are as many, if not more, Indians alive now in North America as there were at the time of the Discovery. We are faced with the need to support an increasing number of patently non-productive members of society even as the support of potentially productive elements has become a major governmental problem.

Our agriculture to the extent of some half of our food plants has benefited from Indian economy, and our camping equipment, some of our sports, and some of our military tactics have also absorbed Indian elements. Perhaps, too, we may derive something from their arts. Encouragement of Indian decoration and art might make just such an integrating force as would enable Indian communities to change from their present condition of being complete almoners. The Indian arts, too, should be a background to the creation of a national art. At present, save for the survivals of Indian culture in the Southwest and for some heroic attempts made by governmental agencies to revive Indian arts elsewhere, our native American heritage is being allowed to disintegrate.

Appraisal of North American Indian Art

SECTION 1—*Architecture*. The architecture of the North American Indian was rudimentary, being confined primarily to shelters. The skin tipi, bark wigwam, and the brush-thatched wickiup, are primitive in the extreme and the more pretentious plank-house of the Northwest Coast and the large communal houses of the Iroquois are merely more developed types of shelter, unsuitable for modern needs. A superficial beauty of line in some instances by no means commends them as significant in artistic achievement or inspiration. The stone and adobe Pueblo houses are more suited to our present life, but the New Mexican adaptations of old forms to modern dwellings derive rather from equivalent constructions in Mexico and Spain. In spirit and in outline we have, nonetheless, a relationship with the Indian past that is being utilized in the Santa Fé architecture.

The great eastern mounds, surmounted by their sanctuaries, are more impressive in their social implications. However, they have little to offer the needs of modern architecture, the requirements of which are so totally different. Their bulk and mass never reach the imposing sequence of planes found in the ceremonial structures of Middle America. The North American Indians often achieved efficient housing systems, but never developed, except in the archaeological and ethnological sense, an architecture.

Section 2—*Design*. The decorative branch of art, often considered by European observers to rank below architecture, sculpture, and painting, stands pre-eminent among the aesthetic products of the

48

New World peoples. That pure design should provide such an interest for New World artists must be a result of that long apprenticeship in weaving, so much a part of the history of North American tribes. Balance, harmony, proportion, exert strong controls over the graphic arts, and are primary characteristics of sculpture, as may be seen in the case of the highly abstract motives of the Northwest Coast.

The evolution of North American design apparently begins in the geometric designs on basketry, and, on being extended to other media like pottery or skin containers, retains its abstract character. Sometimes, however, as in the case of Mimbres pottery, naturalistic elements are used with a most ingratiating effect and the Caddo vessels show animal effigy bowls completely covered with curvilinear designs that by no means appear incongruous. The curvilinear patterns of the northeastern tribes, both in their primitive and Europeanized states, show a curious freedom from the rectilinear restrictions of woven designs. The original application of this type of decoration to birch bark containers may account for the development of such ornament, since there would be no technical limitation like the rectangles implicit in weaving a basketry or textile design.

Section 3—*Sculpture.* In the field of sculpture, American Indian art is most significant. The handling of stone, wood, and clay is marked by a keen appreciation of the possibilities of the medium used, as well as by the mastery of basic balance and proportion which must underlie the reproduction of natural forms by this means. The extraordinary feature of North American aboriginal sculpture is that it presents such achieved styles when the technical basis of the makers was at a neolithic level. There is no precise equivalent for this advanced art on the corresponding technical planes in the Old World.

The recent wood sculpture of the Northwest Coast, the pre-Columbian arts of the Hopewell mound-builders and of the tribes of the Southeast show an extreme versatility. Fidelity to nature may

49

be balanced by conceptions of ritualistic abstraction in the same culture. A tiny piece a few inches high may reveal the same ordered massiveness as a monumental sculpture many times its size. Permeating the whole of each tribal art is the working of the group mind; and individual skill seems more evident in the execution than in the conception. Mass emotions evoke a colder art than do the visual projections of the individual mind with its inherent plea for personal consideration. These Indian sculptures reveal mass craftsmanship creating tangible conceptions of the supernatural relationships between the tribe and the physical environment in which they must live.

Such emotional responses in the modern observer are often provoked by the anonymous arts of the past. Yet there may be personal expression buried in this matrix. An outward view of a factory causes our own humanists to decry "the mass production of a machine age," but social reformers often denounce the intense selfishness and egoism that gives direction to such heartless mechanisms. However off the course our estimates of the direction of these arts may be, we do see the creative drives channeled along the lines of religious need and the religion designed to help the group rather than to satisfy the spiritual yearnings of the individual. The net effect of the Indian sculpture is that of an abrasive which reduces the jagged contours of individuality, so very evident in the directionless efforts of much of our modern sculpture, with its strong insistence on personality, on individual signature, and on personal philosophy.

Section 4—*Painting and Draughtsmanship.* We have no good corpus of North American Indian painting in the past, but the etched shells and copper reveal a draughtsmanship carefully subjected to the requirements of design. The higher cultures of the past had the serious problem of sustaining life en masse with a resultant preliminary insistence on ceremony and ritual. Such a background would

50

not necessarily call for pictorial instruction, but rather for the recording of ceremonial elements.

The spectacular liberation of the Plains Indian with the resultant opportunities for dramatic prowess demanded a pictorial record, and a lively, even if crude, style of drawing developed, with a curious blending of naturalistic observation with conventional standards of reproduction. In the Southwest we have seen how the modern Pueblo could shake off the conventions of ritual drawing to evolve under white stimulus a fresh and free art, tethered lightly to the design training of the past. It is not too much to suppose that in this blend of the white world with the Indian is a conceivable point of departure for a national art. We have, in our own experience, seen the development of a Mexican national style, formed by a similar union of Indian design and balance with white skills in presentation.

Section 5—*Pottery.* The extraordinary variety of ceramic forms and decoration in the New World is bewildering. The potter's art holds a fascination for the Indian which he indulges to the full, even in his highest cultural development. As described previously, the principle of form is based on building up elements of clay, not through drawing out the vessel on the potter's wheel. Thus European ideals of perfect proportion which derive largely from ancient Greece are at sharp variance with the solid bulk of an Indian specimen.

Yet the design of a Pueblo pot or the quaint aliveness of a southeastern effigy vessel has a warmth, a personal quality, not found in the modern European ceramic. The function of an Indian vessel was so much more important than such a utensil is in modern European life that any fusion between the arts of the two continents would be remote and hypothetical. However, to a student of the development of art, this interest and emphasis on pottery are important.

Section 6—*Weaving.* The weaving of the American Indian was a highly developed art. In Peru it developed to heights barely achieved in the Old World, since every technique known for the entire Old

51

World was practised in this relatively restricted area. While in North America there was no comparable skill, nonetheless there is a long tradition of Indian weaving, and in the case of the Southwestern tribes the product both in substance and design has met with a definite favor in white eyes. The Northwest Coast blanket and the twined bags of the eastern tribes both show that the Indian has a very definite affinity for this craft. The great imagination and skill embodied in the numberless patterns woven into textiles and baskets, or embroidered upon textiles and skins, indicate the Indian interest in abstract design. In fact, design tends to predominate over form throughout the aboriginal arts of the Americas and might be called the dominant Indian artistic expression.

Section 7—*Jewelry*. The jeweler's art is scantily represented in North America, but what there is, is often good. Stone pendants are carved for texture and for shape, and turquoise and jet along with shell have been frequently used in attractive mosaic patterns. Shell, from the earliest days in North American history, has been a favorite object of adornment, both because of its color and its ease of manufacture into beads. We have seen how the carving of shell gorgets in the Southeast can reach the proportions of a major art.

The use of metals for jewelry is rare before the white colonists arrived. Copper is used for headdresses, rings, and the like, and there are some crude instances where gold and silver were hammered in a crude plating over ear plugs of copper. Some gold pendants are known from Florida and Georgia, but these are beautiful because of the metal rather than the form. In modern times the excellent silver and turquoise jewelry of the Navajo makes a pleasing and significant addition to the corpus of world ornament.

PLATES

THE FOLLOWING PLATES are designed to give an impression of the range of ancient and modern Indian art. One plate, the first, must of necessity be given to a map. The remaining ninety-five were allotted to cover the past and present of the varied output of the North American Indian tribes. The method of selection is, perhaps, of interest. Miss Gerry and the writer examined the outstanding examples of Indian art in the New York City collections and in the literature. Then, with Mr. Cramer's photographic sense to guide us, the museums were combed for outstanding specimens, judged from the three points of view of the tribal style, the potential interest to a modern audience, and the susceptibility of the specimens to photographic reproduction. Some 870 examples were then photographed in miniature film and of these some 370 were enlarged to a size suitable for reproduction and exhibition. These negatives and enlargements are in the custody of the Photographic Department of the American Museum of Natural History. From this final group the last selection was made, and a few photographs from other sources were added to illustrate examples which had been overlooked.

This book is a pioneer in its field. The writer takes all blame for his sins of omission and commission. He has the deepest sympathy for the irritation of those whose favorite style has been slighted, since he too has suffered the same misery in suppressing fine pieces from one area for the sake of giving fairer representation to the art of another region. The writer also hopes that this modest selection will stimulate others to avail themselves of the rich aesthetic heritage which the American Indian has bequeathed us.

PLATE 1

The map shows the house types and food animals of the principal culture areas of North America at the time of white contact. The time chart below is frankly relative, since, save for the Southwest, no absolute time scales have been established.

	B.C. 10000	B.C. 5000	B.C. 500	A.D. 0	A.D. 500	A.D. 750	A.D. 1000	A.D. 1250	A.D. 1500	A.D. 1600	A.D. 1700	A.D. 1800	A.D. 1900
ESKIMO					Asiatic contact Old Bering Sea		Norse contact Greenland		White contact Whalers, traders, explorers				
NORTH-WEST					Hunters and fishers Low type High type					White contact High Culture	Con-quest		
CALIFORNIA	29 Palms Culture				Hunters and fishers Low type				White contact			Conquest	
PLAINS	Folsom Culture				Hunters				Farmers	White contact High culture	Conquest		
NORTHEAST				Hunters		Nomadic farmers	Hope-well	Middle Mississippi		Iroquois	White contact Conquest		
SOUTHEAST				Hunters		Nomadic farmers	Southern Mississippi culture			Creek	White contact Conquest		
SOUTHWEST ANASAZI	Folsom Bishops Cap		Basket Maker I–II	Basket Maker III Pueblo I–II		Pueblo III Great Period			Pueblo IV	White contact Pueblo V		Conquest	
HOHOKAM	Cochise			Hohokam				Salado cul-ture		White contact Papago-Pima		Conquest	
VALLEY OF MEXICO	Formative steps?		Lower Middle Culture	Upper Middle Culture	Toltec		Chi-chimec	Aztec	White Conquest				
MAYA	Formative steps?		Middle Culture	"Old Empire"		"New Empire"		Mexi-can Period	Maya Re-turn	White Conquest			

Tentative Time Chart showing relative sequence of cultures in North America and Middle America. The Middle or Archaic cultures of Middle America represent, in technical development, a stage equivalent to the chronologically much later Pueblo III and IV. All dates are provisional.

ANCIENT ART OF THE AMERICAN INDIAN (PLATES 2-38)

The prehistoric art of North America consists of those elements of human culture which have been able to resist the destructive forces of man and nature. Refuse heaps produce broken and discarded examples of human handiwork; caches of different kinds of implements are sometimes found; but the greatest number of complete specimens come from graves. The custom of burying equipment for the use of the dead was widespread among the American Indians.

Thus our record of the achievements of the prehistoric Indians must depend on objects of stone and baked clay, with a scattering of pieces made from bone and shell. Textiles and wooden implements have almost all disintegrated. Consequently in selecting examples of Indian art in the past, one must rely on plastic forms, since the weaving, beadwork, and painting which carry the main trend of the aesthetic expression of the modern tribes are lacking.

Plate 1

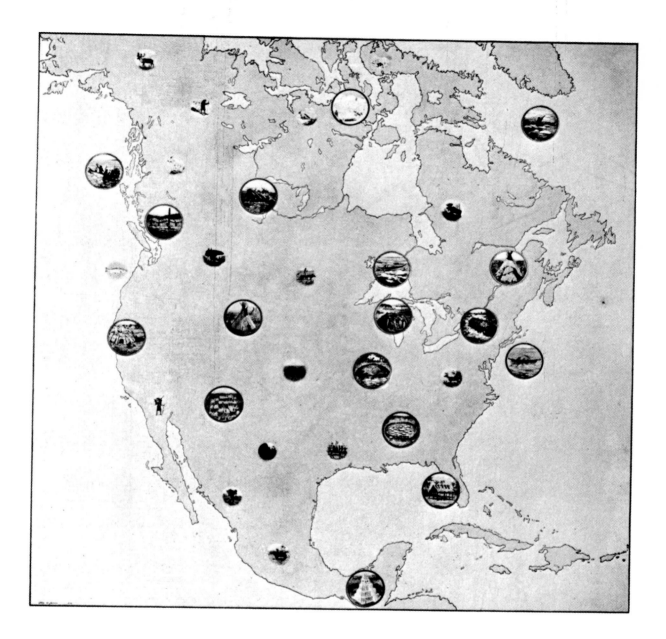

Ancient Art of the Eskimo (Plates 2-3) Excavations in ancient Eskimo sites produce objects indicative of the development of the adjustment of these people to a hunting and fishing life in the Arctic. Decoration and the creation of art forms are more common to the earliest, Old Bering Sea, period, whereas skillful workmanship prevails in the later stages. The beautiful patina of the ancient ivories shown here gives a lovely effect, that enhances a limited range of design.

ANCIENT ESKIMO ART

PLATE 2

CARVINGS IN IVORY

Top Row, WINGED OBJECT, USE UNKNOWN

Culture, Old Bering Sea	*Size,* 8 inches
Region, Northwest Alaska	*Location,* U. S. National Museum
Period, (?) Century	*Museum No.* 42,927

Bottom Row, FEMALE FIGURE

Culture, Punuk	*Size,* 4⅜ inches
Region, Punuk Island, near St. Lawrence Island	*Location,* U. S. National Museum
Period, (?) Century	*Museum No.* 344,107

HANDLE

Culture, Old Bering Sea	*Size,* 6¼ inches
Region, St. Lawrence Island	*Location,* U. S. National Museum
Period, (?) Century	*Museum No.* 353,765

HARPOON HEAD (note split to insert a stone blade)

Culture, Old Bering Sea	*Size,* 4¾ inches
Region, Little Diomede Island	*Location,* U. S. National Museum
Period, (?) Century	*Museum No.* 347,940

Plate 2

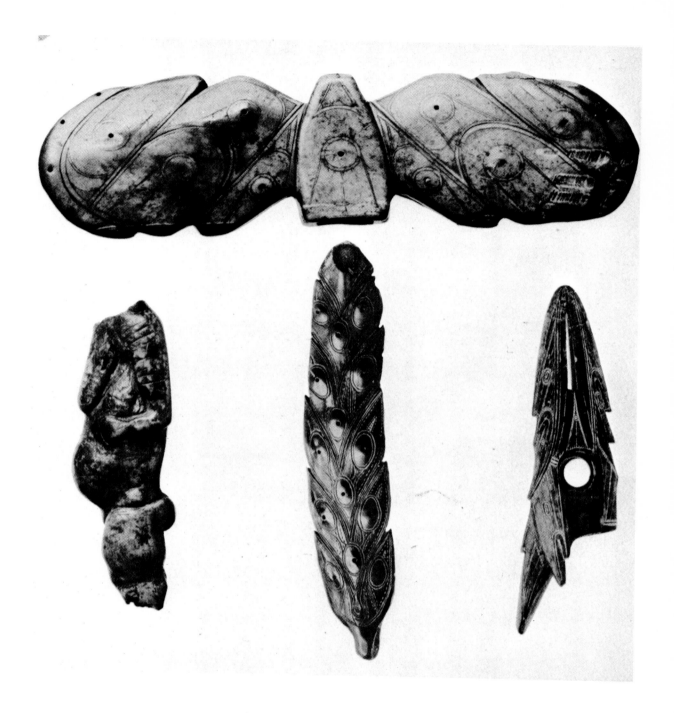

ANCIENT ESKIMO ART

PLATE 3

TOOL OF IVORY

Tribe, Eskimo *Size,* 6½ x 1¾ inches
Region, Alaska *Location,* Field Museum, Chicago
Period, Protohistoric *Museum No.* 13,617

Plate 3

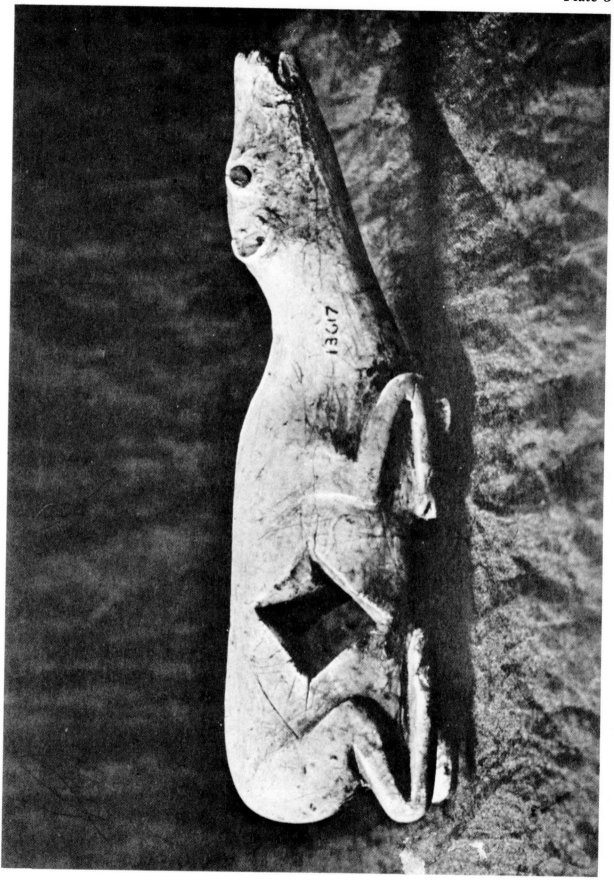

Ancient Art of the Northwest Coast and Columbia Basin (Plates 4-5) The archaeology of this area produces only imperishable objects, which are often found in the accumulations of shells, discarded after consumption of their contents, by the ancient peoples. We do not know the nature of the wood carving of this period which was to reach so high a development among the modern peoples (Plates 75-92). These early peoples, however, did possess a stylized stone sculpture, whose relationship to the aboriginal cultures of the east and south constitutes a tantalizing enigma.

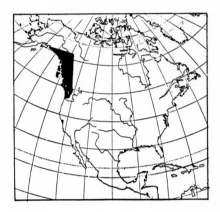

ANCIENT ART OF THE NORTHWEST COAST AND COLUMBIA BASIN

PLATE 4

FIGURE OF MARBLE WITH ABALONE SHELL INLAY EYES

Culture, Unknown
Region, Columbia Basin
Period, Prehistoric

Size, 5 inches high
Location, American Museum of Natural History
Museum No. 16/IA 629

Plate 4

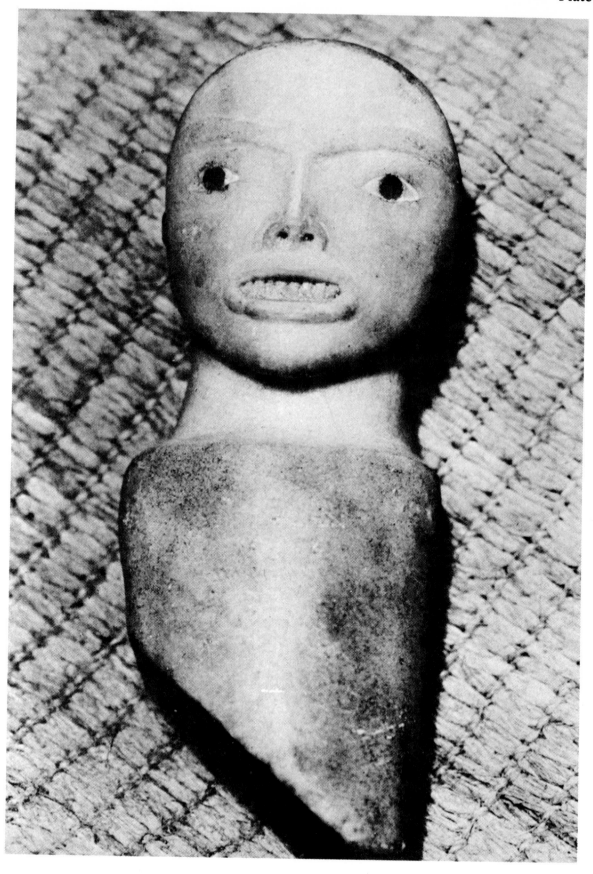

PLATE 5

SEATED FIGURE OF STONE

Culture, Unknown
Region, Washington State
Period, Prehistoric —
 6 ft. below surface of shell mound

Size, 7 x 7½ inches
Location, Museum of the American Indian, Heye Foundation
Museum No. 1/9485

Plate 5

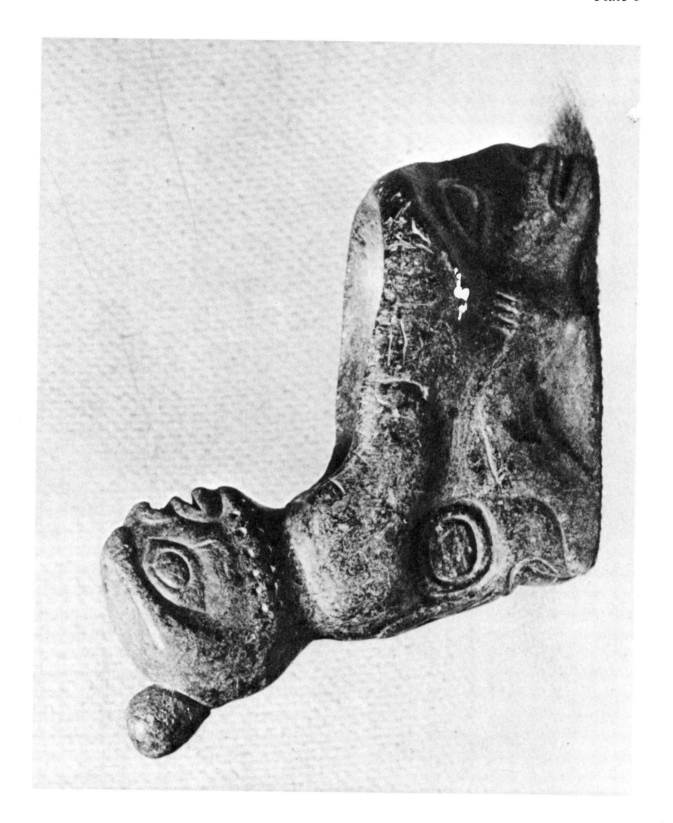

Ancient Art of California (Plates 6-7) The prehistoric peoples of California lived by hunting, fishing, and gathering nuts and various shell foods. They had no agriculture and, only in the south of the present State, made a poor pottery. Despite this meagre development of the technique of living, some fine stone objects have survived, notably the stone vessels that were used as cooking pots.

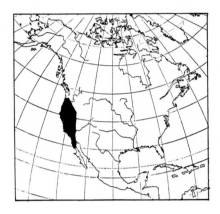

ANCIENT ART OF CALIFORNIA

PLATE 6

CARVING OF KILLER WHALE IN STEATITE

Culture, Unknown
Region, San Nicholas Island
Period, Prehistoric

Size, 3¾ x 12½ inches
Location, Museum of the American Indian, Heye Foundation
Museum No. 19/38

Plate 6

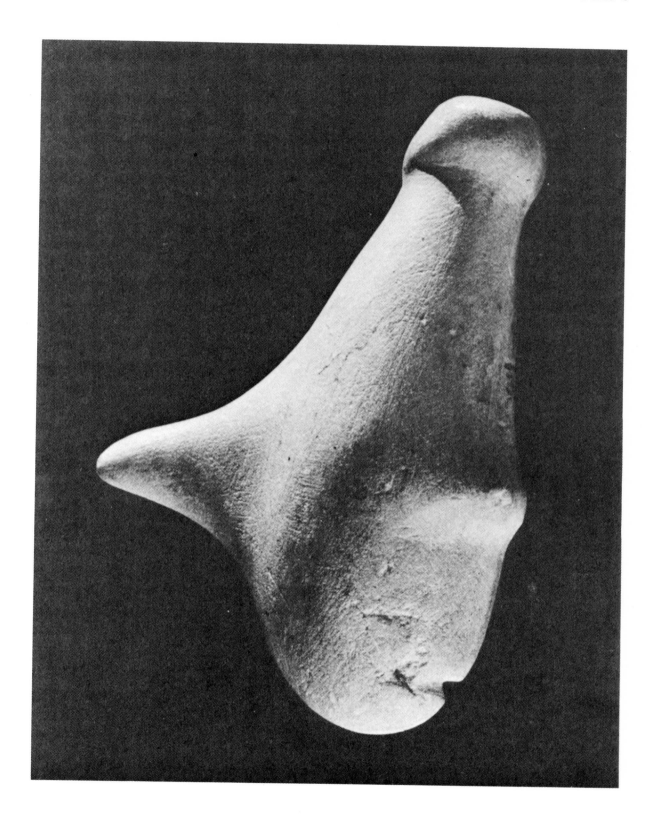

PLATE 7

STEATITE BOWL

Culture, Unknown
Region, Refugio, Santa Barbara, Calif.
Period, Prehistoric

Size, approx. 10 x 11 inches
Location, Museum of the American Indian, Heye Foundation
Museum No. 6/2861

Plate 7

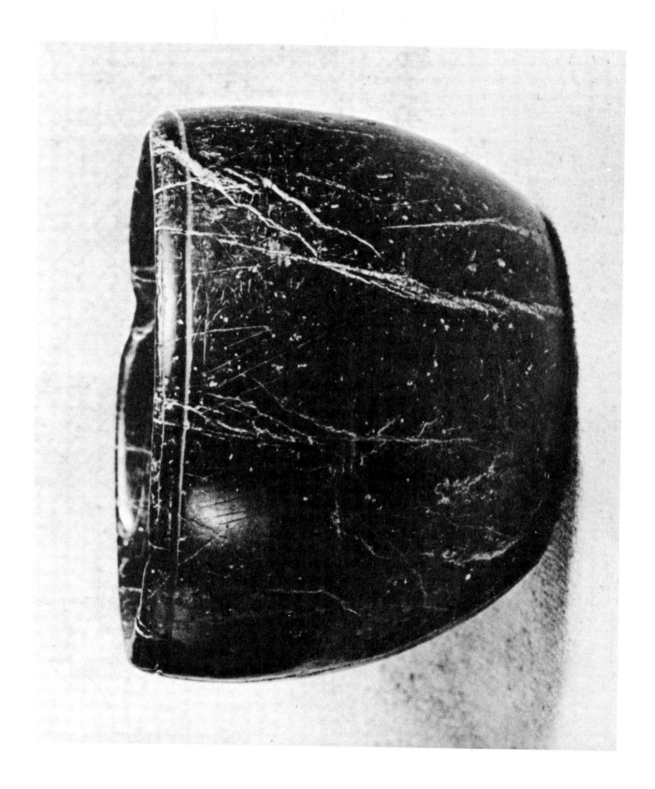

Ancient Art of the Northeastern United States (Plates 8-16) The ancestors of the Indian tribes discovered by the Colonists had an important religious cult of building burial mounds, which reached its fullest expression in southern Ohio. Important personages were honored in this way, and very beautiful objects of ceremonial use were buried with the dead. The pipe bowls made in the form of animals were intended probably for use at great occasions. Reeds could have served as effective mouth pieces. Objects like these pipes are far superior to the general material culture which, from the implements which have survived, combined a good flint chipping technique with a poor pottery. The sudden flourishing of this realistic art is a fascinating aspect of the development of Indian culture. Notable in this area is the utilization of copper nodules from Lake Superior, which were beaten out into tools and ornaments.

ANCIENT ART OF THE NORTHEASTERN UNITED STATES

EFFIGY PIPE, REPRESENTING OTTER WITH FISH IN MOUTH, FLINT-CLAY

Culture, Hopewell
Region, Tremper Mound, Scioto County, O.
Period, Twelfth to Fifteenth (?) Century

Size, 4⅛ x 2⅛ inches
Location, Ohio State Museum, Columbus
Museum No. 125/24

Plate 8

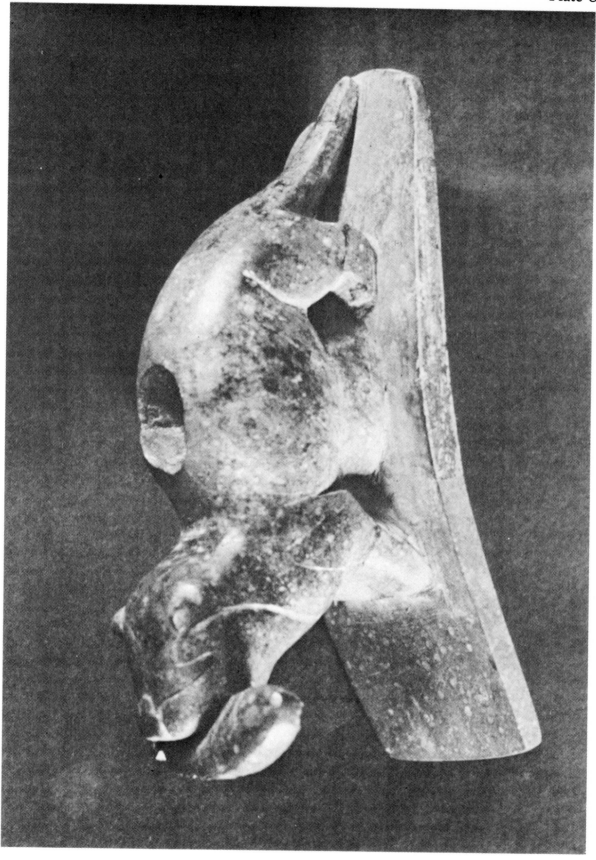

PLATE 9

EFFIGY PIPE, REPRESENTING SEATED MOUNTAIN LION, FLINT-CLAY

Culture, Hopewell
Region, Tremper Mound, Scioto County, O.
Period, Twelfth to Fifteenth (?) Century

Size, 4¼ x 2¼ inches
Location, Ohio State Museum, Columbus
Museum No. 125/32

Plate 9

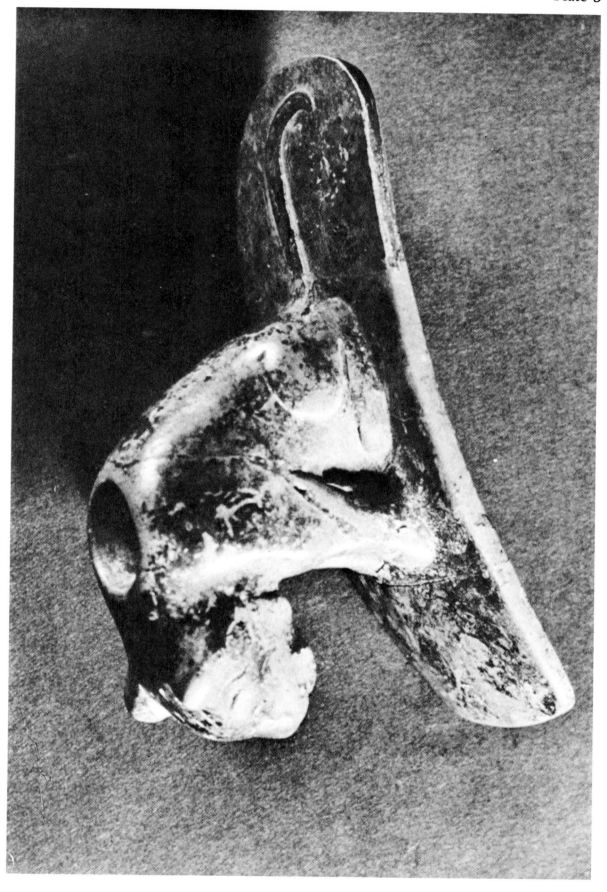

PLATE 10

EFFIGY PIPE, REPRESENTING HAWK, FLINT-CLAY, EYES INLAID WITH COPPER

Culture, Hopewell
Region, Tremper Mound, Scioto County, O.
Period, Twelfth to Fifteenth (?) Century

Size, 3¼ x 2⅝ inches
Location, Ohio State Museum, Columbus
Museum No. 125/17

Plate 10

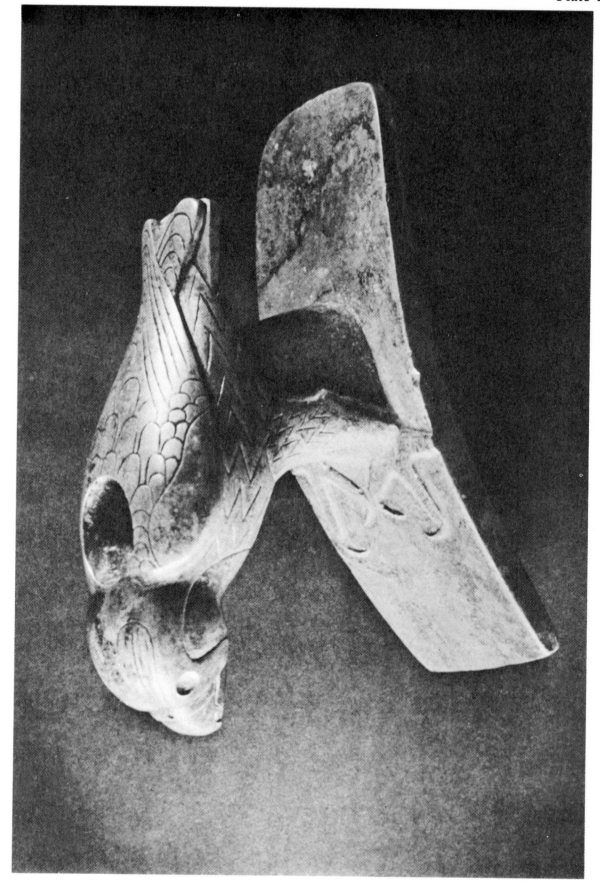

ANCIENT ART OF THE NORTHEASTERN UNITED STATES

PLATE 11

EFFIGY PIPE, REPRESENTING MAN, FLINT-CLAY

Culture, Adena
Region, Adena Mound, Ross County, O.
Period, Twelfth to Fifteenth (?) Century

Size, 7⅞ inches
Location, Ohio State Museum, Columbus
Museum No. not taken

Plate 11

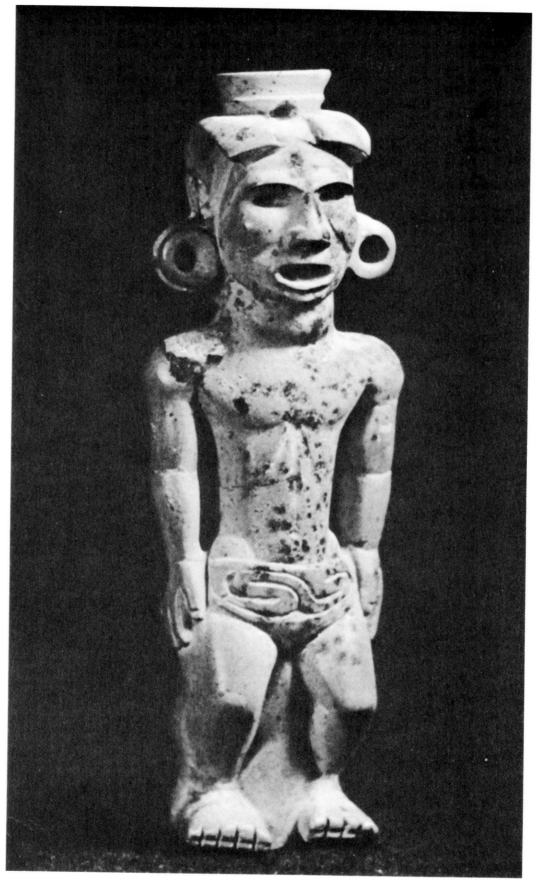

PLATE 12

STONE PIPE WITH ANIMAL ON BOWL

Culture, Algonkin (?)
Region, Warren, Rhode Island
Period, Sixteenth (?) Century

Size, 9¾ x 4 inches
Location, Museum of the American Indian, Heye Foundation
Museum No. 9/5210

Plate 12

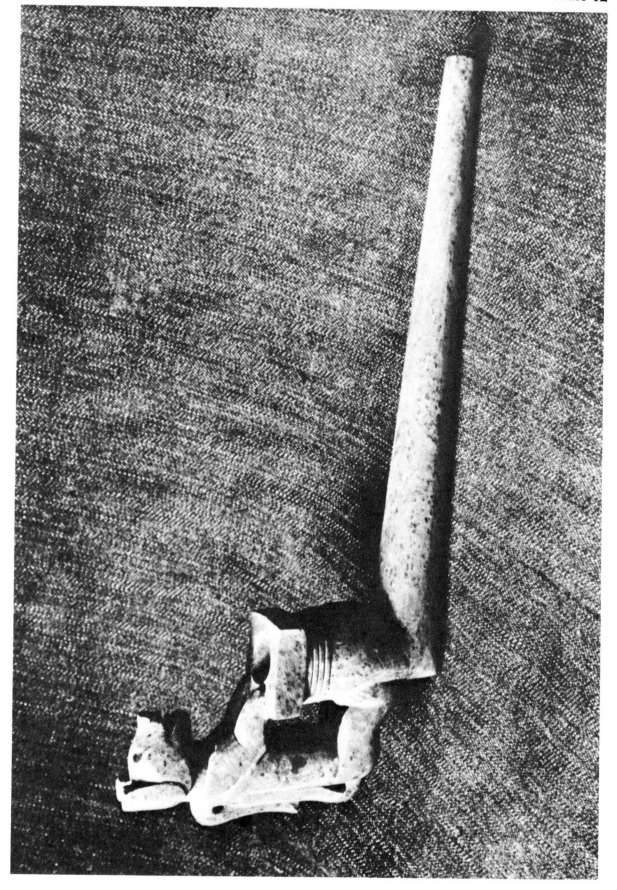

ANCIENT ART OF THE NORTHEASTERN UNITED STATES

PLATE 13

SEATED FIGURE OF STONE

Culture, Middle Mississippi
Region, Union County, Illinois
Period, Fourteenth to Sixteenth (?) Century

Size, 12½ x 10 inches
Location, Field Museum, Chicago
Museum No. 55,500

Plate 13

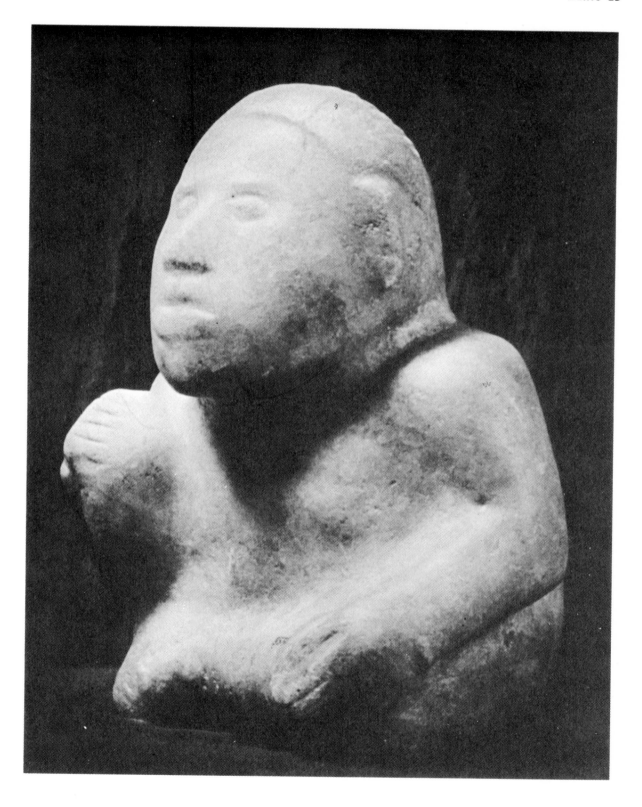

PLATE 14

FIGURE OF WOMAN, BAKED CLAY

Culture, Hopewell

Region, Turner Mounds, Hamilton County, O.

Period, Twelfth to Fifteenth (?) Century

Size, approx. 6¾ inches

Location, Peabody Museum, Harvard University

Museum No. 29,682

Plate 14

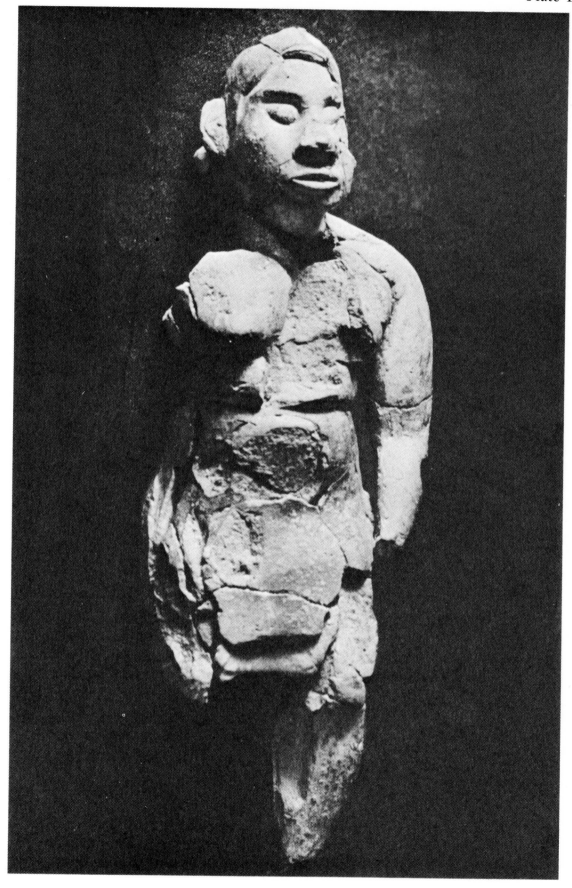

PLATE 15

HUMAN HEAD, ANTLER

Culture, Hopewell
Region, Hopewell Mounds, Ross County, O.
Period, Twelfth to Fifteenth (?) Century

Size, $3\frac{1}{2}$ x $2\frac{1}{2}$ inches
Location, Field Museum, Chicago
Museum No. 56,735

Plate 15

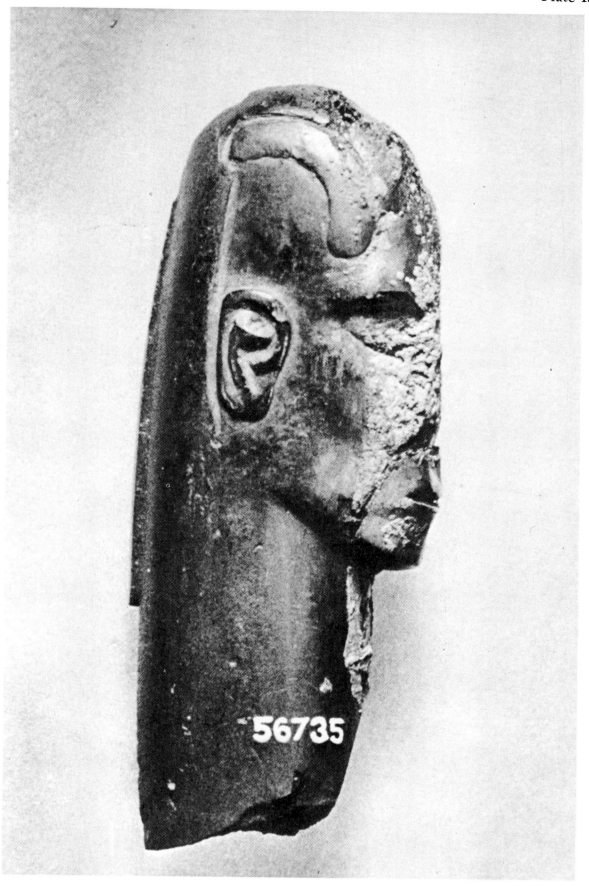

PLATE 16

SILHOUETTE OF FLYING BIRD, COPPER REPOUSSÉ

Culture, Hopewell
Region, Mound City Group, Ross County, O.
Period, Twelfth to Fifteenth (?) Century

Size, 12 x 8 inches
Location, Ohio State Museum, Columbus
Museum No. 260/125

Plate 16

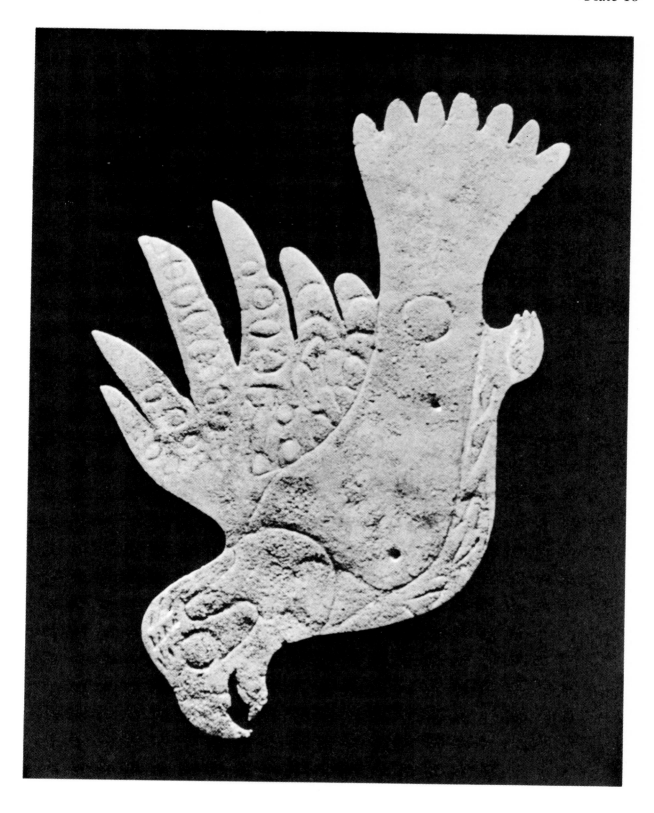

Ancient Art of the Southeastern United States (Plates 17-29) The peoples of the Southeastern United States were making the first steps toward a firmly integrated ceremonial culture of the Middle American type when the French and Spaniards first described them. These Indians reared mounds to serve as foundations for temples and for the palaces of their chiefs. As a corollary of growing ceremonial interest, symbolic forms were made, and, in contrast to the free naturalism of Ohio, some of these sculptures and designs seem stiff and labored. Yet in comparing the range of expression of the Northeast (Plates 8-16) with those of the Southeast (Plates 17-29) it will be very evident that there was a beginning of an artistic sophistication, that suggests the background of Middle American art. Contact between the two areas would seem at the present writing to be in terms of the passage of ideas and attitudes, rather than through trade and actual copying of Mayan and Mexican designs.

ANCIENT ART OF THE SOUTHEASTERN UNITED STATES

PLATE 17

ENGRAVED DISC OF SANDSTONE

Culture, Lower Mississippi
Region, Issaquena County, Miss.
Period, Fourteenth to Fifteenth (?) Century

Size, 8½ inches diameter by ¾ inch thick
Location, Ohio State Museum, Columbus
Museum No. 14/23

Plate 17

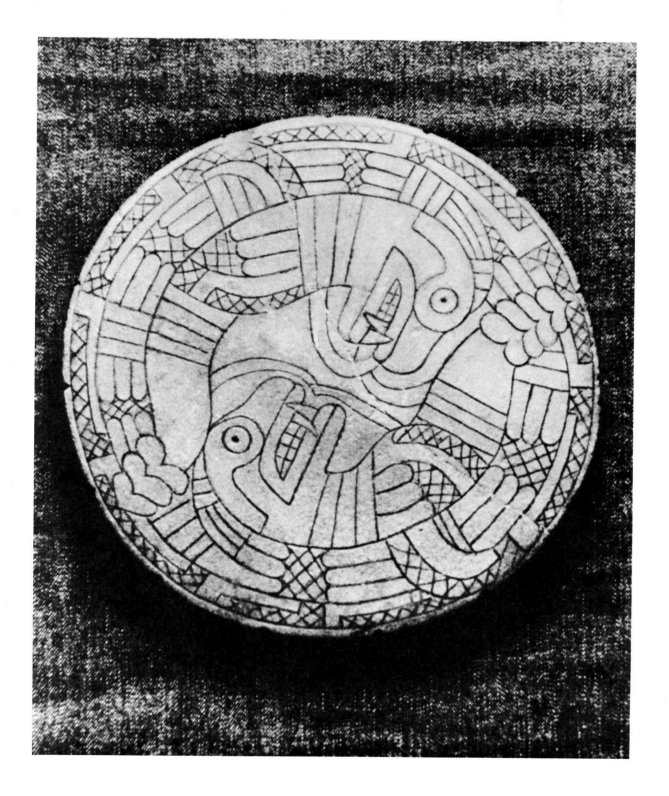

PLATE 18

ENGRAVED GORGET OF SHELL

Culture, Lower Mississippi

Region, Temple Mound, Le Flore County, Okla.

Period, Fourteenth to Fifteenth (?) Century

Size, 5 inches diameter

Location, Museum of the American Indian, Heye Foundation

Museun No. 18/9085

Plate 18

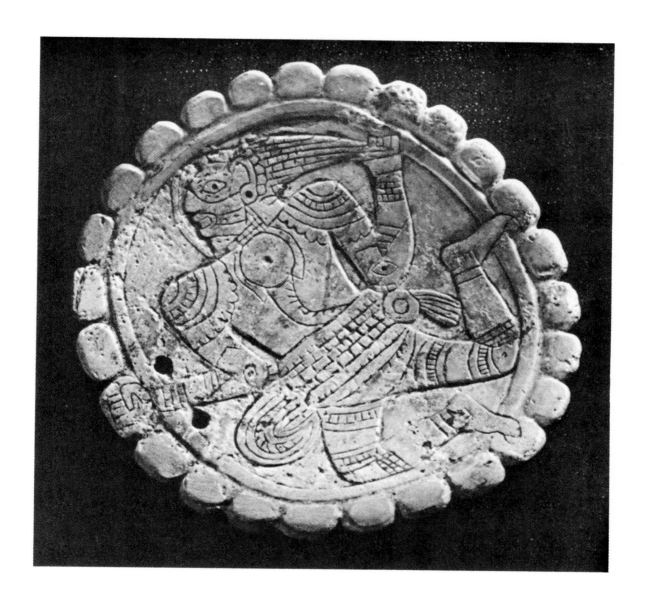

PLATE 19

SHELL GORGET WITH DECORATION INCISED AND IN RELIEF

Culture, Lower Mississippi *Size,* 4¾ inches diameter
Region, Temple Mound, Le Flore County, Okla. *Location,* Museum of the American Indian, Heye Foundation
Period, Fourteenth to Fifteenth (?) Century *Museum No.* 18/9084

Plate 19

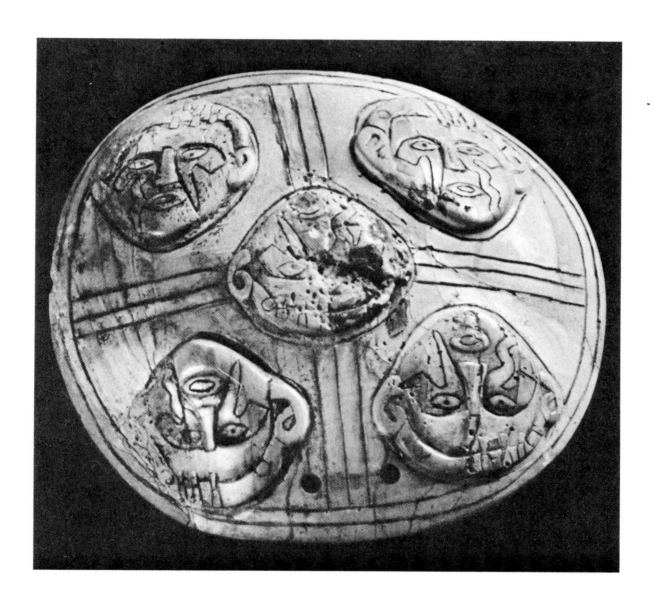

PLATE 20

DIORITE BOWL REPRESENTING CRESTED MALE WOOD DUCK

Culture, Lower Mississippi

Region, Moundville, Hale County, Alabama

Period, Fourteenth to Fifteenth (?) Century

Size, Height of bowl proper 8 inches

Location, Museum of the American Indian, Heye Foundation

Museum No. 16/5232

Plate 20

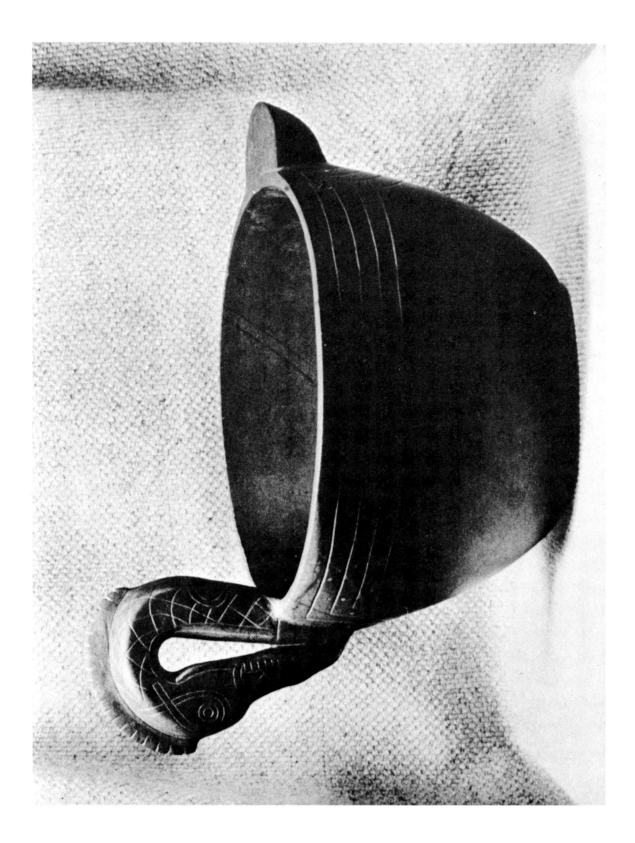

PLATE 21

PORPHYRITIC SANDSTONE PIPE IN FORM OF CROUCHING HUMAN FIGURE

Culture, Lower Mississippi
Region, Moundville, Hale County, Alabama
Period, Fourteenth to Fifteenth (?) Century

Size, 4 x 8½ inchess
Location, Museum of the American Indian, Heye Foundation
Museum No. 17/2810

Plate 21

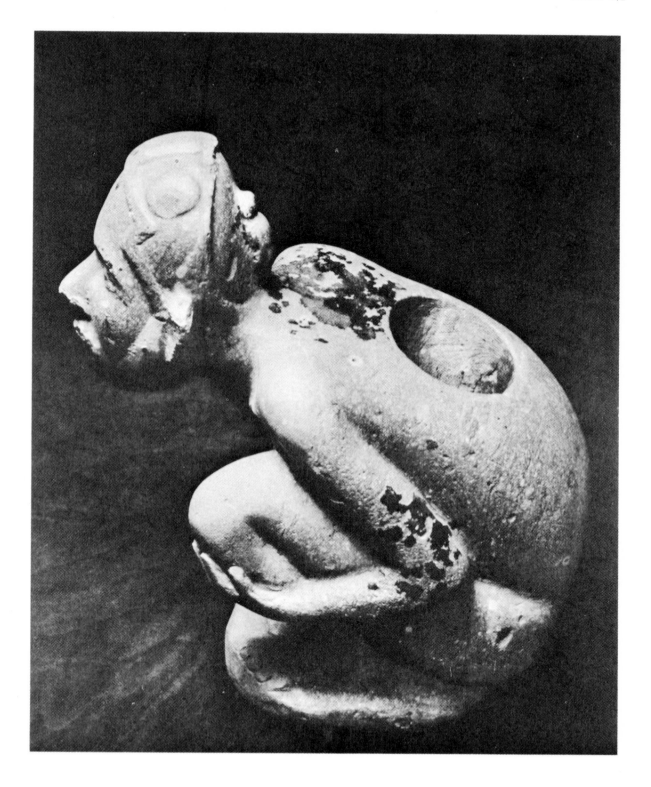

PLATE 22

HUMAN HEAD IN LIMESTONE

Culture, Lower Mississippi

Region, Monette, Craighead County, Alabama

Period, Fourteenth to Fifteenth (?) Century

Size, 2 x 2 inches

Location, Museum of the American Indian, Heye Foundation

Museum No. 17/5426

Plate 22

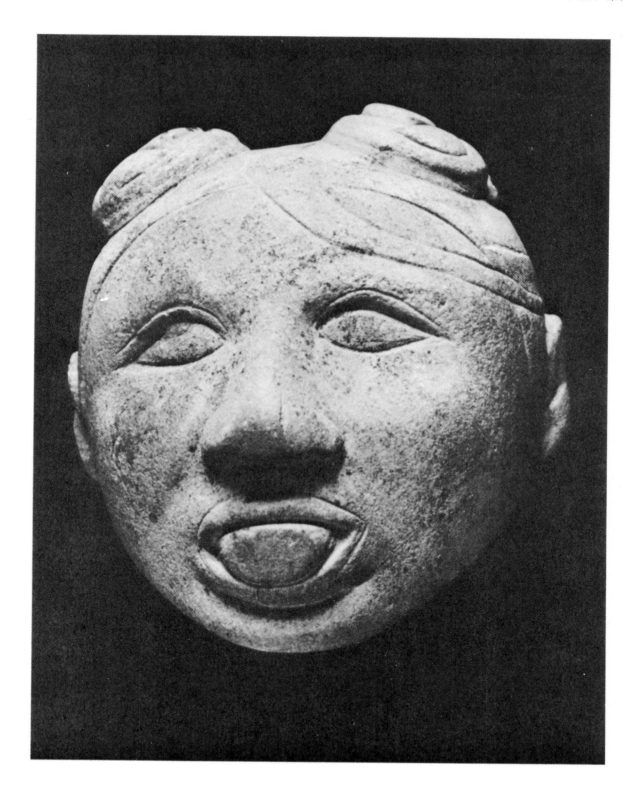

STEATITE PIPE IN FORM OF BIRD

Culture, Lower Mississippi

Region, East Laporte, Jackson County, N. C.

Period, Fourteenth to Fifteenth (?) Century

Size, 9 x 4½ inches

Location, Museum of the American Indian, Heye Foundation

Museum No. 15/1085

Plate 23

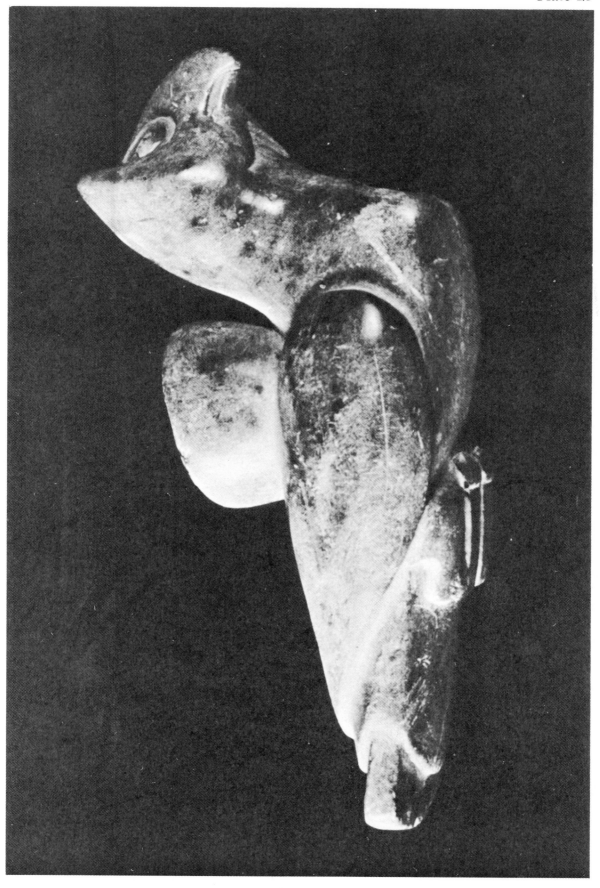

PLATE 24

POTTERY JAR IN FORM OF HUMAN HEAD

Culture, Lower Mississippi *Size,* 6½ x 6½ inches
Region, Blytheville, Mississippi County, Ark. *Location,* Museum of the American Indian, Heye Foundation
Period, Fourteenth to Fifteenth (?) Century *Museum No.* 5/2981

Plate 24

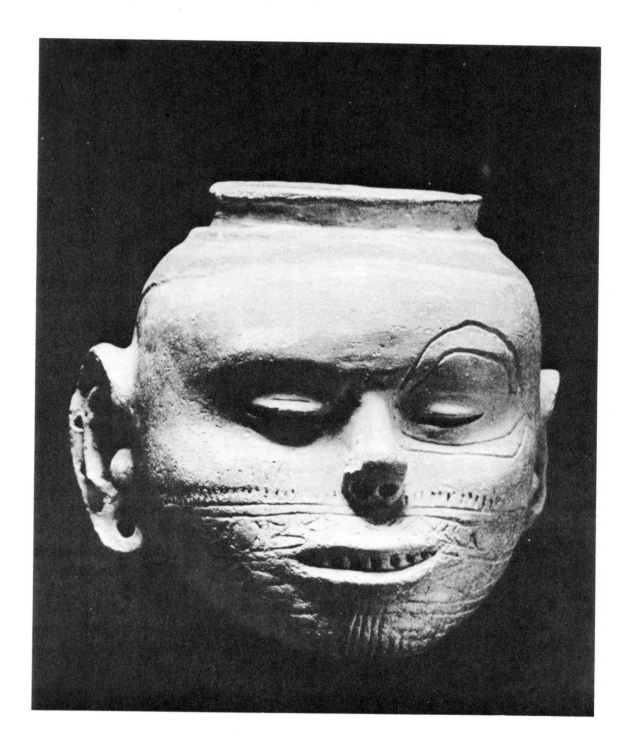

PLATE 25

POTTERY JAR REPRESENTING HUNCHBACK

Culture, Lower Mississippi

Region, Rhodes Place, Crittenden County, Ark.

Period, Fourteenth to Fifteenth (?) Century

Size, 8¼ x 7 inches

Location, Museum of the American Indian, Heye Foundation

Museum No. 17/4149

Plate 25

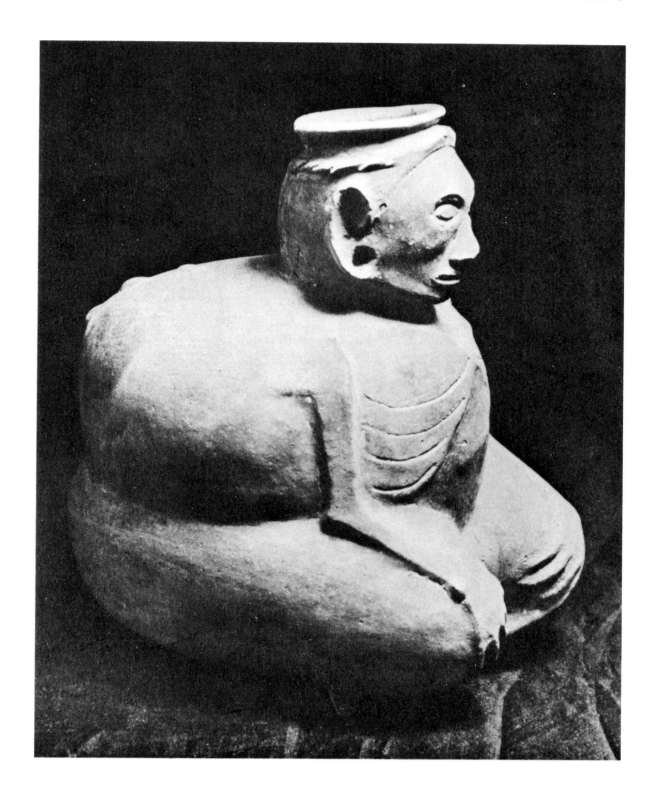

PLATE 26

BOTTLE, BLACKWARE, INCISED DECORATION FILLED WITH RED OCHRE

Culture, Lower Mississippi
Region, Keno Place, Morehouse Parish, La.
Period, Fourteenth to Fifteenth (?) Century

Size, 5½ x 7½ inches
Location, Museum of the American Indian, Heye Foundation
Museum No. 17/3682

Plate 26

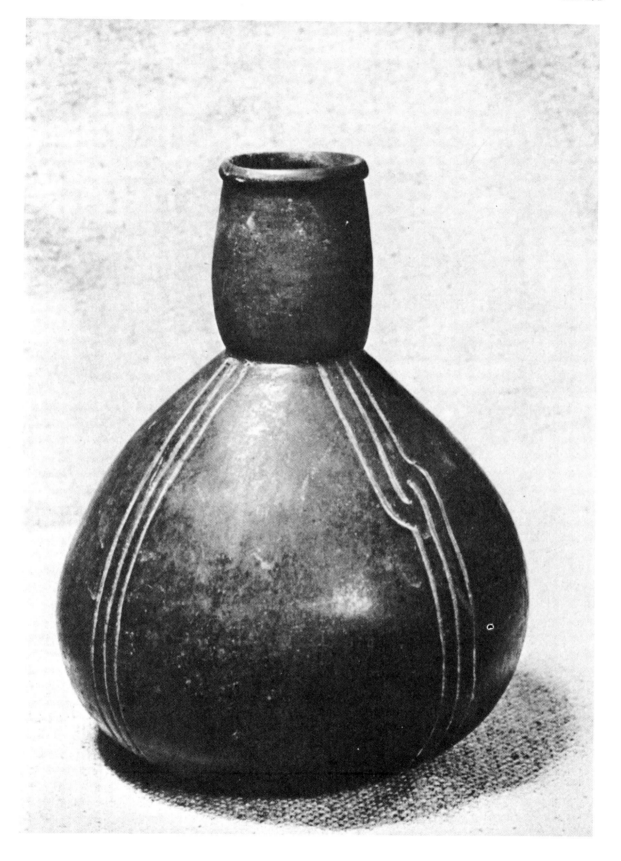

PLATE 27

POTTERY JAR, INCISED DECORATION

Culture, Lower Mississippi

Region, Carden Bottom, Yell County, Ark.

Period, Fourteenth to Fifteenth (?) Century

Size, 5 x 7¼ inches

Location, Museum of the American Indian, Heye Foundation

Museum No. 5/6318

Plate 27

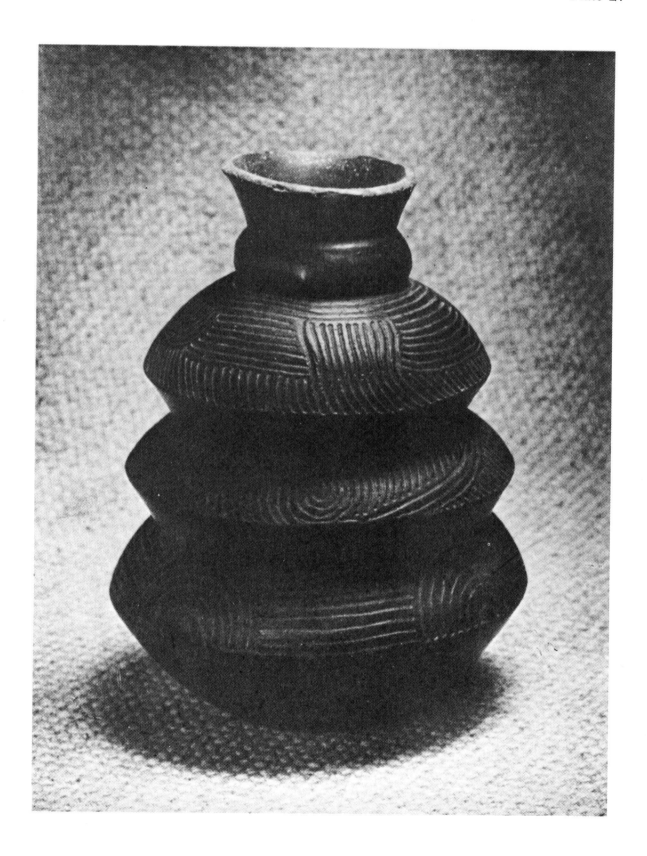

PLATE 28

POTTERY JAR, LOST COLOR (BATIK PROCESS) DECORATION

Culture, Lower Mississippi

Region, Monette, Craighead County, Ark.

Period, Fourteenth to Fifteenth (?) Century

Size, 7¼ x 7 inches

Location, Museum of the American Indian, Heye Foundation

Museum No. 5/1082

Plate 28

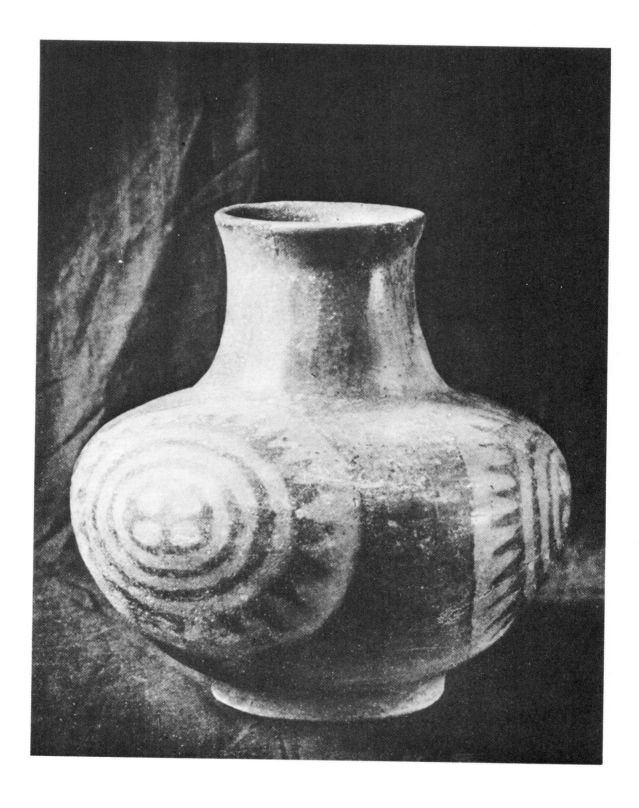

PLATE 29

POTTERY EFFIGY BOWL

Culture, Lower Mississippi
Region, Cross County, Ark.
Period, Fifteenth (?) Century

Size, 8¼ x 6 x 6¼ inches
Location, Field Museum, Chicago
Museum No. 50,812

Plate 29

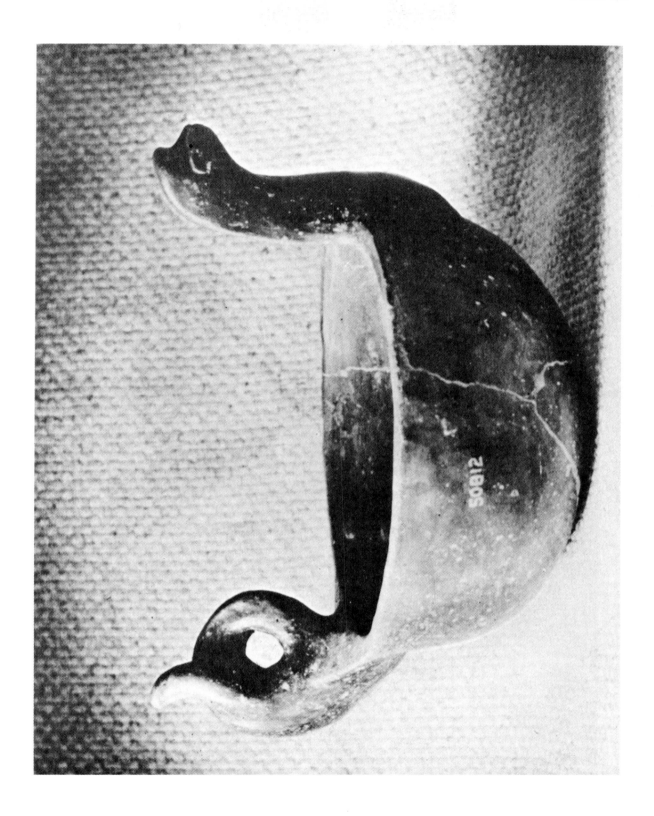

Ancient Arts of the Southwestern United States We know the archaeology of the Southwestern United States far better than that of any other region in the two Americas. Two major branches of the culture existed, the Anasazi of Northern Arizona and New Mexico, the Hohokam of Southwestern Arizona. A continuous development has been traced and dates from the early centuries of the Christian era to the present day. The Southwestern people were sedentary farmers, and by the eleventh century the Anasazi began to live in their communal dwellings, located in the open country or in the shallow caves where celebrated Cliff Houses are found. The Anasazi art expression followed textile and ceramic design rather than sculpture, and the same condition to a slightly lesser extent holds true of the Hohokam. As a result the artistic achievements of the Southwestern people seem inferior to those of the Eastern tribes, but actually the Anasazi and Hohokam groups were much more highly developed along technical lines than their Eastern brethren. The selection of plates has followed the more striking aspects of the sub-cultures in these two major Southwestern divisions.

ANCIENT ARTS OF THE SOUTHWESTERN UNITED STATES

PLATE 30

BOWL WITH RABBIT DESIGN, BLACK AND WHITE

Culture, Mimbres
Region, Swarts Ranch, Grant County, New Mexico
Period, Eleventh Century

Size, Diameter 8 inches
Location, Peabody Museum, Harvard University
Museum No. 94,700

Note on Plates 30-31 the holes in the centers of the bowls, showing how the vessels were "killed" ceremonially before being placed in graves.

Plate 30

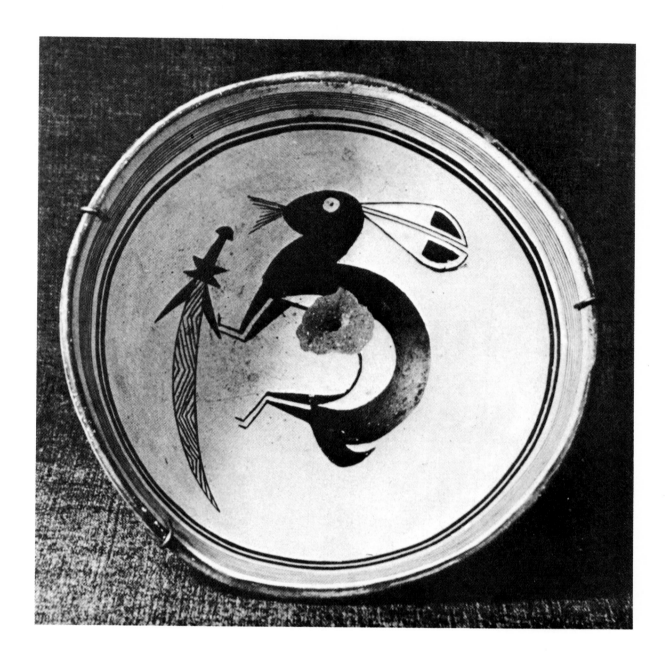

PLATE 31

BOWL WITH DESIGN OF TWO PEOPLE UNDER A BLANKET, BLACK AND WHITE

Culture, Mimbres
Region, Swarts Ranch, Grant County, New Mexico
Period, Eleventh Century

Size, Diameter 9 inches
Location, Peabody Museum, Harvard University
Museum No. 95,815

Plate 31

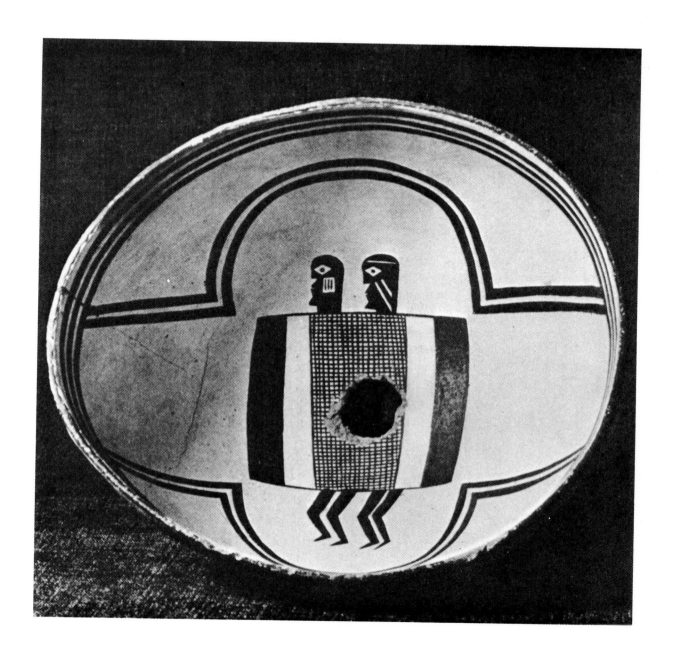

PLATE 32

BOWL WITH BAT PAINTED IN REVERSE, THE BLACK DECORATIVE PAINTING OUTLINING THE WHITE SLIP

Culture, Mimbres
Region, Mimbres Valley, New Mexico
Period, Eleventh Century

Size, approx. 9 inches
Location, U. S. National Museum
Museum No. 326,245

Plate 32

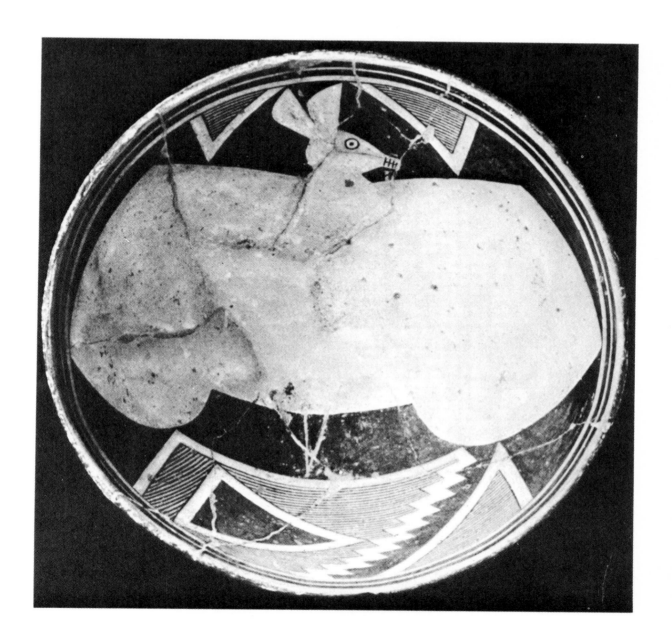

PLATE 33

BOWL DECORATED IN BLACK ON YELLOW

Culture, Prehistoric Hopi (Sikyatki)
Region, Northern Arizona
Period. Sixteenth Century

Size, Diameter 8½ inches
Location, U. S. National Museum
Museum No. 155,622

Plate 33

ANCIENT ARTS OF THE SOUTHWESTERN UNITED STATES

PLATE 34

JAR DECORATED IN BLACK AND RED ON YELLOW

Culture, Prehistoric Hopi (Sikyatki) *Size,* Height 7 inches; diameter 13 inches
Region, Northern Arizona *Location,* U. S. National Museum
Period, Sixteenth Century *Museum No.* 155,690

Plate 34

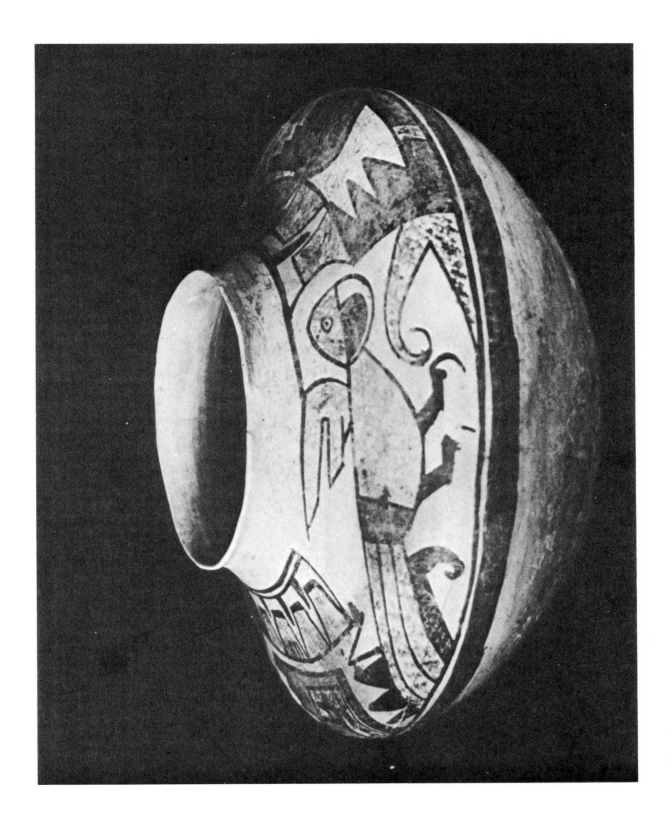

PLATE 35

STONE MORTAR REPRESENTING MOUNTAIN SHEEP, VOLCANIC ROCK

Culture, probably Hohokam
Region, Twenty miles west of Phoenix, Arizona
Period, A. D. 700-900

Size, 4 x 5 x 2 inches
Location, Museum of the American Indian, Heye Foundation
Museum No. 19/5109

Plate 35

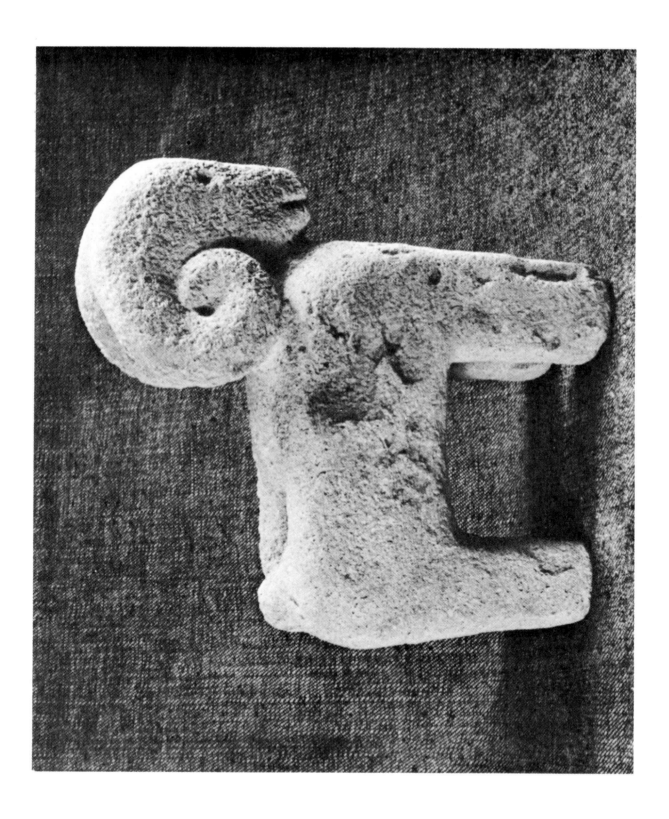

PLATE 36

HORNED TOAD EFFIGY, SANDSTONE[1]

Culture, Hohokam
Region, Snaketown, south of Phoenix, Arizona
Period, A.D. 700-900

Size, 9½ inches
Location, Gila Pueblo, Globe, Arizona
Museum No. not taken[2]

[1] Photograph by E. T. Nichols 3rd [2] cf. Gladwin and others, *Snaketown, Vol. 1,* pl. lxxv b

Plate 36

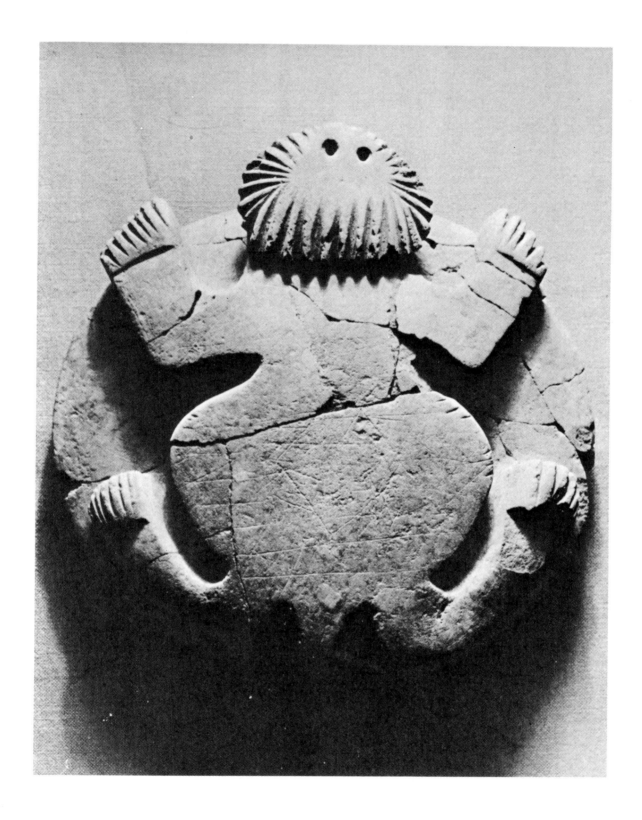

PLATE 37

HEADS OF SMALL CLAY FIGURES[1]

Culture, Hohokam

Region, Snaketown, south of Phoenix, Arizona

Period, A.D. 900-1100

Size, Left approx. 1½ inches: right approx. 1⅞ inches

Location, Gila Pueblo, Globe, Arizona

Museum No. not taken[2]

[1] Photograph by E. T. Nichols 3rd

[2] cf. Gladwin and others, *Snaketown, Vol. 1,* pl. cxcv, f, m

Plate 37

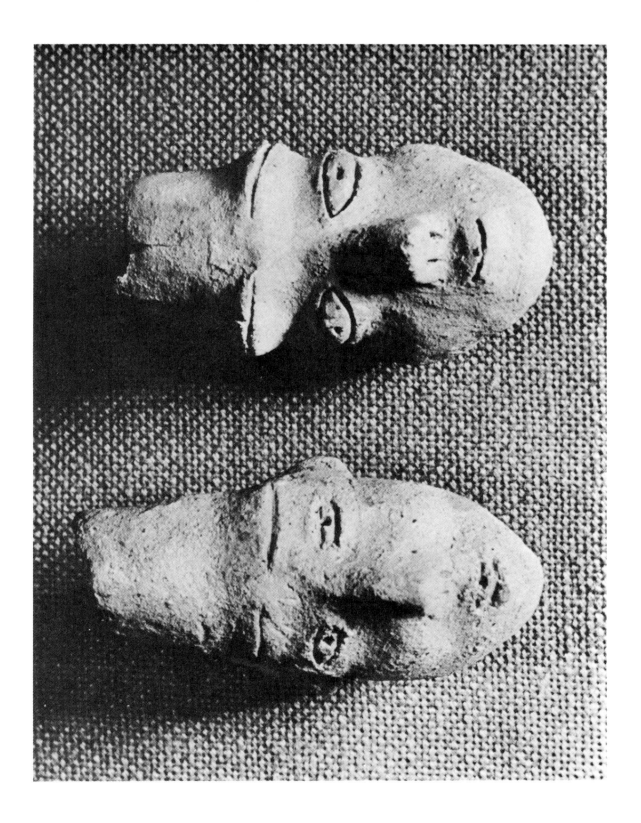

PLATE 38

STONE PAINT PALETTE ADORNED BY BIRD KILLING RATTLE-SNAKE

Culture, Hohokam
Region, Snaketown, south of Phoenix, Arizona
Period, A. D. 700-900

Size, approx. 6¾ inches
Location, Gila Pueblo, Globe, Arizona
Museum No. not taken[2]

[1] Photograph by E. T. Nichols 3rd [2] cf. Gladwin and others, *Snaketown, Vol. 1,* pl. ci, g

Plate 38

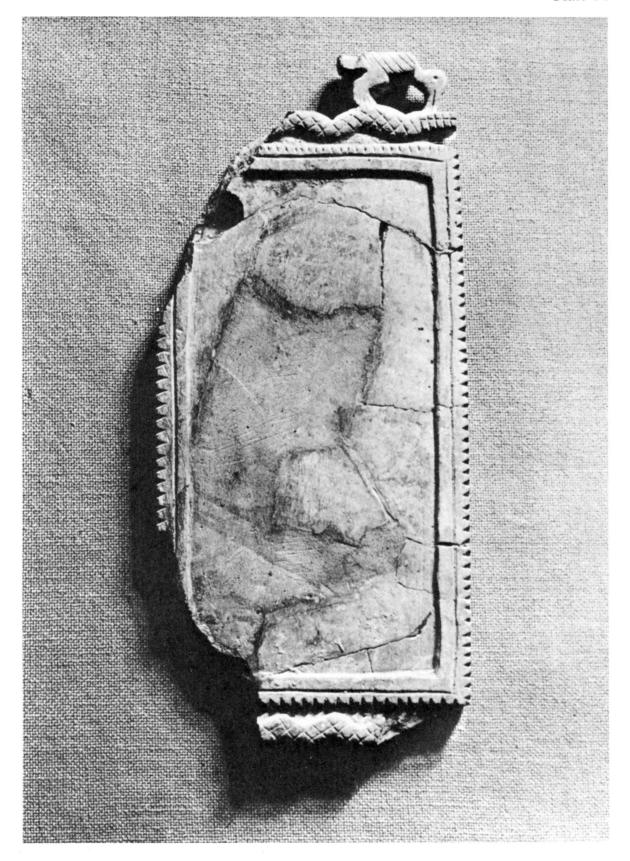

MODERN ART (PLATES 39-96)

The arts of the modern Indian tribes include many aspects of their culture that would not survive the disintegrating forces of nature and time. Thus the element of pure design as applied to clothing and baskets can be observed in much more detail in the following plates than in the preceding. The impact of the white colonization and the ensuing pressure on the tribes of North America tended to keep the groups on the move. Therefore the rich expression in sculpture of a ceremonial cult, which needs a more or less permanent base, tended to disappear. Only on the Northwest Coast do we find a plastic comparable to the great efforts of the past, and in this area, white colonization has not seriously affected Indian life until relatively recent times.

Modern Arts of the Southwestern Pueblos (Plates 39-50) The sedentary tribes of the Southwest are the lineal descendants of the ancient peoples. There is no sharp cleavage between the past and present. The Kachinas, small dolls in the form of supernatural beings, present a series of sculptural forms, that we do not find in the archaeological collections. Pottery, up to the last few years, was a rich and important folk art, each town having its own distinctive styles. From the point of view of vitality and assimilation a short burst of painting is highly interesting since, although European technical processes were used, the content and flavor is essentially Pueblo. The beauty of the costumes and the disposition of figures in the native dances give a richness to Pueblo art, that is conspicuously absent in the archaeological collections.

Map Illustrating the Area of Distribution of the

MODERN ARTS OF THE SOUTHWESTERN PUEBLOS

PLATE 39

WOMAN'S HEADDRESS (TABLITA) WOOD

Tribe, Hopi
Region, Northern Arizona
Period, Recent

Size, 19½ x 11½ inches
Location, Denver Art Museum
Museum No. QH-26-AP

Plate 39

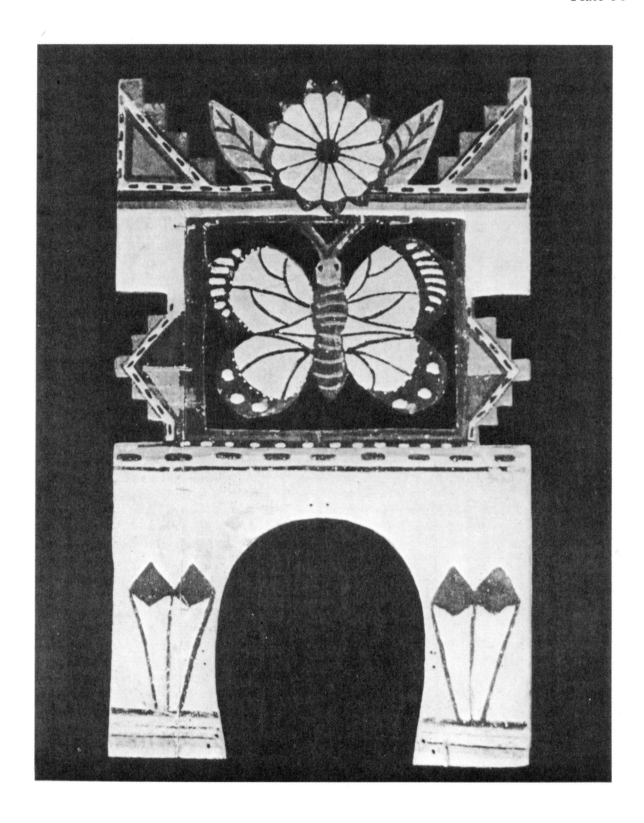

PLATE 40

KACHINA, "HAHAI-I" WOOD

Tribe, Hopi

Region, Oraibi, Northern Arizona

Period, Recent

Size, 8 inches high

Location, Laboratory of Anthropology, Sante Fe

Museum No. L 10/1842

Plate 40

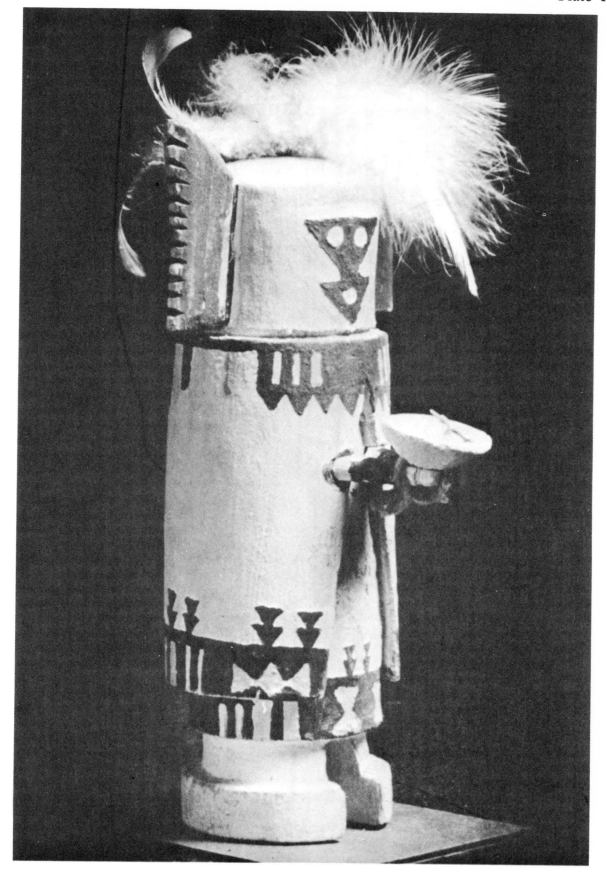

PLATE 41

KACHINA, "MONG-WU," (WARRIOR KACHINA) WOOD

Tribe, Hopi *Size,* 11 inches
Region, Northern Arizona *Location,* Museum of Northern Arizona, Flagstaff
Period, Recent *Museum No.* not taken

Plate 41

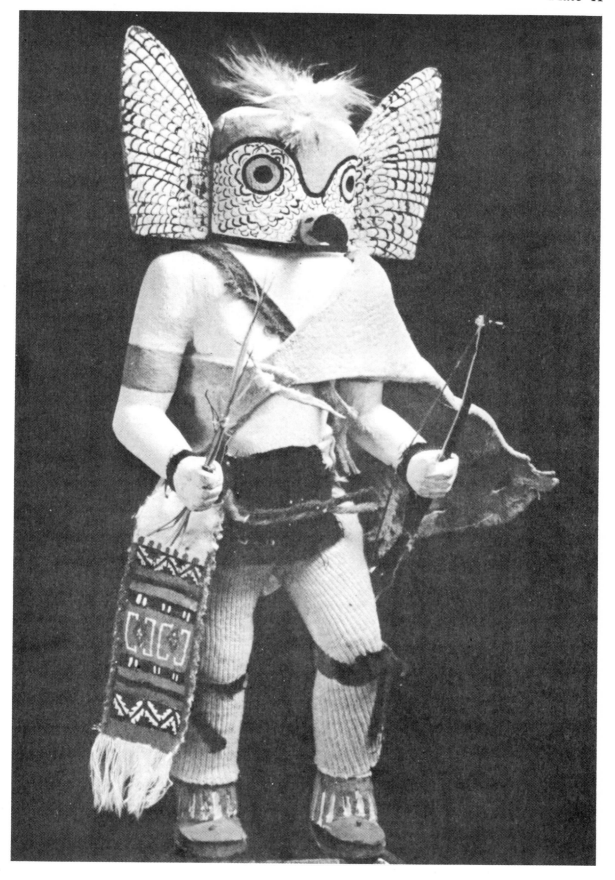

PLATE 42

KACHINA, "KANA-A" WOOD

Tribe, Hopi *Size,* 11¾ inches
Region, Northern Arizona *Location,* Museum of Northern Arizona, Flagstaff
Period, Recent *Museum No.* not taken

Plate 42

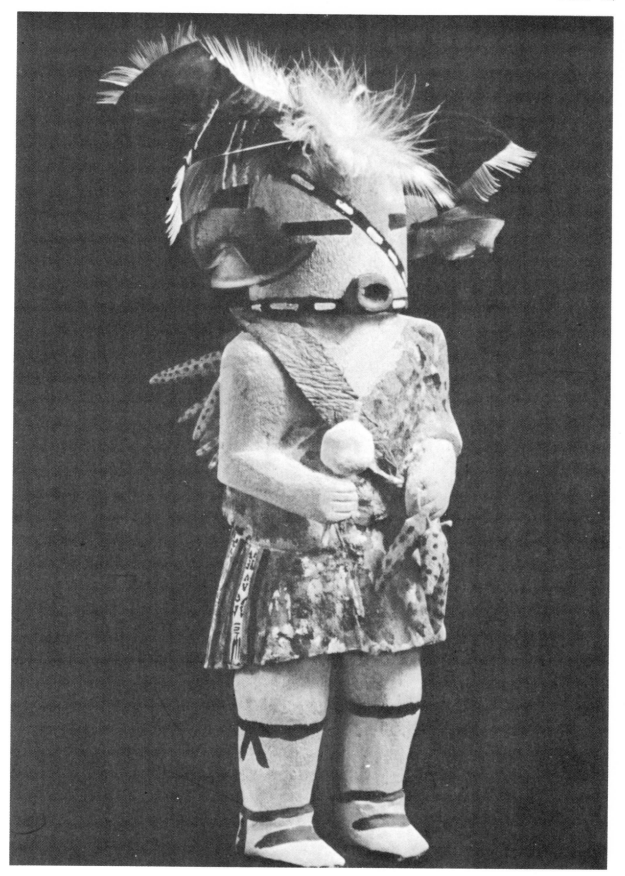

PLATE 43

KATCHINA, "MUDHEAD" WOOD

Tribe, Hopi

Region, Northern Arizona

Period, Recent

Size, 11 inches

Location, Denver Art Museum

Museum No. not taken

Plate 43

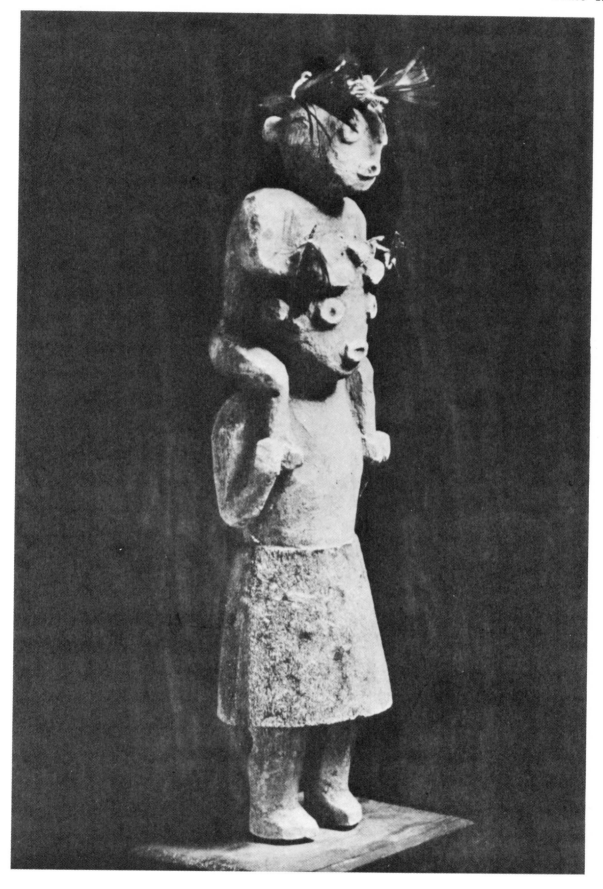

MODERN ARTS OF THE SOUTHWESTERN PUEBLOS

PLATE 44

TURQUOISE BIRD

Tribe, Zuni
Region, Northern Arizona
Period, Recent

Size, 3 x 1⅛ x 1¼ inches
Location, C. T. Wallace Collection, Zuni
Museum No. none

Plate 44

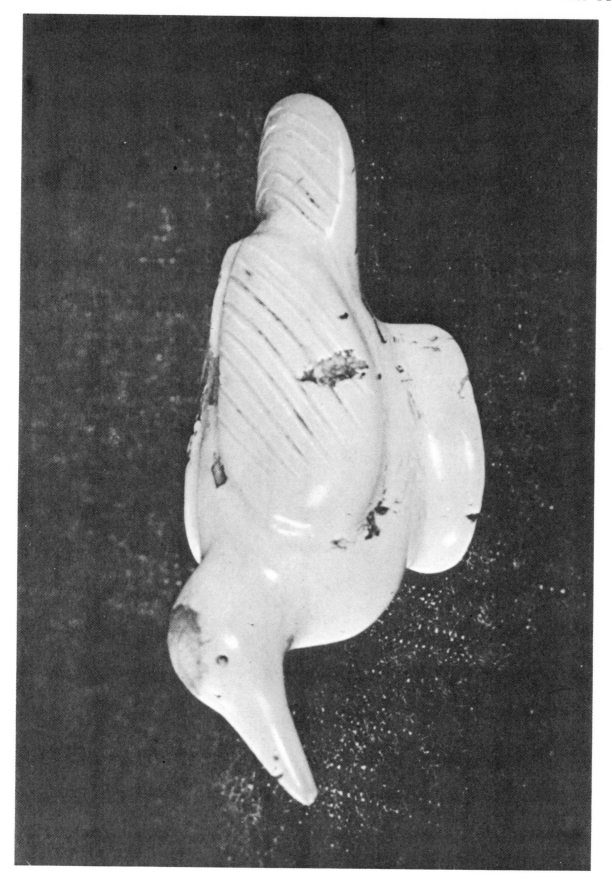

PLATE 45

STONE FETISH REPRESENTING MOUNTAIN SHEEP

Tribe, Zuni

Region, Northern Arizona

Period, Possibly proto-historic

Size, 2½ x 3¾ x 6¾ inches

Location, Laboratory of Anthropology, Santa Fe

Museum No. L 10/502

Plate 45

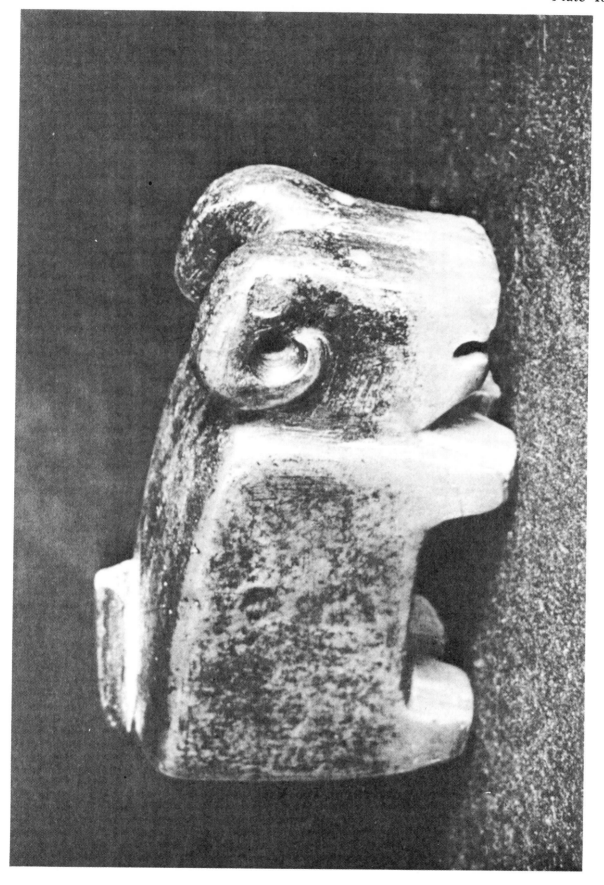

MODERN ARTS OF THE SOUTHWESTERN PUEBLOS

PLATE 46

JAR, RED AND BLACK ON WHITE, BIRD AND PLANTS

Tribe, Zia
Region, Northern New Mexico
Period, Modern

Size, 10 x 12 inches
Location, Laboratory of Anthropology, Santa Fe
Museum No. IAF /239

Plate 46

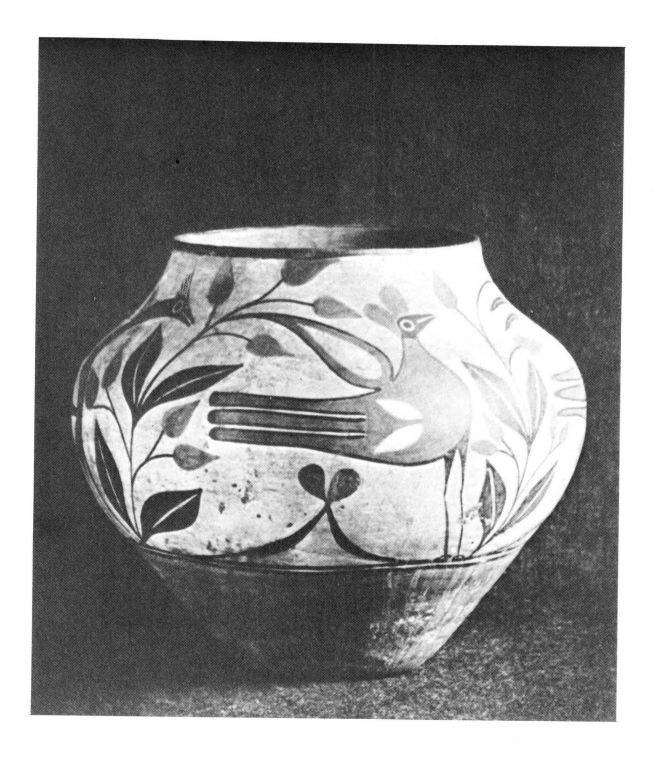

MODERN ARTS OF THE SOUTHWESTERN PUEBLOS

PLATE 47

CEREMONIAL JAR, WHITE WITH BLACK AND RED DECORATION

Tribe, Zuni
Region, Northern Arizona
Period, Nineteenth Century

Size, 11½ x 10 inches
Location, Laboratory of Anthropology, Santa Fe
Museum No. LIO/57

Plate 47

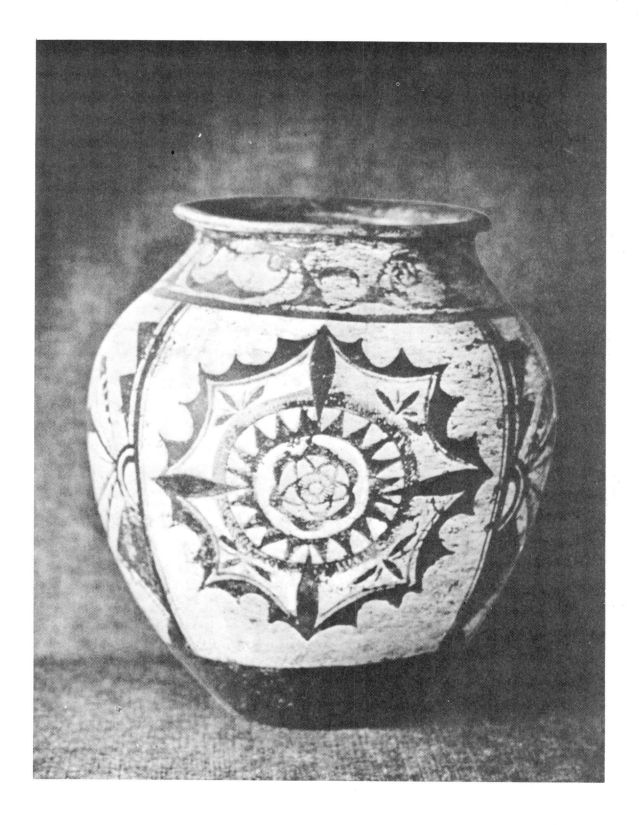

PLATE 48

WATER COLOR "WOMEN GETTING WATER"
BY LORENCITA ATENCIO (TO-POVE)

Tribe, San Juan

Region, Northwestern New Mexico

Period, Recent

Size, 13¼ x 9¼ inches

Location, Mrs. Charles Dietrich Collection, Santa Fe

Museum No. none

Plate 48

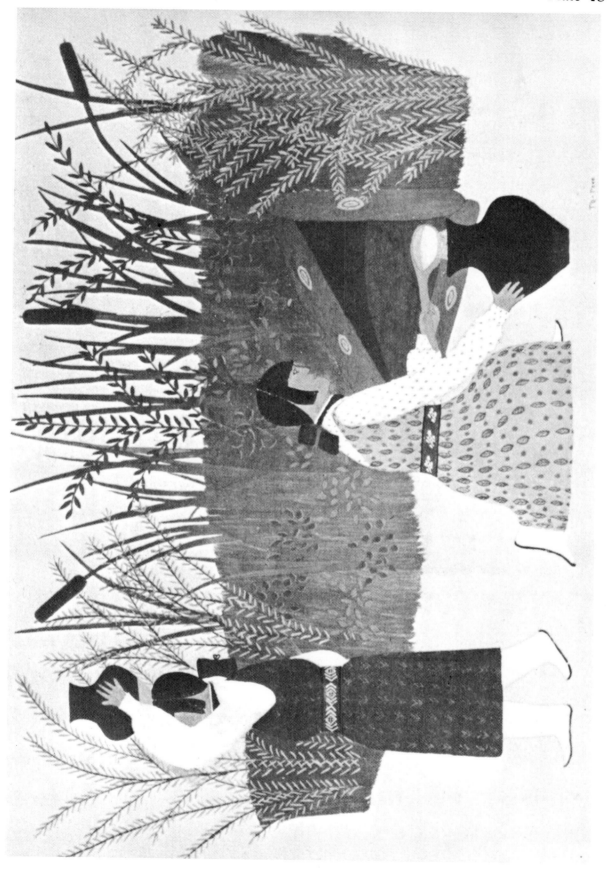

PLATE 49

WATER COLOR "LITTLE DANCE CEREMONY"
BY FRED KABOTIE

Tribe, Hopi
Region, Northern Arizona
Period, Modern

Size, 21 x 12¼ inches
Location, Dr. Edgar L. Hewett Collection, Santa Fe
Museum No. none

Plate 49

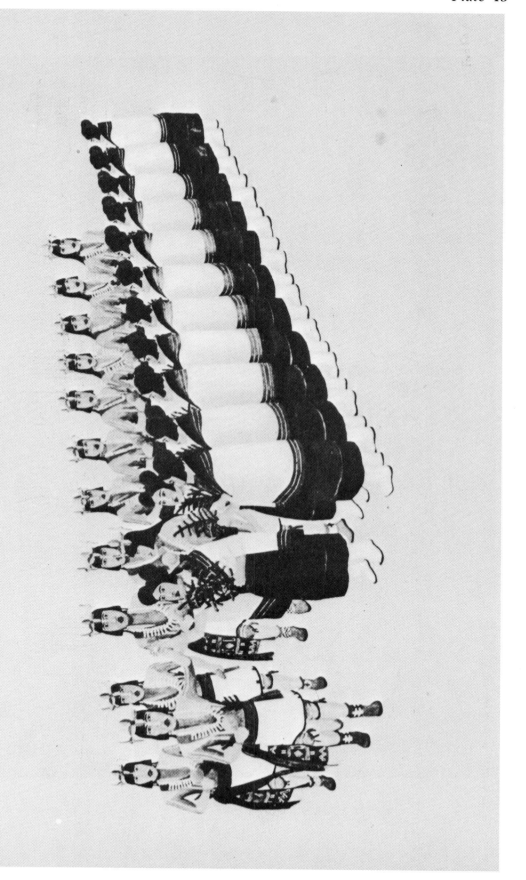

MODERN ARTS OF THE SOUTHWESTERN PUEBLOS

PLATE 50

WATER COLOR "SUMMER CEREMONY"
BY AWA-TSIREH

Tribe, San Ildefunso

Region, Rio Grande, New Mexico

Period, Modern

Size, 25 x 12½ inches

Location, Dr. Edgar L. Hewett Collection, Santa Fe

Museum No. none

Plate 50

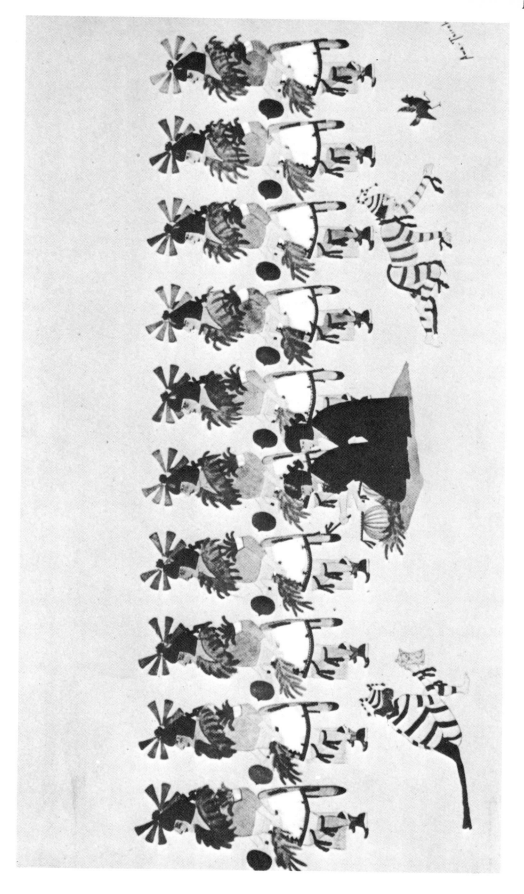

Modern Arts of the Southwestern Nomads The coming of the whites greatly benefited the nomadic tribes of the Southwest. The introduction of sheep provided the Navajos with a steady food supply as well as wool for blankets. Silver coins from both Mexico and the United States were melted down and cast as ornaments. The ancient arts are represented in the sand paintings, symbolic patterns made with different colored sands, used in curative ceremonies. Some Navajo children have been taught painting in the schools, but there is much less connection with the native tradition than in the case of the Pueblo. Basketry, always an important aboriginal craft, continues to be made among various tribes, especially the Apache. The Navajo, while not advanced due to their manner of life in an unfavorable environment, have nevertheless mightily increased in numbers and have made one of the most successful adaptations of European culture traits to aboriginal life.

MODERN ARTS OF THE SOUTHWESTERN NOMADS

PLATE 51

SILVER WRIST (GUARD AGAINST BOW STRING) INSET WITH TURQUOISE

Tribe, Navajo
Region, Northern Arizona
Period, Modern

Size, 2⅝ x 3¾ inches
Location, Laboratory of Anthropology, Santa Fe
Museum No. L 10/1119

Plate 51

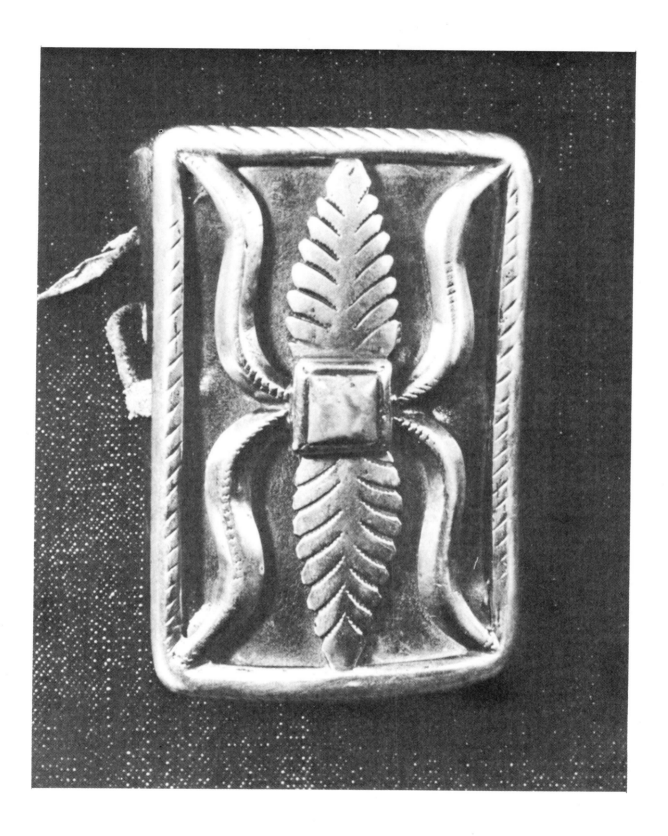

PLATE 52

SILVER BRACELET, TOOLED AND DIE STAMPED

Tribe, Navajo
Region, Northern Arizona
Period, Modern

Size, 1⅜ inches wide
Location, Laboratory of Anthropology, Santa Fe
Museum No. L 10/1050

Plate 52

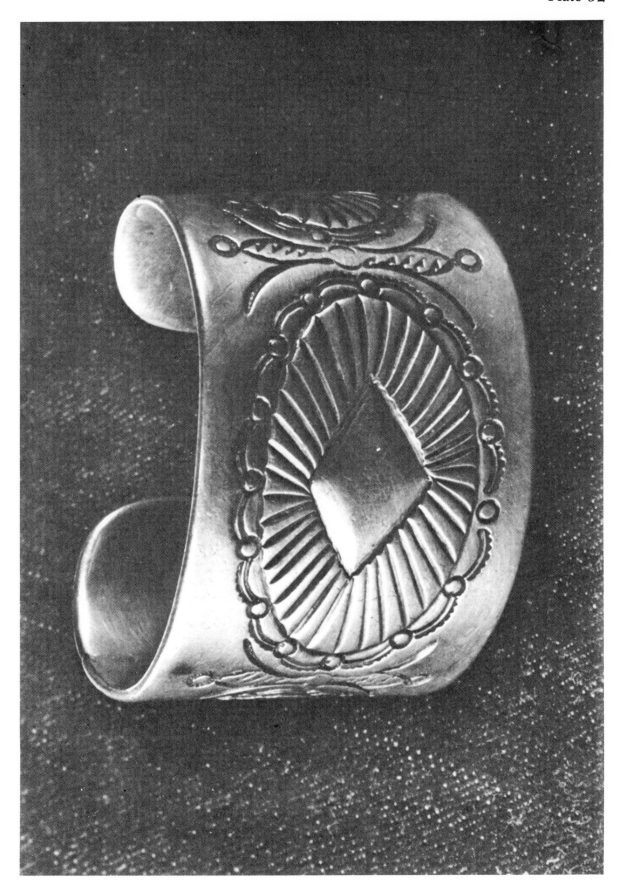

PLATE 53

SAND PAINTING, NIGHT CHANT CEREMONY, PICTURE OF THE WHIRLING LOGS

Tribe, Navajo
Region, Northern Arizona
Period, Modern

Size, up to 10 feet
Location, See Matthews, W., *The Night Chant, Memoirs,* American
Museum of Natural History, Vol. 6, Pl. 6, 1906

Plate 53

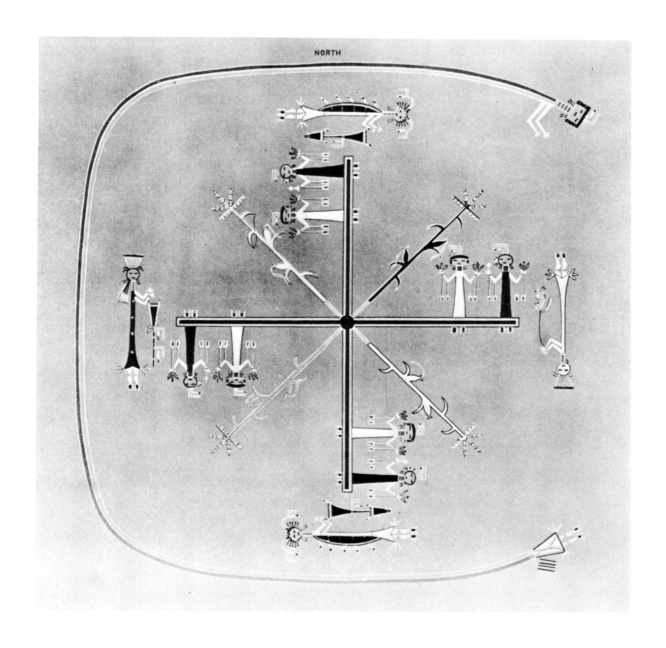

NORTH

PLATE 54

ROCK PAINTING, ANTELOPE, IN RED-BROWN PIGMENT
BY LITTLE LAMB

Tribe, Navajo

Region, Antelope House, Canyon del Muerto, Arizona

Period, 1804

Size, 7 feet long

Location, Copy by Ann Axtell Morris[1] in American
Museum of Natural History

Museum No. none

[1] Charles L. Bernheimer Pictograph Project of the American Museum of Natural History

Plate 54

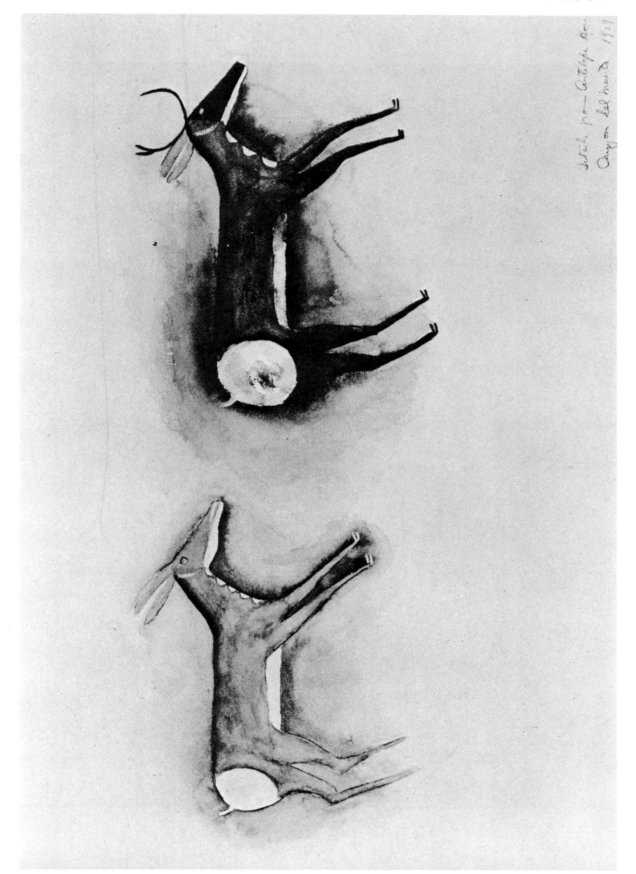

PLATE 55

WOOL BLANKET, ALL HANDSPUN

Tribe, Navajo *Size,* 53 x 77 inches
Region, Northern Arizona *Location,* Laboratory of Anthropology, Santa Fe
Period, Circa 1890 *Museum No.* T.5

Plate 55

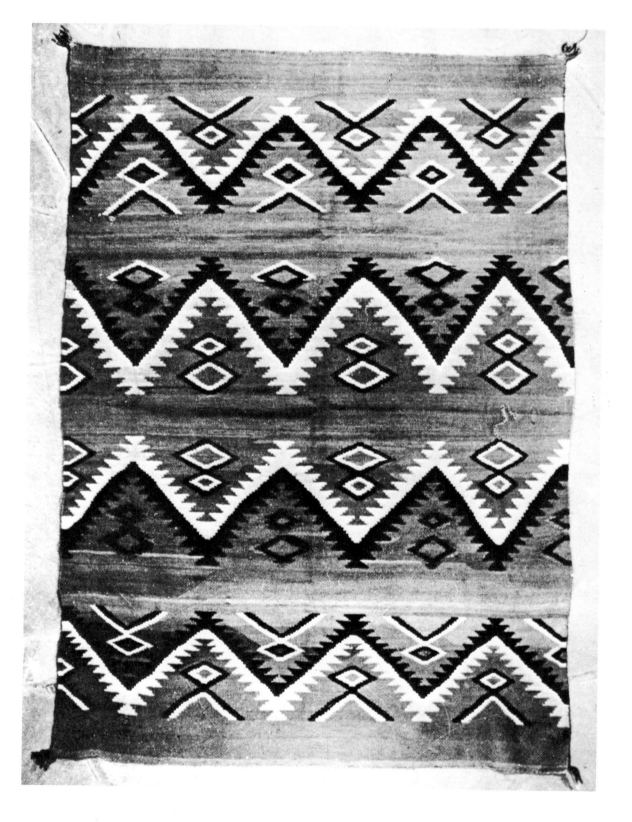

PLATE 56

WOOL BLANKET, HANDSPUN, FOUR-PLY COMMERCIAL AND YARN FROM RAVELED CLOTH

Tribe, Navajo
Region, Northern Arizona
Period, Circa 1880

Size, 54 x 66 inches
Location, Laboratory of Anthropology, Santa Fe
Museum No. 10/412

Plate 56

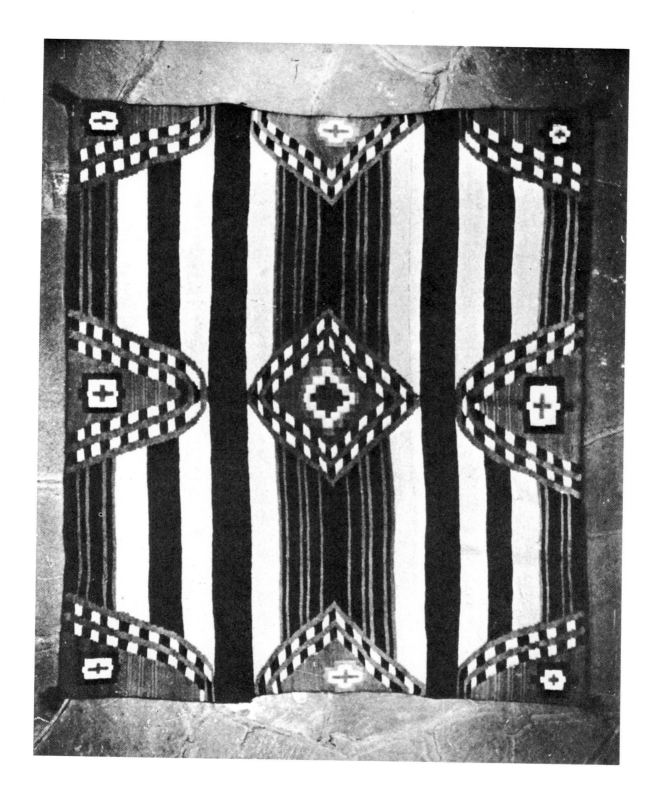

PLATE 57

WOOL BLANKET, ATYPICAL, COMMERCIAL YARN
RED BACKGROUND, BLACK, WHITE, GREEN, BLUE, YELLOW, LAVENDER

Tribe, Navajo

Region, Northern Arizona

Period, Bought in early 1880's

Size, 62 x 80½ inches

Location, Laboratory of Anthropology, Santa Fe

Museum No. L 10/1948

Plate 57

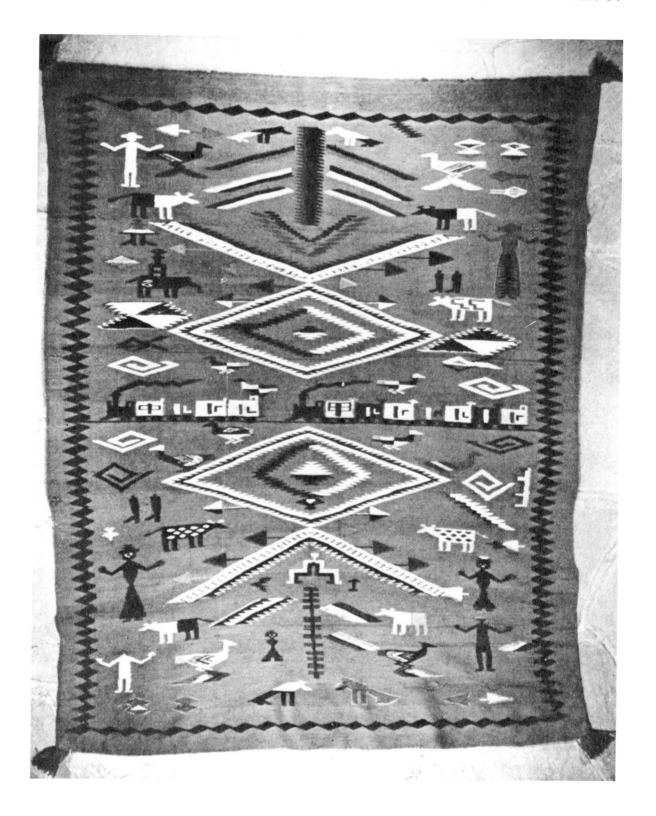

MODERN ARTS OF THE SOUTHWESTERN NOMADS

PLATE 58

COILED BASKET

Tribe, Western Apache
Region, Southwestern Arizona
Period, Modern

Size, 13½ x 4 inches
Location, Denver Art Museum
Museum No. YA-44-P

Plate 58

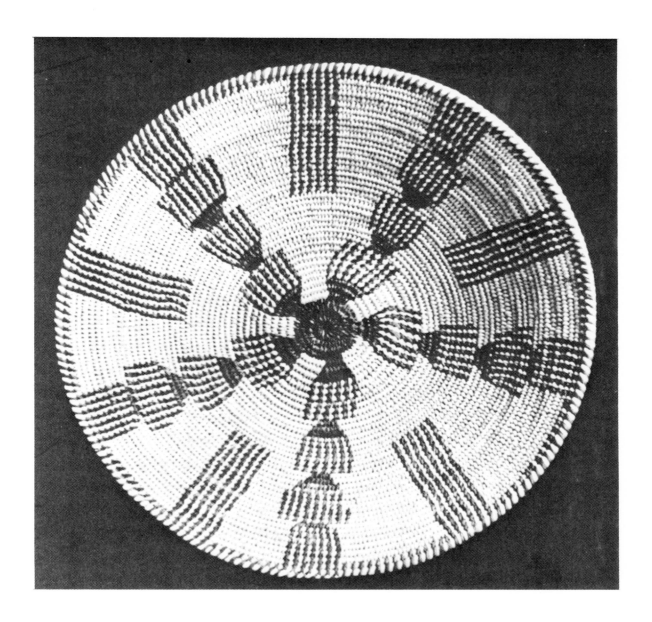

Modern Arts of the Northeastern United States The white colonization rapidly wiped out the Indian tribes east of the Mississippi. Little of the native art remains and in the Southeast it has practically disappeared. The Iroquois of New York State and Canada were able to maintain more of their native culture than the other Eastern groups, since their military prowess made them useful allies in the various struggles between the French, British, and Colonials. The Iroquois False-Face Society, a religious organization, still keeps a native carving tradition alive. An adaptation of native and European technique may be seen in Plate 62, where an Iroquois sculptor, working under a W. P. A. project, produced small figures, very Indian in the presentations of their physique.

Some of the more northerly Indian groups, living under forest conditions in regions undesirable for colonization, long retained much of their ancient lore. These groups, however, never reached the high developments of the native tribes which were destroyed or, like the Creeks and Choctaws, transplanted to the West.

MODERN ARTS OF THE NORTHEASTERN UNITED STATES

PLATE 59

COMB OF ANTLER, DEPICTING MEN ON HORSEBACK

Tribe, Iroquois
Region, Great Sully Site, Cayuga County, N. Y.
Period, Eighteenth Century

Size, 2 x 3 inches
Location, Rochester Museum of Arts and Sciences
Museum No. A. R. 20,439

Plate 59

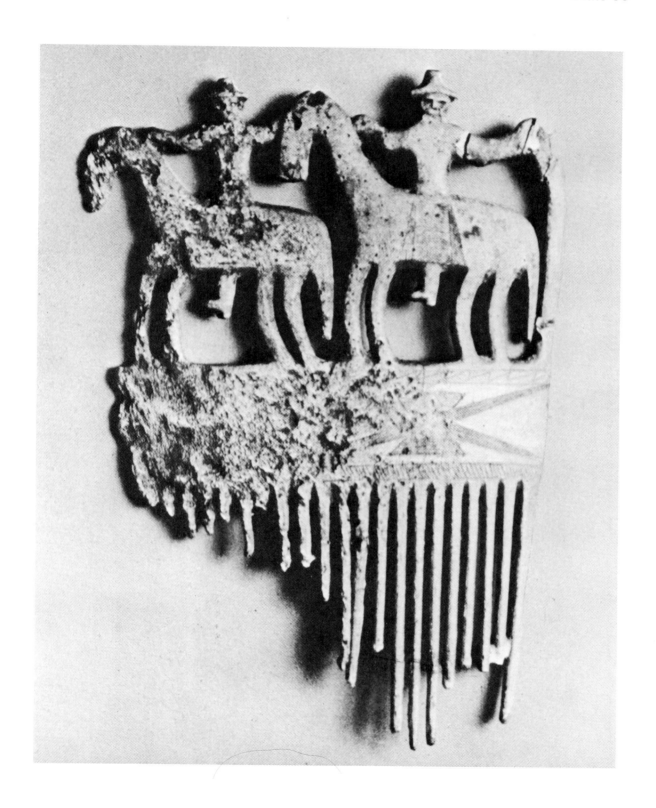

PLATE 60

MASK, WOOD AND HORSEHAIR

Tribe, Iroquois *Size,* 11 x 7 inches
Region, Grand River Reserve, Canada *Location,* Field Museum, Chicago
Period, Modern *Museum No.* 55,746

Plate 60

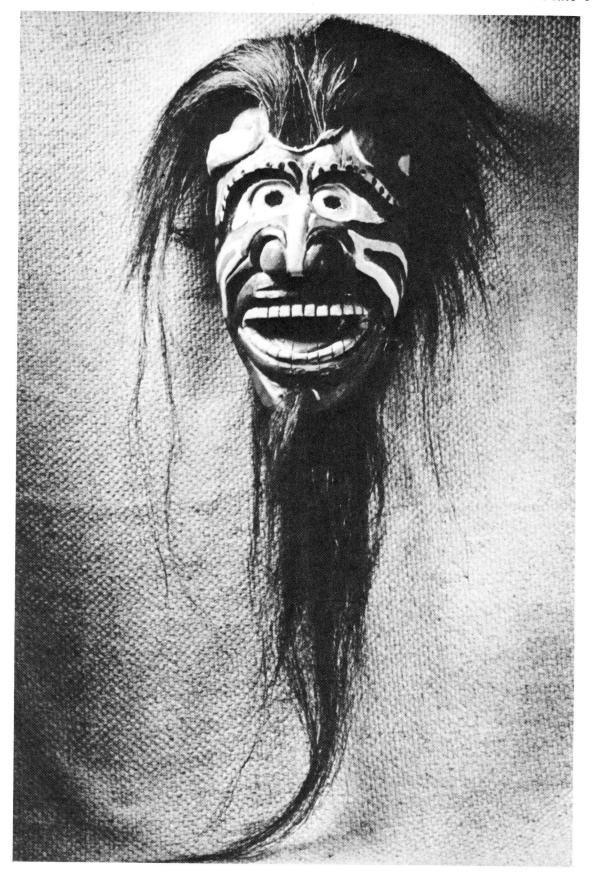

PLATE 61

CLOWN MASK, WOOD

Tribe, Seneca (Iroquois)
Region, Northern New York
Period, Modern

Size, 10¼ x 6½ x 3½ inches
Location, Denver Art Museum
Museum No. N. Sen. 8-P.

Plate 61

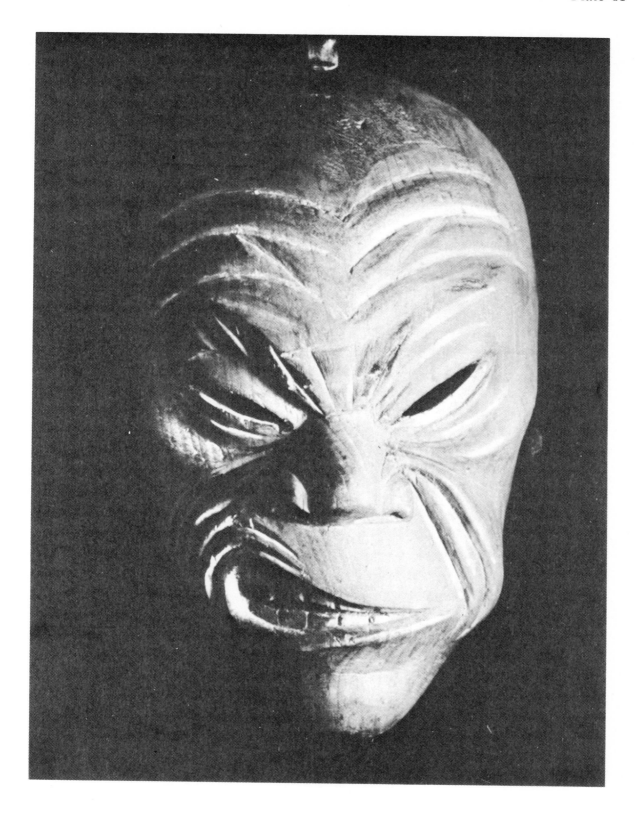

Plate 62

MODERN ARTS OF THE NORTHEASTERN UNITED STATES

PLATE 63

BIRCHBARK BASKET, WITH FIGURES OF MOOSE, BEAVER, BEAR, ETC.

Tribe, Algonquin *Size,* 7½ x 6 x 12 inches
Region, Northern United States *Location,* Denver Art Museum
Period, Modern *Museum No.* CWC-1-P.

Plate 63

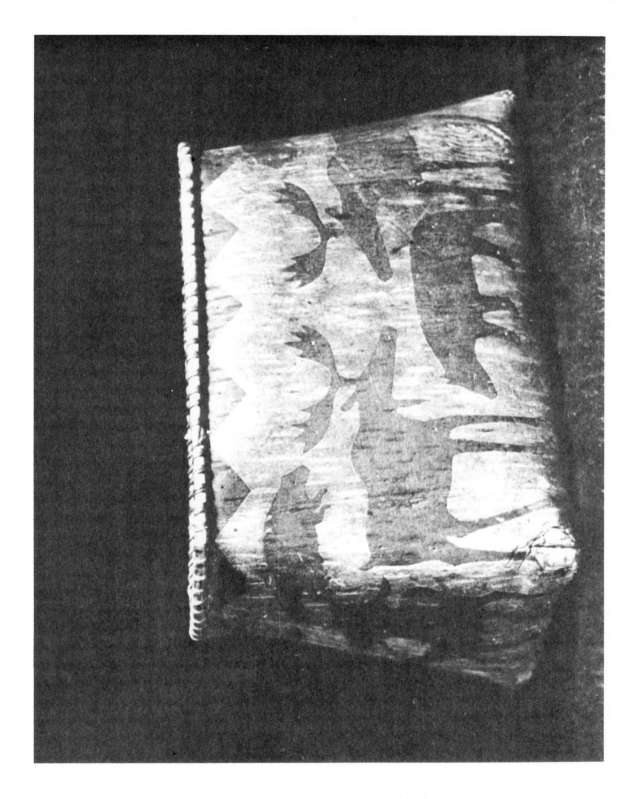

PLATE 64

WOVEN BAG, MADE OF LINDEN BARK CORD AND COLORED YARNS

Tribe, Sauk and Fox *Size,* 15 x 11 inches
Region, Tama, Iowa *Location,* Field Museum, Chicago
Period, Modern *Museum No.* 34,790

Plate 64

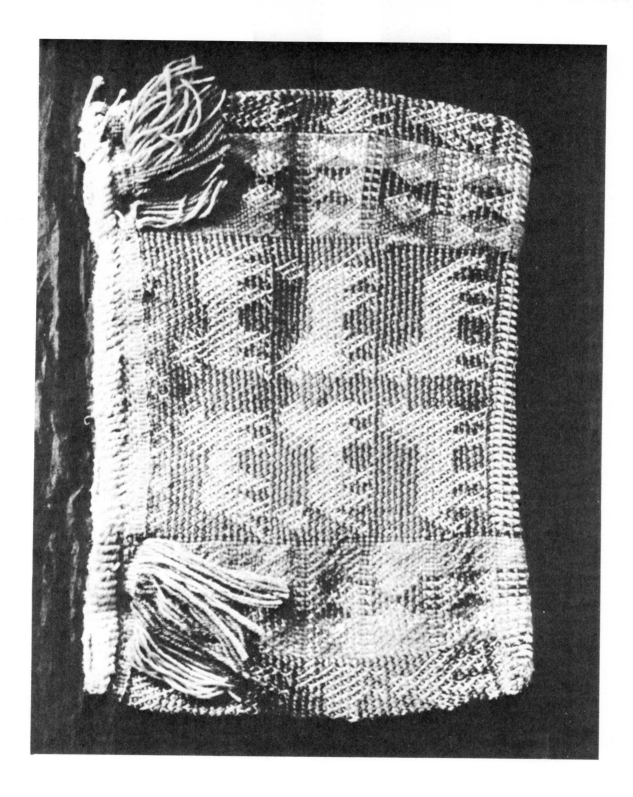

Modern Arts of the Plains The great plains of the west harbored the typical Indian of story and motion picture. Their art in essence combined their manner of life with their highly picturesque dress. No photograph of a museum specimen can do them justice. We include some examples of their lively representational drawing and their beautiful beadwork. The Plains Indian, for a brief and glorious period, was liberated by white culture. The horse gave him the mobility to use the migrant buffalo herds as a stable food-supply, the rifle an opportunity for glory in war and hunt, the trade beads of European manufacture a freedom in design and color which porcupine quill work never had. At present the peyote cult offers an opportunity for the continuation of the old arts, since this religion harks back to ancient days and ancient ways.

MODERN ARTS OF THE PLAINS

PLATE 65

DETAIL FROM PAINTED BUFFALO ROBE

Tribe, Kiowa (?) *Size,* over-all 5 ft. 9 in. x 6 ft. 2 in.: figures 10 inches
Region, Oklahoma *Location,* Miss Amelia E. White Collection, Santa Fe
Period, Nineteenth Century *Museum No.* none

Plate 65

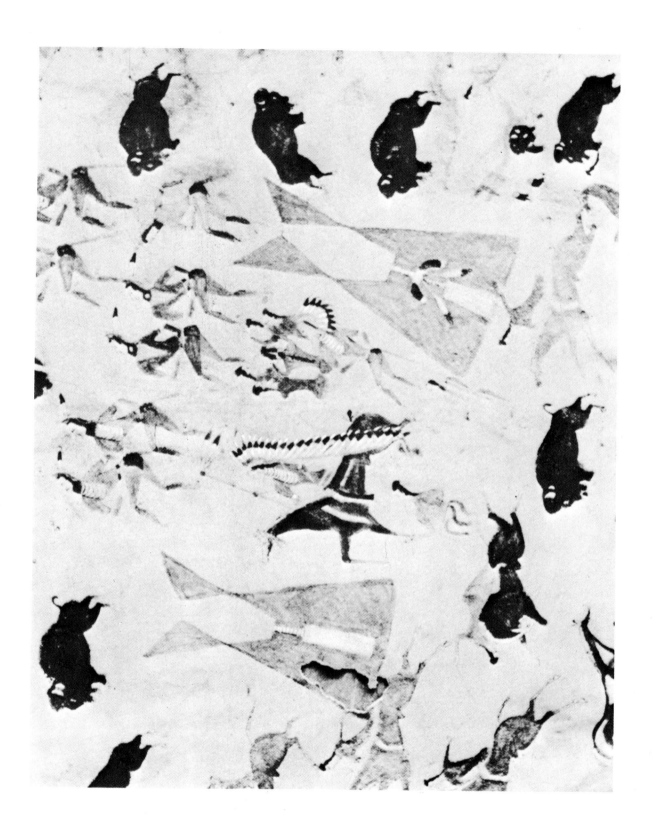

PLATE 66

DETAIL OF BUFFALO HIDE SHOWING HUNTING SCENE
(FROM MINIATURE TIPI)

Tribe, Unknown

Region, Plains

Period, Nineteenth Century

Size, approx. 50 x 25 inches

Location, American Museum of Natural History

Museum No. 50. 1-6500

Plate 66

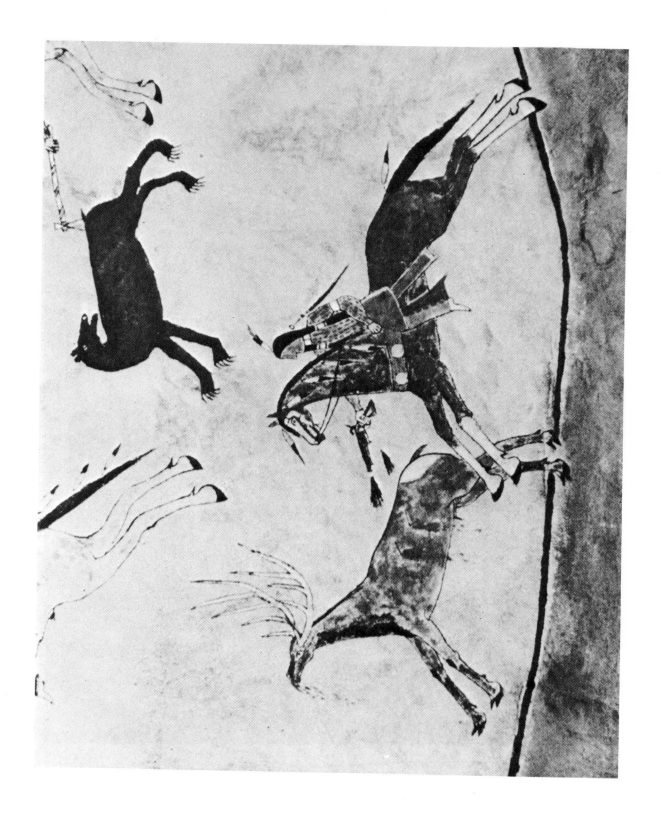

PLATE 67

LEATHER PIPE BAG, DECORATED WITH PORCUPINE QUILLS

Tribe, Sioux (?)

Region, Dakotas (?)

Period, Nineteenth Century

Size, Width 7 inches; length 19½ inches

Location, Denver Art Museum

Museum No. XX/436

Plate 67

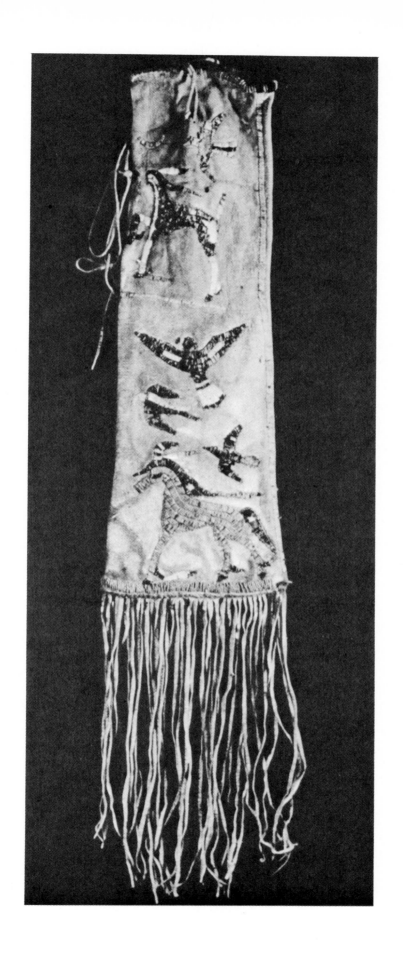

PLATE 68

YOUNG WOMAN'S SHOULDER YOKE, TRIMMED WITH BEADS

Tribe, Sarsi

Region, Alberta, Canada

Period, Nineteenth Century

Size, 16 x 12 inches

Location, Rochester Museum of Arts and Sciences

Museum No. AE 1898

Plate 68

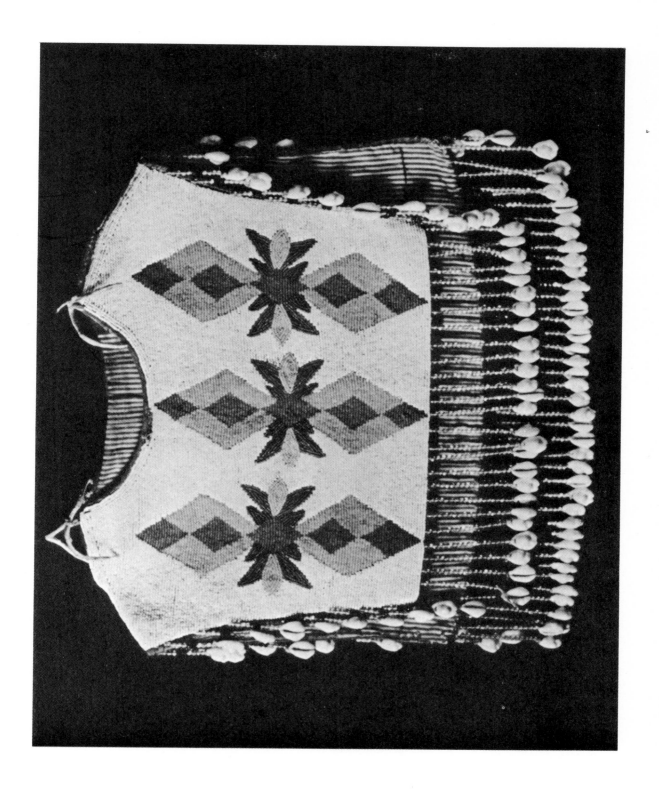

PLATE 69

WOMAN'S BEADED CAPE, TRIMMED WITH BEADS

Tribe, Ute
Region, Colorado
Period, Nineteenth Century

Size, not taken
Location, Denver Art Museum
Museum No. C 281

Plate 69

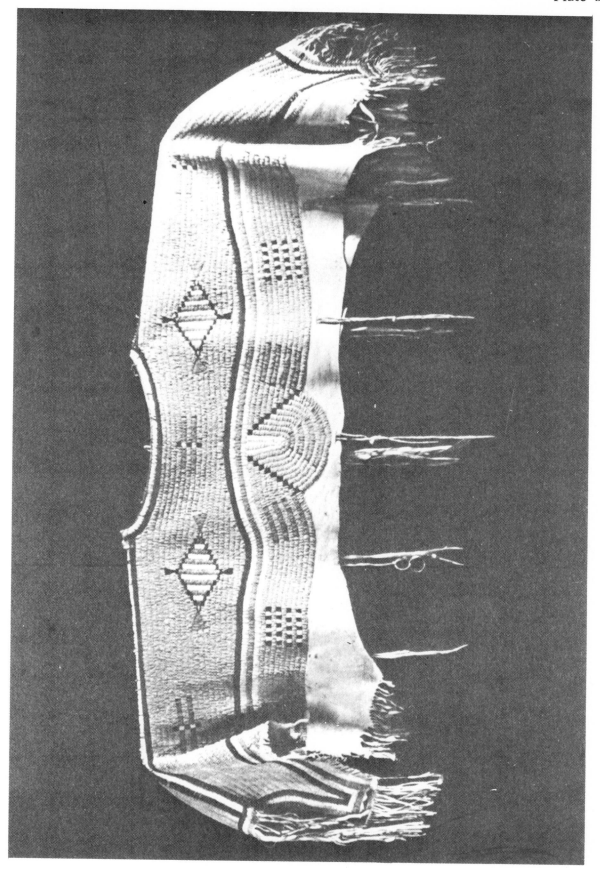

MODERN ARTS OF THE PLAINS

PLATE 70

WOMAN'S DRESS, BEADED SKIN

Tribe, Brulé Sioux
Region, Dakota
Period, Nineteenth Century

Size, not taken
Location, Denver Art Museum
Museum No. BS-70-P

Plate 70

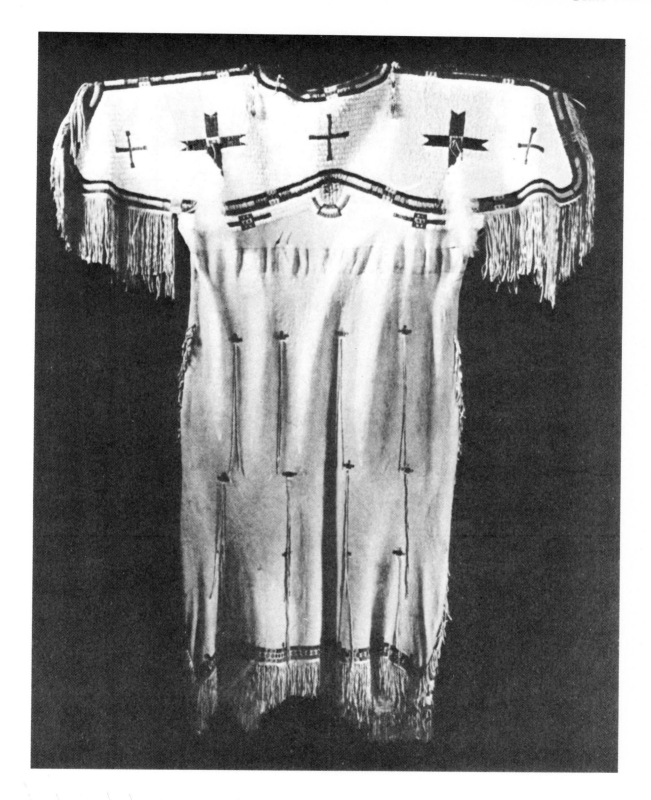

MODERN ARTS OF THE PLAINS

PLATE 71

FAN, FEATHERS WITH BEADED HANDLE FOR USE IN PEYOTE CEREMONIES

Tribe, not given
Region, Oklahoma
Period, Modern

Size, 21¼ inches over-all
Location, Denver Art Museum
Museum No. B-58-P

Plate 71

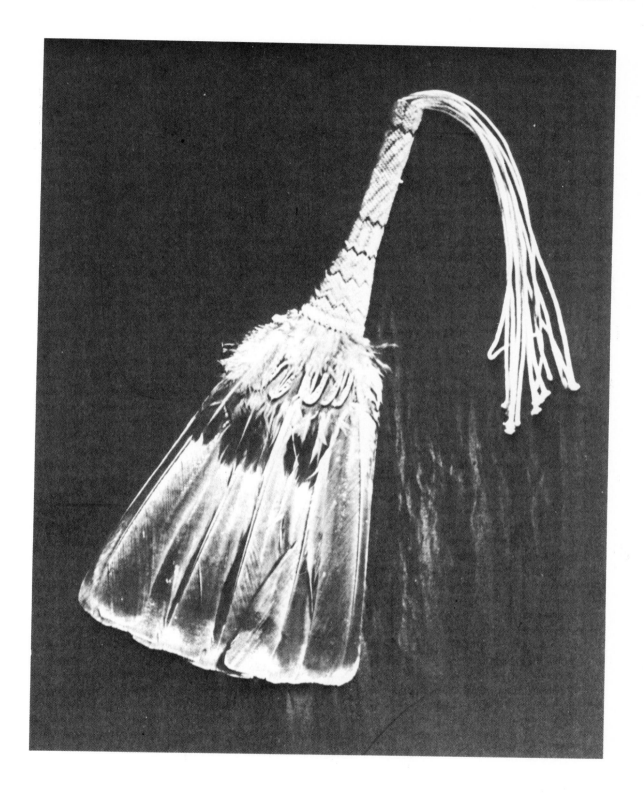

Modern Arts of California and the Northwest (Plates 72-74) The tribes of California confined their aesthetic interests chiefly to basketry, a technique in which they excelled over all the peoples of the New World. The finest weaves and the beautiful feather covering do not receive justice from photography in black and white. We therefore include a few less striking examples to show form and weave. The same technique extended northward among the tribes of the Northwest Coast.

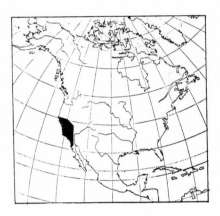

MODERN ARTS OF CALIFORNIA

PLATE 72

BASKET

Tribe, Tulare (?)
Region, Tulare County, California
Period, Nineteenth Century

Size, 6 x 5½ inches
Location, Denver Art Museum
Museum No. YTU-22-P

Plate 72

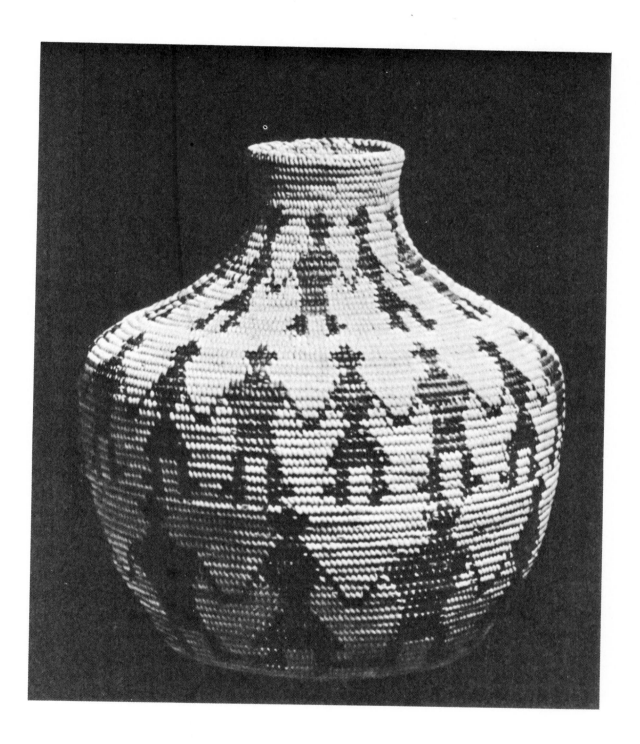

MODERN ARTS OF CALIFORNIA AND THE NORTHWEST

PLATE 73

BASKET [1]

Tribe, Mission
Region, Central California
Period, Nineteenth Century

Size, 14 x 9 inches
Location, American Museum of Natural History
Museum No. 50. 1/8265A

[1] Photograph by American Museum of Natural History

Plate 73

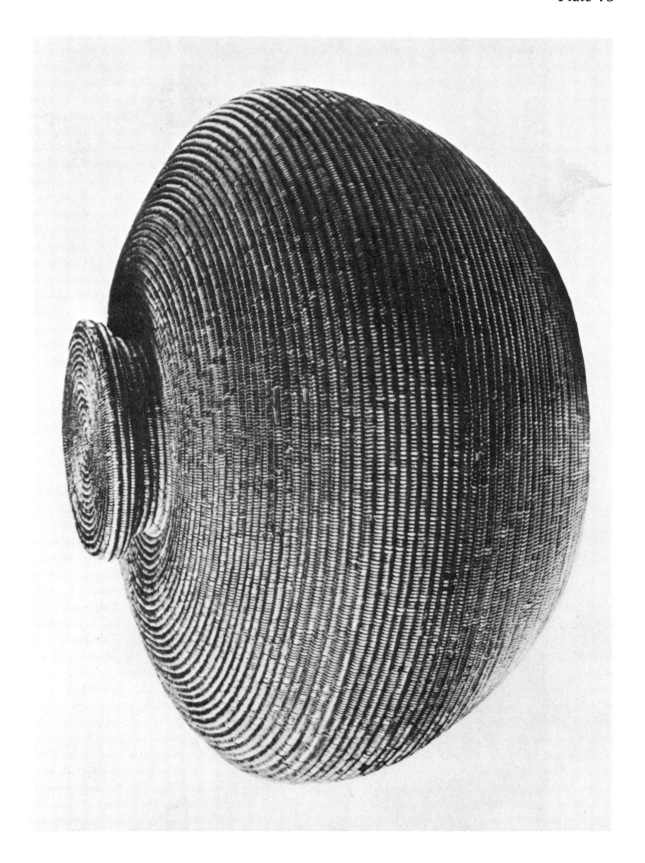

MODERN ARTS OF CALIFORNIA AND THE NORTHWEST

PLATE 74

BASKET

Tribe, Tlingit
Region, Sitka, Alaska
Period, Nineteenth Century

Size, approx. 10 inches
Location, American Museum of Natural History
Museum No. E/2237

Plate 74

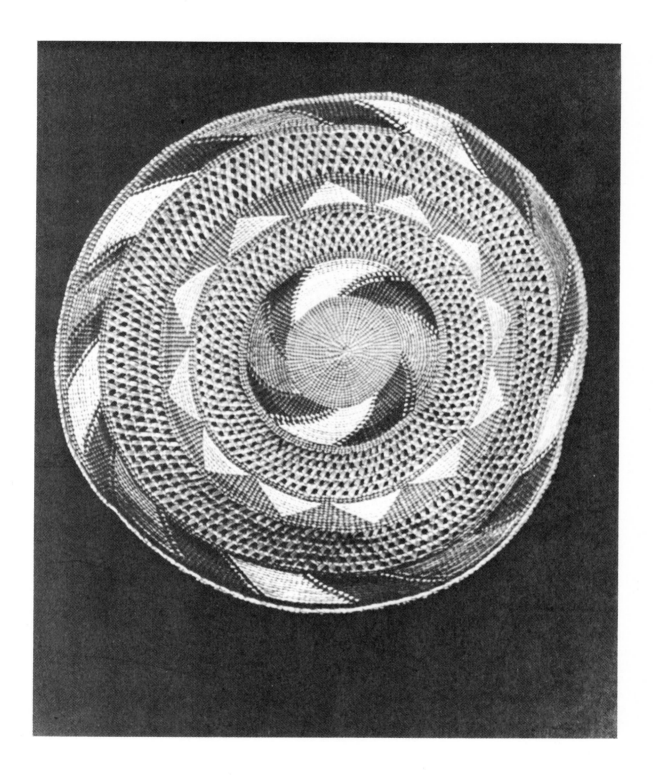

Modern Arts of the Northwest Coast (Plates 75-92) The art of the Northwest Coast is the most highly sophisticated of the North American Indian aesthetic styles. A magical relationship between man and animals, commonly called totemism, was elaborated into a complex system of clan myths, ceremonies, crests, and animals to the expression of which the art was devoted. It is thought that the introduction of steel tools enabled the Indians of the Northwest Coast to develop the sculptural aspects of this system enormously. The same style of symbolic representation ranges from the creation of majestic totem poles and house posts to the ornamentation of combs and bracelets. In the midst of this conventional art there existed a series of masks that are superb examples of realistic sculpture.

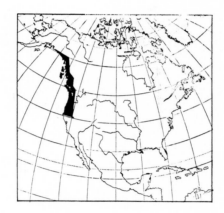

MODERN ARTS OF THE NORTHWEST COAST

PLATE 75

CHILKAT BLANKET, CEDARBARK AND WILDGOAT WOOL[1]

Tribe, Chilkat, Tlingit

Region, Southeastern Alaska

Period, Modern

Size, 5 ft. 3½ inches wide; 4 ft. 5 inches long

Location, American Museum of Natural History

Museum No. 16 1/869

[1] Photograph by American Museum of Natural History

Plate 75

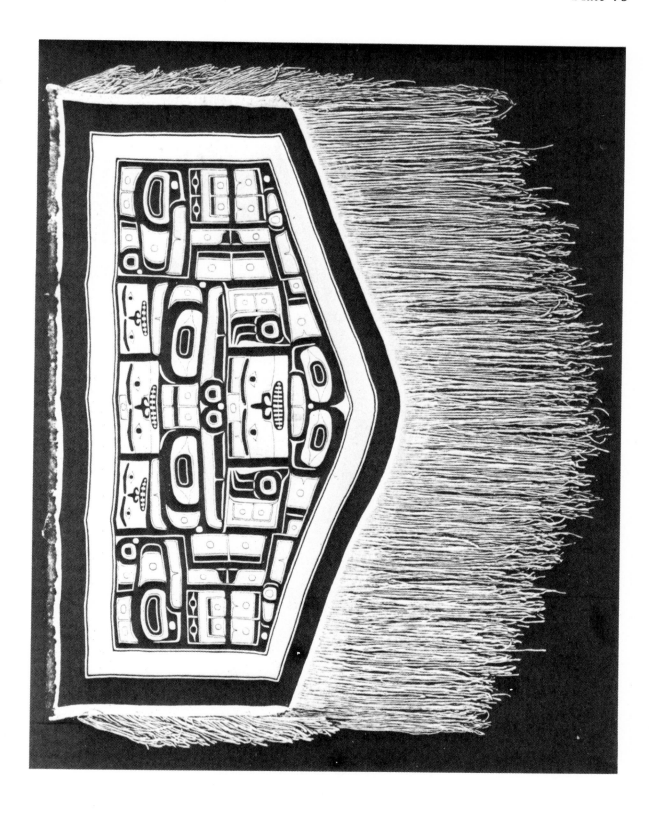

PLATE 76

CARVING IN SLATE OF BEAR WOMAN AND CHILD

Tribe, Haida
Region, Skidigate, British Columbia
Period, Modern

Size, 5 x 2 inches
Location, U. S. National Museum
Museum No. 73,117

Plate 76

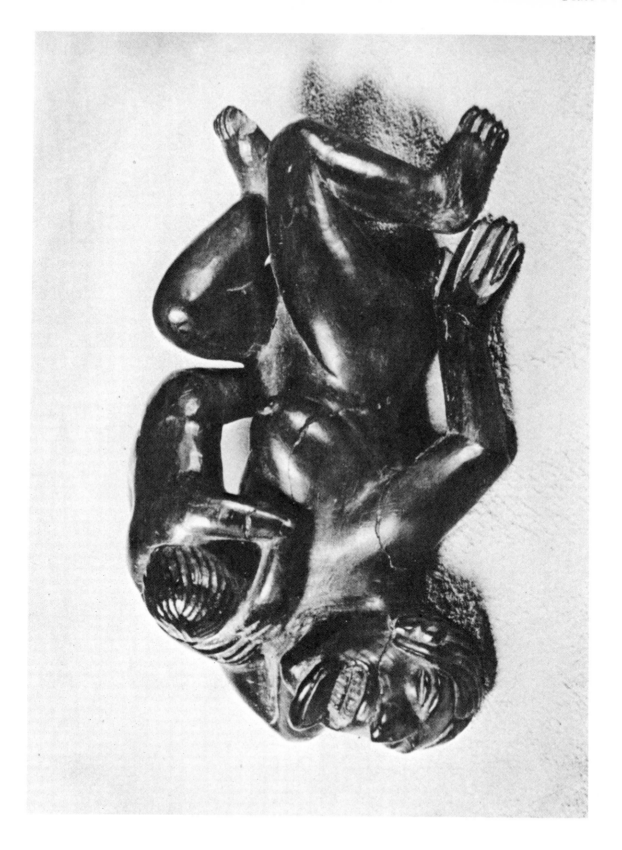

PLATE 77

HOUSE POST

Tribe, Kwakiutl
Region, Vancouver Island
Period, Nineteenth Century

Size, approx. 12 feet
Location, American Museum of Natural History
Museum No. 16/7962

Plate 77

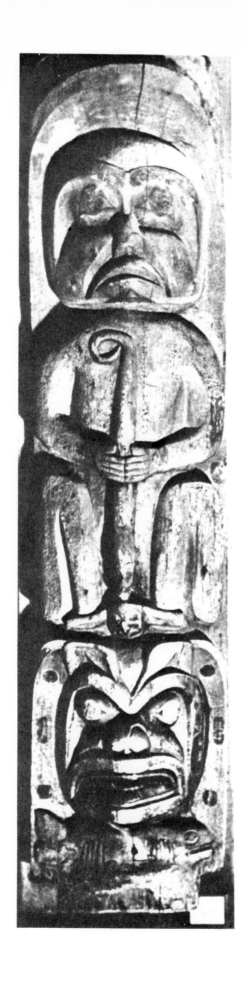

MODERN ARTS OF THE NORTHWEST COAST

PLATE 78

PIPE IN FORM OF BIRD WITH COPPER LINED MOUTH

Tribe, Tlingit
Region, Sitka, Alaska
Period, Modern

Size, approx. 7 inches
Location, American Museum of Natural History
Museum No. T/22,579

Plate 78

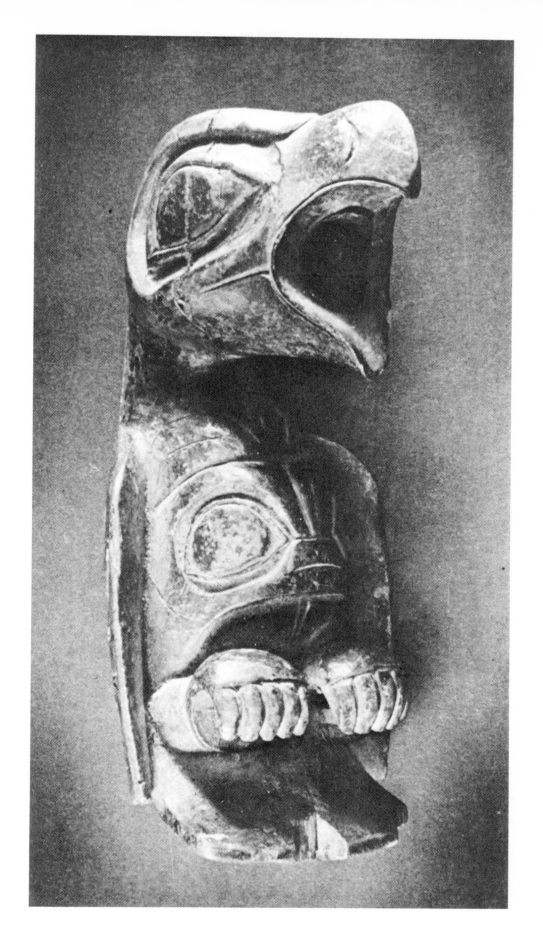

PLATE 79

FIGURE IN WOOD

Tribe. Kwakiutl
Region, British Columbia
Period, Modern

Size, Height 37 inches
Location, American Museum of Natural History
Museum No. 16/8248

Plate 79

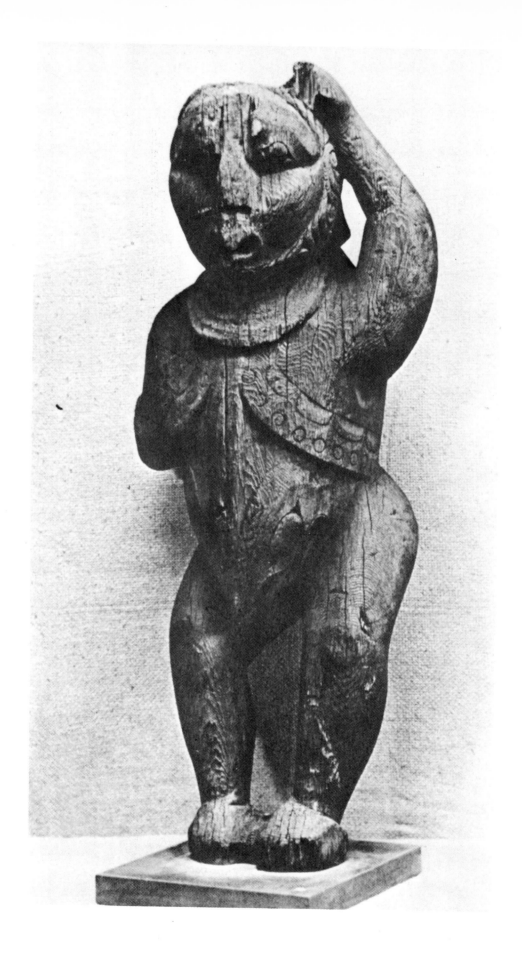

PLATE 80

CARVING OF WOMAN WITH CHILD

Tribe, Nootka
Region, Vancouver Island
Period, Modern

Size, 10½ x 3½ inches
Location, American Museum of Natural History
Museum No. 16/2005

Plate 80

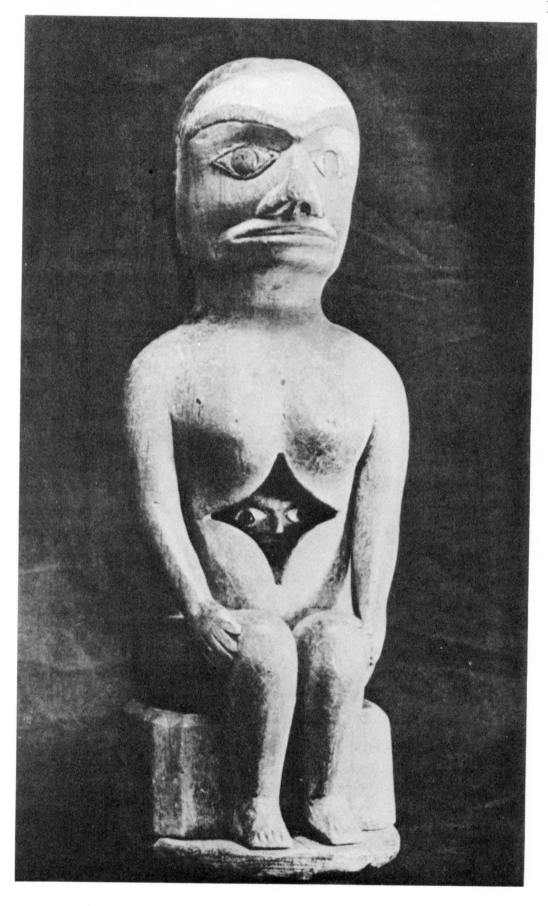

PLATE 81

CARVED HUMAN FIGURE ON SHAMAN'S STAFF

Tribe, Quinault
Region, Washington
Period, Modern

Size, Figure approx. 12 inches: over-all 20 inches
Location, American Museum of Natural History
Museum No. 16A/4921

Plate 81

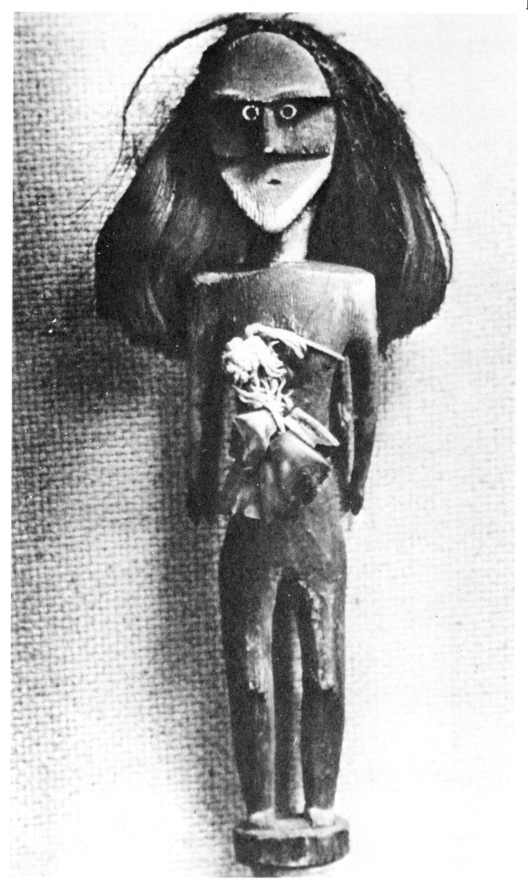

PLATE 82

WOODEN MASK, PAINTED

Tribe, Kwakiutl
Region, British Columbia
Period, Modern

Size, Height approx. 12 inches
Location, American Museum of Natural History
Museum No. 16/962

Plate 82

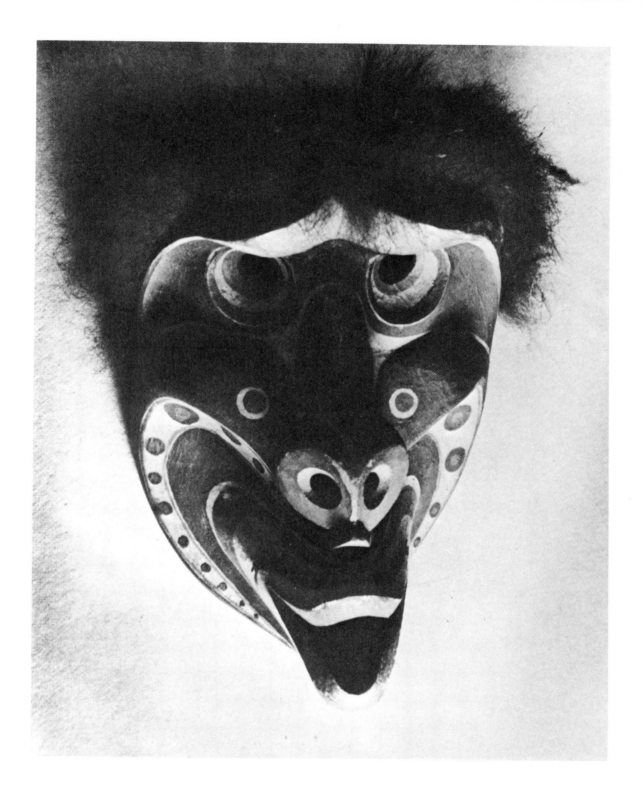

MODERN ARTS OF THE NORTHWEST COAST

PLATE 83

WOODEN HELMET, ORIGINALLY WITH PLUME, DEPICTING PARALYZED MAN

Tribe, Tlingit
Region, Southern Alaska
Period, Nineteenth Century

Size, Height approx. 8 inches
Location, American Museum of Natural History
Museum No. E/453

Plate 83

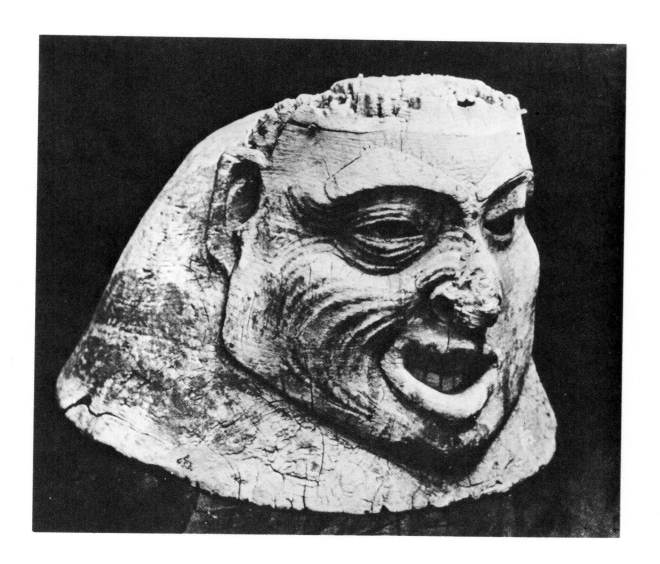

MODERN ARTS OF THE NORTHWEST COAST

PLATE 84

WOODEN MASK REPRESENTING GIRL WITH EARRINGS AND LABRET

Tribe, Haida
Region, Queen Charlotte Islands
Period, Modern

Size, Height approx. 9 inches
Location, American Museum of Natural History
Museum No. 16/362

Plate 84

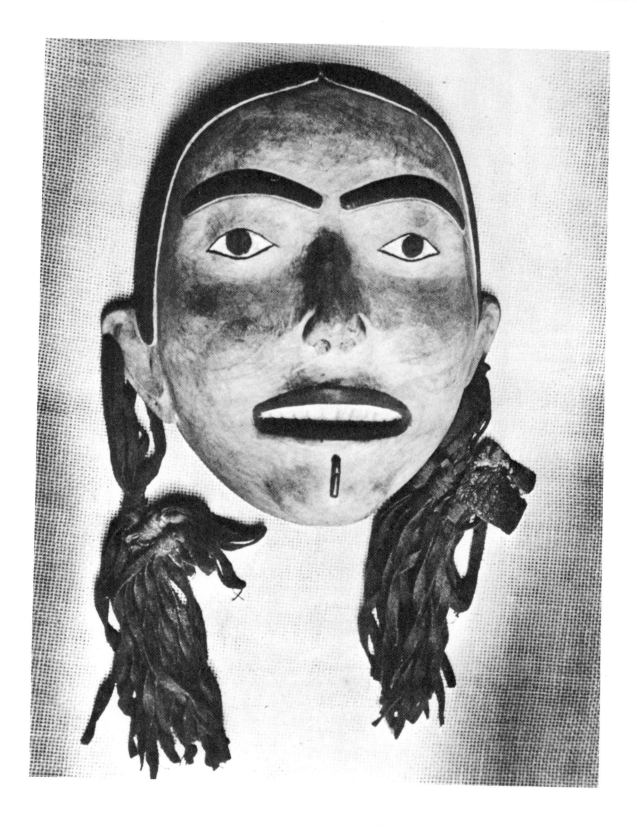

PLATE 85

WOODEN MASK, HUMAN FACE, WITH MOVABLE ORNAMENT ON TOP

Tribe, Tsimshian
Region, British Columbia
Period, Modern

Size, 21 x 7½ inches
Location, Museum of the American Indian, Heye Foundation
Museum No. 6/679

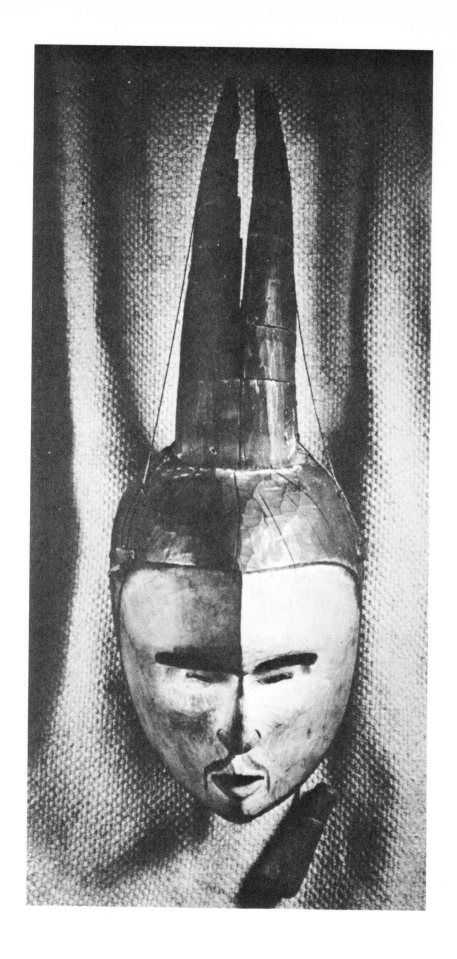

Plate 85

PLATE 86
WOODEN MASK, OLD WOMAN WITH LABRET IN LOWER LIP

Tribe, Tsimshian
Region, Upper Nass River, British Columbia
Period, Modern

Size, 9½ x 7 inches
Location, Museum of the American Indian, Heye Foundation
Museum No. 9/8044

Plate 86

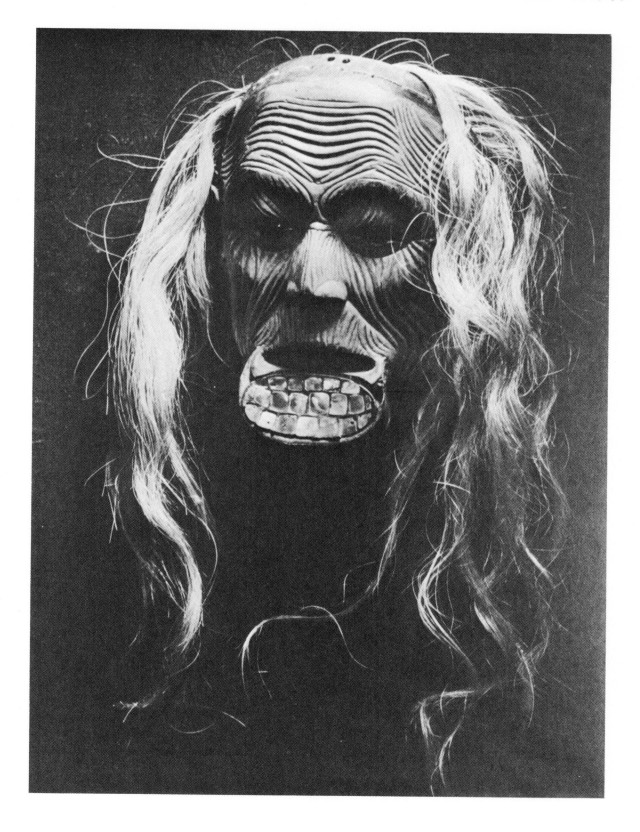

MODERN ARTS OF THE NORTHWEST COAST

PLATE 87

WOODEN DOUBLE MASK, WITH WINGS CLOSING TO FORM ANOTHER FACE

Tribe, Kwakiutl
Region, British Columbia
Period, Modern

Size, approx. 24 inches over-all
Location, American Museum of Natural History
Museum No. 16/8410

Plate 87

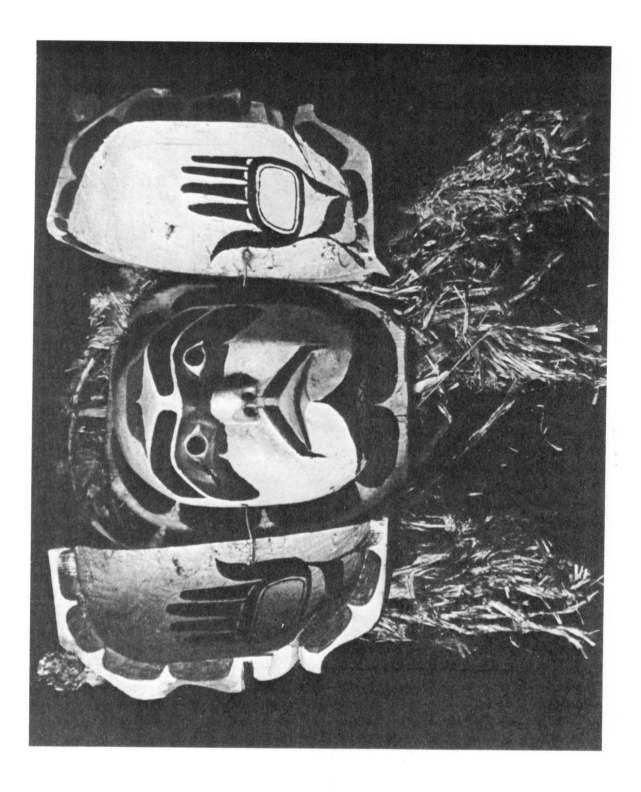

PLATE 88

WOODEN MASK

Tribe, Nootka

Region, Vancouver Island

Period, Modern

Size, 12 x 8 inches

Location, Field Museum, Chicago

Museum No. 85,843

Plate 88

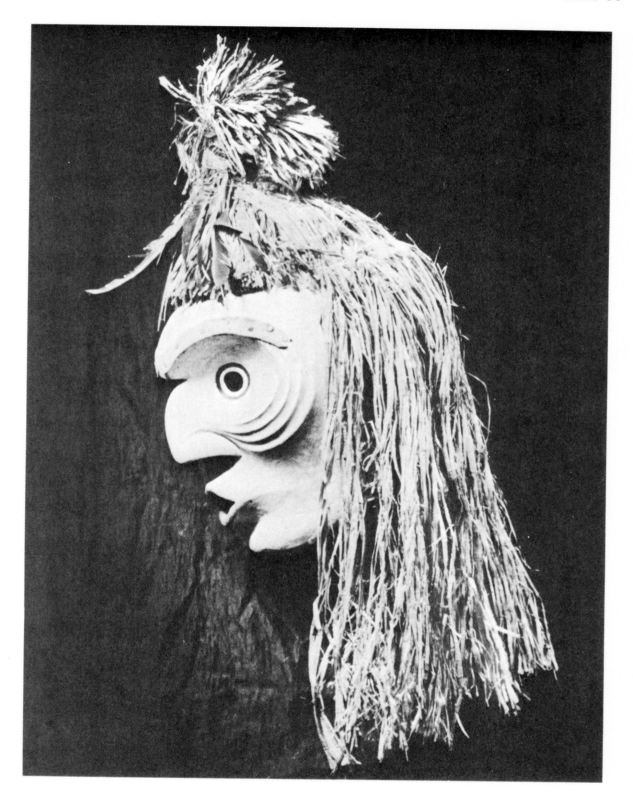

PLATE 89

WOODEN BOX, CARVED TO REPRESENT A BEAR

Tribe, Tlingit
Region, Southeast Alaska
Period, Modern

Size, approx. 9 x 9 inches
Location, American Museum of Natural History
Museum No. E/1228

Plate 89

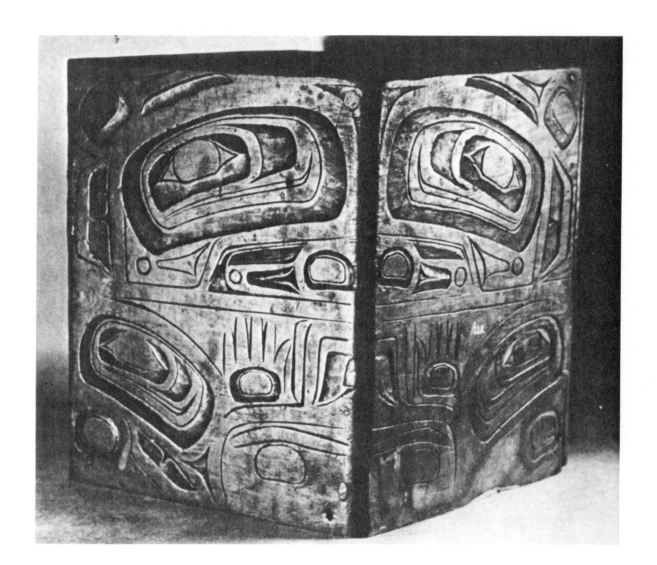

PLATE 90

CHIEF'S RATTLE OF WOOD

Tribe, Tlingit
Region, Southeast Alaska
Period, Modern

Size, 9 x 10 inches
Location, Denver Art Museum
Museum No. QTL-23-P

Plate 90

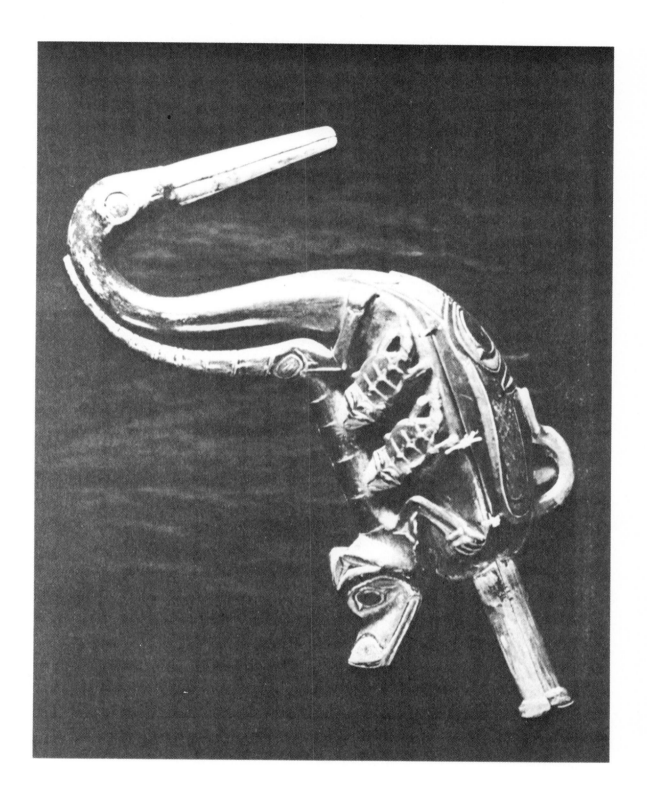

PLATE 91

SHAMAN'S (MEDICINE MAN'S) CHARM, WALRUS IVORY

Tribe, Tlingit
Region, Southeast Alaska
Period, Nineteenth Century

Size, approx. 3½ inches
Location, American Museum of Natural Histoɪ
Museum No. 19/470

Plate 91

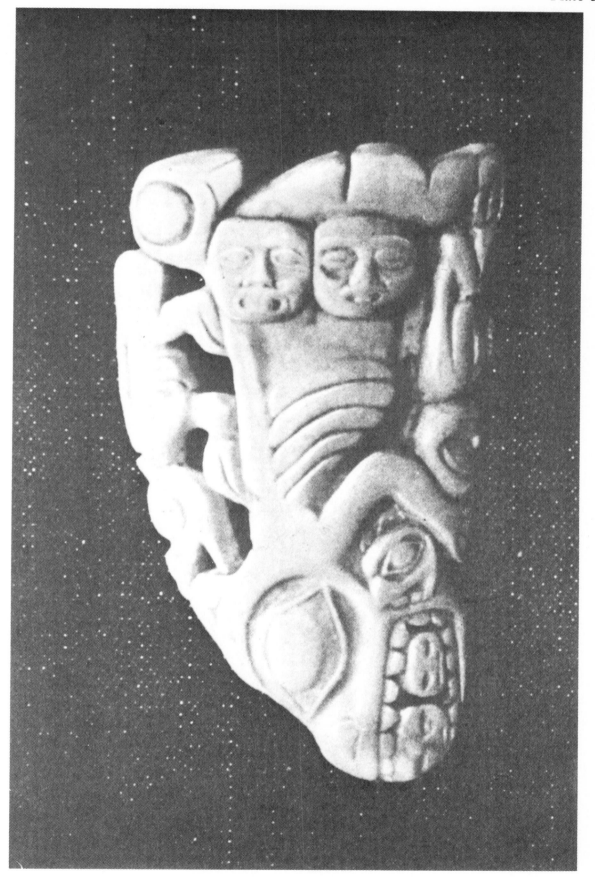

MODERN ARTS OF THE NORTHWEST COAST

PLATE 92

SHAMAN'S (MEDICINE MAN'S) CHARM, WALRUS IVORY

Tribe, Tlingit *Size,* approx. 4½ inches

Region, Southeast Alaska *Location,* American Museum of Natural History

Period, Modern *Museum No.* E/2708

Plate 92

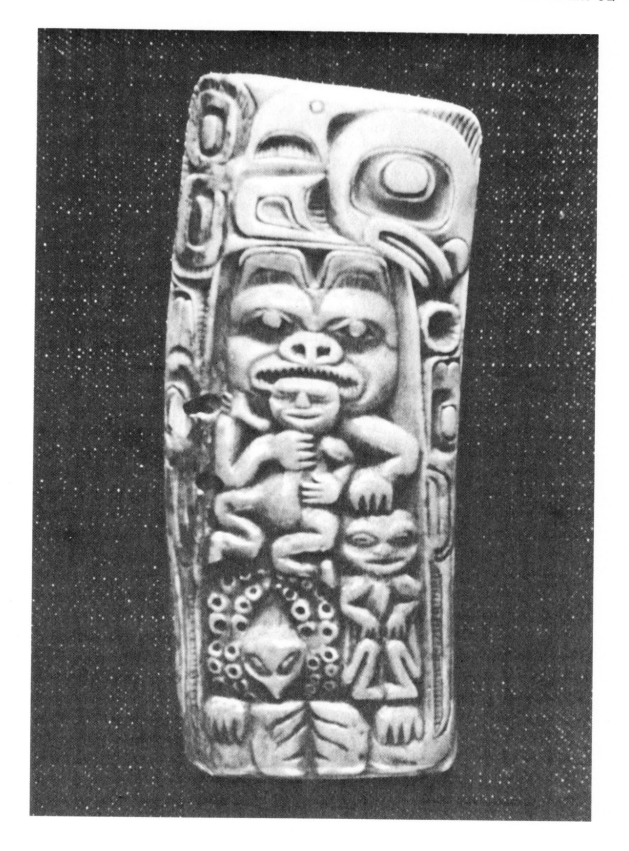

Modern Arts of the Eskimo (Plates 93-96) The culture of the Eskimo has only recently been seriously affected by white contact. Their art is best expressed in the technical perfection of their tools, but for the purpose of trade, a lively representational art has arisen. These little incised drawings on ivory lose much of their charm under the camera. We have therefore confined ourselves to two masks, reflecting an uncanny conception of the supernatural, a small stone carving to show the Eskimo's lively sense of natural forms, and a modern ivory which, like the Iroquois carvings on Plate 62 and the Pueblo paintings on Plates 48-50, defines the anatomical correctness of the Indian's sculpture.

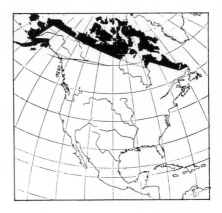

MODERN ARTS OF THE ESKIMO

PLATE 93

WOODEN MASK

Tribe, Eskimo	*Size,* 9 x 6 inches
Region, Point Hope, Alaska	*Location,* Field Museum, Chicago
Period, Modern	*Museum No.* 53,473

Plate 93

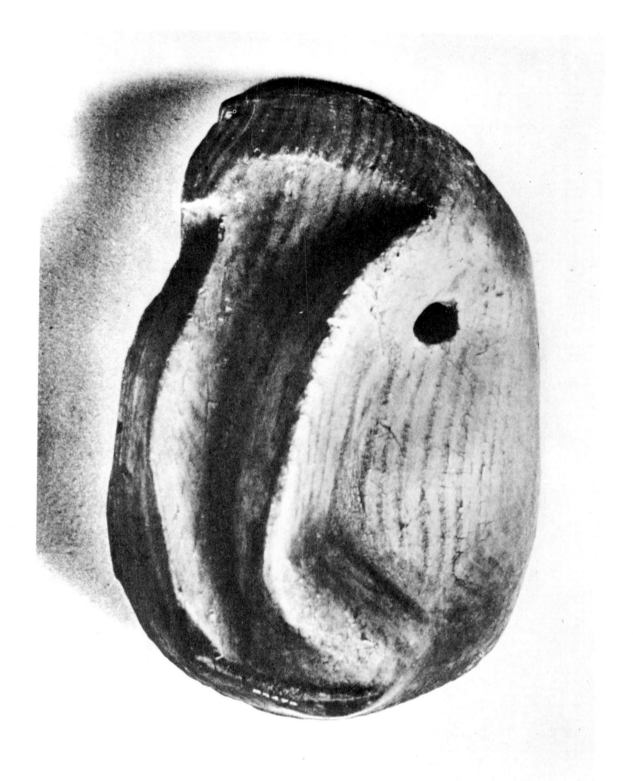

PLATE 94

WOODEN MASK

Tribe, Eskimo *Size,* 11 x 5 inches
Region, East Greenland *Location,* American Museum of Natural History
Period, Modern *Museum No.* 60. 1/7027

Plate 94

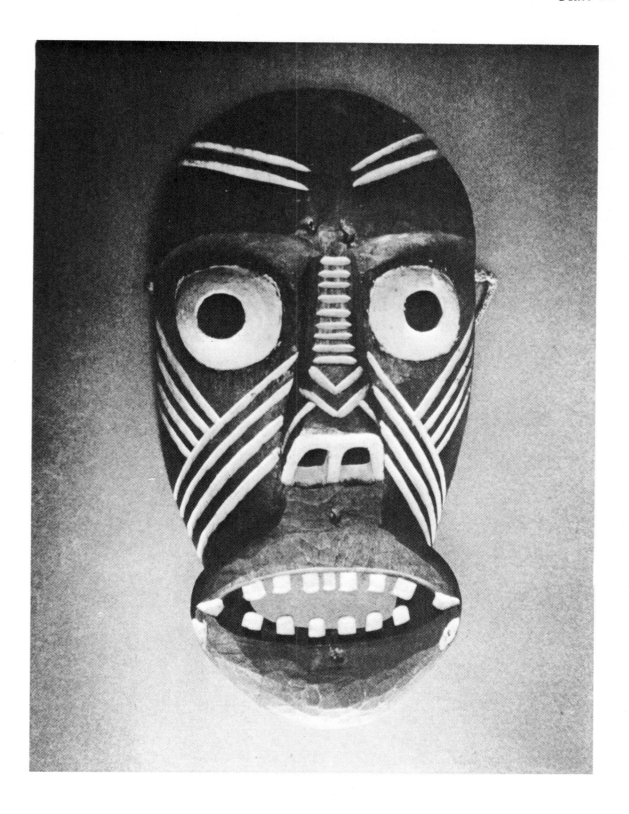

MODERN ARTS OF THE ESKIMO

PLATE 95

SEAL CARVED FROM SOAPSTONE

Tribe, Eskimo
Region, Greenland
Period, Modern

Size, 7½ x 2½ x 2⅛ inches
Location, American Museum of Natural History
Museum No. 60. 1/7082

Plate 95

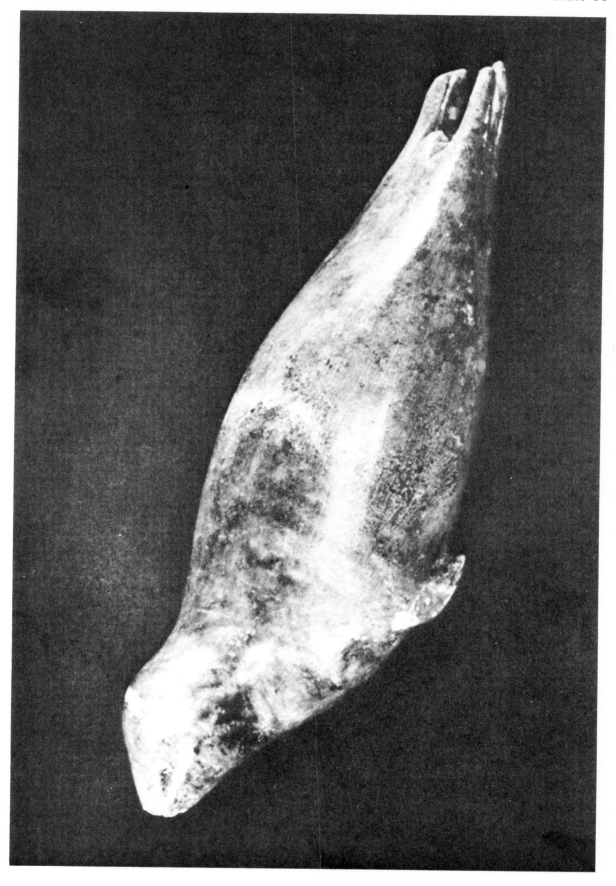

PLATE 96

FIGURE OF WOMAN, WALRUS IVORY

Tribe, Eskimo
Region, Greenland
Period, Modern

Size, 4½ x 1½ inches
Location, American Museum of Natural History
Museum No. 60. 1/7064

Plate 96

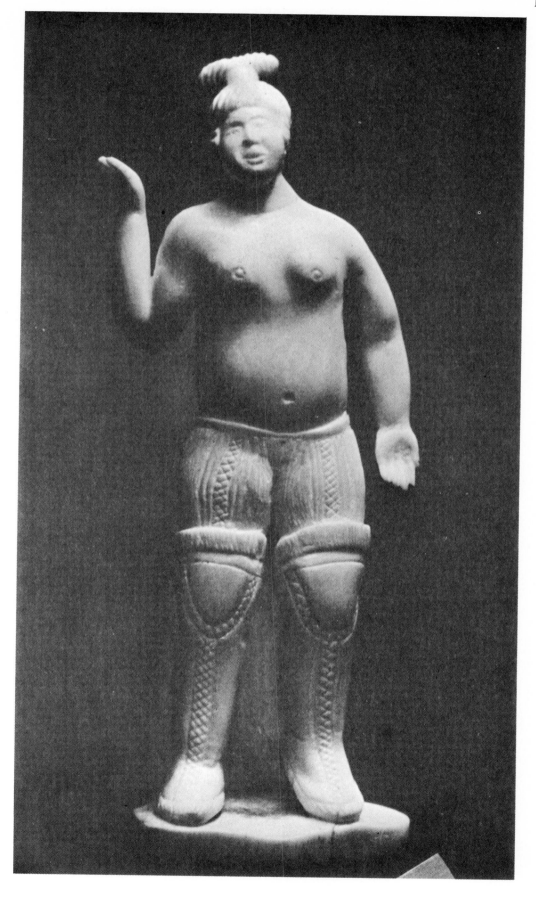

Selected Bibliography

A BIBLIOGRAPHY relating to the arts of the North American Indian, taken literally, would include the two pamphlets published by the Exposition of Tribal Arts and virtually nothing else. To present a list of material bearing on North American Indian Arts would require several hundred pages. Faced by this dilemma, it has seemed advisable to seize neither horn, but to list merely those publications which would best introduce the interested reader to the tribal arts mentioned in the text.

Miss Ruth Gaines has prepared a splendid bibliography in Part II of the Introduction to American Indian Art, prepared by the Exposition of Indian Tribal Arts Inc., that would well repay close attention on the part of the interested reader. The fact that the list of books given in this volume is divided geographically may make it a little more serviceable at first, but the more curious reader will find it essential to use Miss Gaines' compilation for a more detailed consideration of the field of Indian Arts. Equally useful is the mimeographed bibliography compiled by Anne Harding and Patricia Bolling for the Indian Arts and Crafts Board of the Department of the Interior in Washington. This work is arranged by author, subject, and region.

CHAPTER I

SOCIAL SIGNIFICANCE OF INDIAN ART

American Museum of Natural History, Guide Leaflet Series.

Chapman, Kenneth M., Decorative Art of the Indians of the Southwest (A List of Publications containing illustrations from Basketry, Costume and Ornament, Pottery, Textiles, etc., of Especial Value in the Study of Design. Laboratory of Anthropology, Sante Fé, General Series, Bulletin 1, Santa Fé, 1934).

Douglas, F. H., and Douglas F. H., and Jeançon, J. A., Leaflet Series, Denver Art Museum.

Exposition of Indian Tribal Arts, Inc., Introduction to American Indian Art, I, New York, 1931. John Sloan and Oliver La Farge on Painting, Basketry, Weaving, Beadwork, Pottery, Jewelry, Sculpture.

 Introduction to American Indian Art, II, New York, 1931. H. J. Spinden, Fine Art and the First Americans, Indian Symbolism; Mary Austin, Indian Pottery; Alice C. Henderson, Modern Indian Painting; Laura A. Armer, Sand-Painting of the Navajo Indians. Frances L. Newcomb, Description of Sand-Painting; K. M. Chapman, Indian Pottery; N. M. Judd, Indian Sculpture and Carving; C. C. Willoughby,

55

Indian Masks; E. W. Gifford, Indian Basketry; Mary L. Kissell, Indian Weaving; W. C. Orchard, Indian Porcupine Quill and Bead Work; Ruth Gaines, Books on Indian Arts North of Mexico.

Harding, Anne and Bolling, Patricia, Bibliography of Articles and Papers on North American Indian Art. Mimeograph. Department of the Interior, Indian Arts and Crafts Board, Washington, 1938.

Laboratory of Anthropology, Santa Fé, N. M. General Series, Bulletins 1-8.

Spinden, H. J., Creating a National Art, Natural History, vol. 19, no. 6, pp. 622-654, New York, 1919.

Chapter III

SOCIAL BACKGROUND OF INDIAN ART

American Museum of Natural History, Handbook Series, No. 1 The Indians of the Plains, No. 2 The Indians of the Southwest, No. 10 The Indians of the Northwest Coast.

Curtis, E. S., The North American Indian, vols. 1-9, Cambridge, 1903-1913.

Hodge, F. W., ed., Handbook of the American Indian (Bulletin 30, Bureau of American Ethnology, Washington, 1912).

Murdock, G. P., Our Primitive Contemporaries, New York, 1934.

Spinden, H. J., Maya Art (Memoirs of the Peabody Museum of Harvard University, vol. 6, Cambridge, 1913).

Vaillant, G. C., Artists and Craftsmen in Ancient Middle America (Guide Leaflet Series, American Museum of Natural History, No. 88, New York, 1935).

Wissler, C., The American Indian, 3rd Edition, New York, 1938.

Chapter IV

ORIGINS OF INDIAN CULTURE

Gladwin, H. S., Excavations at Snaketown, II. Comparisons and Theories, Medallion Papers No. 26, Gila Pueblo, Globe, 1937.

Howard, E. B., Evidence of Early Man in America, The Museum Journal, vol. 24, pp. 61-175, University Museum, Philadelphia, 1935.

Nelson, N. C., The Antiquity of Man in America in the Light of Archaeology (in The American Aborigines, D. Jenness, ed., pp. 85-130, University of Toronto Press, Toronto, 1933).

Sauer, Carl, American Agricultural Origins (Essays in Anthropology, presented to A. L. Kroeber in Celebration of his Sixtieth Birthday, June 11, 1936, pp. 279-297, Berkeley, 1936).

Wissler, C., The American Indian, New York, 1938.

56

INDIAN ART BEFORE WHITE CONTACT

Section 2—Ancient Arts of the Eskimo

Collins, H. B., Prehistoric Art of the Alaska Eskimo (Smithsonian Miscellaneous Collections, vol. 81, no. 14, Washington, 1929).

Archaeology of St. Lawrence Island, Alaska (Smithsonian Miscellaneous Collections, vol. 96, no. 1, Washington, 1937).

Geist, O. W., and Rainey, F. G., Archaeological Excavations at Kukulik, Saint Lawrence Island, Alaska (Miscellaneous Publications of the University of Alaska, vol. 2, Washington, 1936).

Jenness, D., The Problem of the Eskimo (The American Aborigines: Their Origin and Antiquity. A Collection of Papers by Ten Authors, assembled and edited by Diamond Jenness, The University of Toronto Press, 1933).

Section 3—Ancient Arts of the Northwest Coast

Lewis, A. B., Tribes of the Columbia Valley and the Coast of Washington and Oregon (Memoirs, American Anthropological Association, vol. 1, part 2, Lancaster, 1906).

Smith, H. I., Archaeology of the Gulf of Georgia and Puget Sound (Memoirs, American Museum of Natural History, vol. 4, part 6, New York, 1907).

Smith, H. I., The Archaeology of the Yakima Valley (Anthropological Papers, American Museum of Natural History, vol. 6, part 1, New York, 1910).

Section 4—Ancient Arts of California

Nelson, N. C., Shell Mounds of the San Francisco Bay Region, The Ellis Landing Shell Mound (University of California Publications in American Archaeology and Ethnology, vol. 7, nos. 4-5, Berkeley, 1909, 1910).

Rogers, D. B., Prehistoric Man of the Santa Barbara Coast, Santa Barbara Museum of Natural History, Santa Barbara, 1929.

Steward, J. H., Petroglyphs of California and Adjoining States (University of California Publications in American Archaeology and Ethnology, vol. 24, pp. 47-238, Berkeley, 1929).

Section 5—Ancient Arts of the Plains

Roberts, F. H. H., A Folsom Complex. Preliminary Report on Investigations at the Lindenmeier site in Northern Colorado (Smithsonian Miscellaneous Collections, vol. 94, no. 4, Washington, 1935).

Strong, W. D., An Introduction to Nebraska Archaeology (Smithsonian Miscellaneous Collections, vol. 93, no. 10, Washington, 1935).

Section 6—Ancient Arts of the Northeast

Cole, F. C., and Deuel, T., Rediscovering Illinois, Chicago, 1937.

Funkhouser, W. D., and Webb, W. S., Rock Shelters of Wolfe and Powell Counties, Kentucky (Reports in Archaeology and Anthropology, University of Kentucky, vol. 1, no. 4, Lexington, 1930).

Moorhead, W. K., The Stone Age in North America, 2 vols., Boston and New York, 1910.

A report on the Archaeology of Maine (Department of Archaeology, Phillips Academy, Andover, Mass., 1922).

Parker, A. C., Archaeological History of New York (New York State Museum, Bulletin nos. 235-236, Albany, 1922).

Shetrone, H. C., The Mound Builders, New York, 1930.

Thomas, C., Report on the Mound Explorations of the Bureau of Ethnology (Twelfth Annual Report, Bureau of American Ethnology, Washington, 1890-91).

Willoughby, C. C., Antiquities of the New England Indians, Cambridge, 1935.

Willoughby, C. C., and Hooton, E. A., The Turner Group of Earthworks, Hamilton County, Ohio (Peabody Museum Papers, vol. 8, no. 3, Cambridge, 1922).

Section 7—Ancient Arts of the Southeast

Consult Moorehead, Shetrone, and Thomas in the bibliography of the preceding section.

Harrington, M. R., Certain Caddo Sites in Arkansas (Indian Notes and Monographs, Museum of the American Indian, Heye Foundation, New York, 1920).

The Ozark Bluff-Dwellers (American Anthropologist, n.s. vol. 26, no. 1, Menasha, 1924).

Holmes, W. H., The Aboriginal Pottery of the Eastern United States (Twentieth Annual Report, Bureau of American Ethnology, Washington, 1903).

Handbook of Aboriginal American Antiquities, Part I, The Lithic Industries (Bulletin 60, Bureau of American Ethnology, Washington, 1919).

Moore, Clarence B., Numerous detailed reports on the Southern Mound area, splendidly illustrated in the Journal of the Academy of Natural Sciences of Philadelphia, vols. 10 to 16, Philadelphia, 1894-1915.

Moorehead, W. K., Excavations in the Etowah Site in Georgia (Department of Archaeology, Phillips Academy, Andover, New Haven, 1932).

Swanton, John R., Indian Tribes of the Lower Mississippi Valley and Adjacent Coast of the Gulf of Mexico (Bulletin 43, Bureau of American Ethnology, Washington, 1911).

Section 8—Ancient Arts of the Southwest

Cosgrove, H. S., and C. B., The Swarts Ruin, a Typical Mimbres Site in Southwestern New Mexico (Papers of the Peabody Museum of Harvard University, vol. 15, no. 1, Cambridge, 1932).

Gladwin, H. S. and associates, Excavations at Snaketown, vol. I, Material Culture, vol. II, Comparisons and Theories (Gila Pueblo, Globe, Arizona, 1937).

Guernsey, S. J., and Kidder, A. V., Basket Maker Caves of Northeastern Arizona (Papers of the Peabody Museum of Harvard University, vol. 8, no. 2, Cambridge, 1921).

Kidder, A. V., An Introduction to the Study of Southwestern Archaeology (Department of Archaeology, Phillips Academy, Andover, New Haven, 1924).

The Artifacts of Pecos (Papers of the Phillips Academy, Southwestern Expedition, No. 6, New Haven, 1932).

Kidder, A. V., and Amsden, C. A., The Pottery of Pecos, Vol. I (Papers of the Phillips Academy, Southwestern Expedition, No. 5, New Haven, 1931).

Kidder, A. V., and Shepard, A. O., The Pottery of Pecos, Vol. II (Papers of the Phillips Academy, Southwestern Expedition, No. 7, New Haven, 1936).

Pepper, G. H., Pueblo Bonito (Anthropological Papers of the American Museum of Natural History, vol. 27, New York, 1920).

Roberts, F. H. H., Jr., A Survey of Southwestern Archaeology (American Anthropologist, n.s. vol. 37, pp. 1-35, Washington, 1935).

A Survey of Southwestern Archaeology (Annual Report of the Board of Regents of the Smithsonian Institution, 1935, Smithsonian Report, pp. 507-533, Washington, 1936).

INDIAN ART AFTER WHITE CONTACT

Section 2—The Arts of the Modern Pueblos

Alexander, H. B., Pueblo Indian Painting, Folio, C. Szwedzicki Nice, France 19—.

Bunzel, R., The Pueblo Potter (Columbia University, Contributions to Anthropology, vol. 8, New York, 1929).

Chapman, K. M., Decorative Art of the Indians of the Southwest. A List of Publications containing Illustrations from Basketry, Costume and Ornament, Pottery, Textiles, etc., of Especial Value in the Study of Design (Laboratory of Anthropology, General Series, Bulletin 1, Santa Fé, 1937).

 Pueblo Indian Pottery, 2 vols., Folio, C. Swedzicki, Nice, France, 1933, 1936.

 Pottery of Santo Domingo (Laboratory of Anthropology, Memoirs, No. 1, Santa Fé, 1936).

Goddard, P. E., The Indians of the Southwest (Handbook Series No. 2, American Museum of Natural History, 2nd Ed., New York, 1931).

Guthe, C. E., Pueblo Pottery Making. A Study at the Village of San Ildefonso (Papers, Phillips Academy Southwestern Expedition, no. 2, New Haven, 1925).

Hough, W., The Hopi Indians, Cedar Rapids, 1915.

Kidder, A. V., An Introduction to the Study of Southwestern Archaeology (Department of Archaeology, Phillips Academy, Andover, New Haven, 1924).

Kroeber, A. L., Zuñi Kin and Clan (Anthropological Papers, American Museum of Natural History, vol. 18, Part 2, New York, 1917).

Mera, H. P., The Rain Bird, a Study in Pueblo Design (Laboratory of Anthropology, Memoirs, no. 2, Santa Fé, 1938).

Spier, L., Yuman Tribes of the Gila River (University of Chicago, Publications in Anthropology, Ethnological Series, Chicago, 1933).

Section 3—The Art of the Southwestern Nomads

Amsden, C. A., Navajo Weaving, Its Technique and History, Santa Ana, California, 1934.

Mera, H. P., Navajo Blankets (Laboratory of Anthropology, General Series, Bull. 2, 3, 5, 6, 7, Santa Fé, 1938-1939).

Newcomb, Mrs. F. J., and Reichard, Gladys A., Sand paintings of the Navajo Shooting Chant, J. J. Augustine, New York, 1937.

Reichard, Gladys A., Navajo Shepherd and Weaver, New York, 1936.

Section 4—The Arts of Modern Southeastern Tribes

MacCauley, C., The Seminole Indians of Florida (Fifth Annual Report, Bureau of American Ethnology, Washington, 1887).

Mooney, J., Myths of the Cherokee (Nineteenth Annual Report, Bureau of American Ethnology, Washington, 1900).

Speck, F. G., Ethnology of the Yuchi Indians (Anthropological Publications, University of Pennsylvania, vol. 1, no. 1, Philadelphia, 1909).

 Decorative Art and Basketry of the Cherokee (Bulletin, Public Museum of the City of Milwaukee, vol. 2, no. 2, Milwaukee, 1920).

Section 5—The Arts of the Modern Northeastern Tribes

Hoffman, W. J., The Menomini Indians (Fourteenth Annual Report, Bureau of American Ethnology, Part I, Washington, 1896).

Skinner, A., Material Culture of the Menomini (Indian Notes and Monographs, Museum of the American Indian, Heye Foundation, New York, 1921).

Smith, H. I., An Album of Prehistoric Canadian Art (Victoria Memorial Museum,

Anthropological Series 8, Canada Department of Mines, Bulletin 37, Ottawa, 1923).

Speck, F. G., The Double Curve Motive in Northeast Algonkin Art (Canada Geological Survey, Department of Mines, Memoir 42, Anthropological Series 1, pp. 1-17, Ottawa, 1914).

Speck, F. G., Culture Problems in Northeastern North America (Proceedings, American Philosophical Society, vol. 65, pp. 272-311, Philadelphia, 1926).

Section 6—The Art of the Modern Plains Tribes

Ewers, J. C., Plains Indian Painting, Berkeley, 1939.

Jacobson, O. B., Kiowa Indian Art, Folio, C. Szwedzicki, Nice, 1929.

Kroeber, A. L., The Arapaho (American Museum of Natural History, Bulletin 18, pp. 1-229, 279-454, New York, 1902).

Lowie, R. H., Crow Indian Art (Anthropological Papers of the American Museum of Natural History, vol. 21, New York, 1922).

See also other papers on the Crow in vols, 9, 11, 16, 21, 25, of the same series.

Mallery, G., Pictographs of the North American Indians (Fourth Annual Report, Bureau of Ethnology, Washington, 1886).

Wissler, C., Decorative Art of the Sioux Indians (Bulletin, American Museum of Natural History, vol. 18, Part 3, New York, 1904).

Influence of the Horse in the Development of Plains Culture (American Anthropologist, n.s. vol. 16, pp. 1-25, Lancaster, 1914).

Indian Beadwork (American Museum of Natural History, Guide Leaflet, No. 50, New York, 1931).

North American Indians of the Plains (Handbook Series no. 1, American Museum of Natural History, New York, 1934).

See also other papers in vols. 1, 5, 7, 11, 17, 29, of the Anthropological Papers of the American Museum of Natural History.

Section 7—The Arts of the Modern California Tribes

Barrett, S. A., Pomo Indian Basketry (University of California Publications in American Archaeology and Ethnology, vol. 7, no. 3, Berkeley, 1908).

Dixon, R. B., Basketry Designs of the Indians of Northern California (American Museum of Natural History, Bulletin 17, Part 1, pp. 1-32, New York, 1902).

Kroeber, A. L., Handbook of the Indians of California (Bulletin 78, Bureau of American Ethnology, Washington, 1925).

Kroeber, A. L., Basketry Designs of the Mission Indians (American Museum of Natural History, Guide Leaflet, no. 55, New York, 1932).

Spier, L., Tribal Distribution in Washington (General Series in Anthropology, no. 3, Menasha, 1936).

Section 8—The Arts of the Modern Northwestern Tribes

Barbeau, C. M., The Origin of the Totem Pole (Proceedings of the 23d Congress of Americanists, New York, 1928, pp. 505-512, New York).

Boas, F., The Decorative Art of the Indians of the North Pacific Coast (Bulletin of the American Museum of Natural History, vol. 9, New York, 1897).

Primitive Art (Instituttet for Sammenlignende Kulturforskning, Serie B, Skrifter 8, Oslo, 1927).

Emmons, G. T., and Boas, F., The Chilkat Blanket (Memoirs, American Museum of Natural History, vol. 3, part 4, New York, 1907).

Goddard, P. E., Indians of the Northwest Coast (Handbook Series, no. 10, American Museum of Natural History, New York, 1934).

Swanton, J. R., Contributions to the Ethnology of the Haida (Memoirs of the American Museum of Natural History, vol. 8, Leiden, 1909).

60

Section 9—The Arts of the Modern Eskimo

Boas, F., The Eskimo of Baffin Land and Hudson Bay (Bulletin, American Museum of Natural History, vol. 15, New York, 1907).

Birket-Smith, Kaj, The Caribou Eskimos (Report of the Fifth Thule Expedition, 1921-24. Vol. 5, Copenhagen, 1929).

Jenness, D., The Indians of Canada (Bulletin 65, National Museum of Canada, Ottawa, 1932).

Osgood, C., The Distribution of the Northern Athapaskan Indians (Yale University, Publications in Anthropology, No. 7, New Haven, 1936).

Rasmussen, K., The People of the Polar North. London, 1908.

Stefansson, V., My Life with the Eskimo. New York, 1919.

Weyer, E. M., Jr., The Eskimos. New York, 1932.

CHAPTER VII

APPRAISAL OF NORTH AMERICAN INDIAN ART

Section 1—Architecture

Mindeleff, V., A Study of Pueblo Architecture (Bureau of American Ethnology, Annual Reports, vol. 8, Washington, 1887).

Morgan, L. H., Houses and House Life of the American Aborigines (Contributions to North American Ethnology, vol. 4, Washington, 1881).

Shetrone, H. C., The Mound Builders. New York, 1930.

Waterman, T. T., The Native Houses of Western North America (Indian Notes and Monographs, Museum of the American Indian, Heye Foundation, New York, 1921).

The Architecture of the American Indians (American Anthropologist, n.s., vol. 29, no. 2, pp. 210-230, Menasha, 1927).

Section 2—Design

Amsden, C. A., Navajo Weaving: Its Technique and History. Santa Ana, California, 1934.

An Analysis of Hohokam Pottery Design (Medallion Papers, Gila Pueblo, no. 23, Globe, Arizona, 1936).

Boas, F., The Decorative Art of the North American Indians (Popular Science Monthly, vol. 63, pp. 481-498, New York, 1903).

Primitive Art (Instituttet for Sammenlignende Kulturforskning, Serie B, Skrifter 8, Oslo, 1927).

Chapman, K., Bird Designs (Art and Archaeology, vol. 4, pp. 307-316, Washington, 1916).

Cosgrove, H. S. and C. B., The Swarts Ruin (Papers of the Peabody Museum of Harvard University, vol. 15, no. 1, Cambridge, 1932).

Holmes, W. H., Origin and Development of Form and Ornament in Ceramic Art (Fourth Annual Report, Bureau of Ethnology, Washington, 1886).

A Study of the Textile Art in Its Relation to the Development of Form and Ornament (Sixth Annual Report, Bureau of Ethnology, Washington, 1888).

Aboriginal Pottery of the Eastern United States (Twentieth Annual Report, Bureau of American Ethnology, Washington, 1903).

Kroeber, A. L., Basket Designs of the Indians of Northwestern California (University of California Publications in American Archaeology and Ethnology, vol. 2, no. 4, Berkeley, 1905).

Speck, F. G., The Double Curve Motive in Northeastern Algonkin Art (Memoir 42, Geological Survey of Canada, Anthropological Series, no. 1, Ottawa, 1914).

Spinden, H. J., Maya Art (Memoirs of the Peabody Museum, Harvard University, vol. 6, Cambridge, 1913).

 Indian Symbolism (Introduction to American Indian Art, part II, pp. 3-18, New York, 1931).

Vaillant, G. C., Artists and Craftsmen in Ancient Central America (Guide Leaflet Series, American Museum of Natural History, no. 88, New York, 1935).

Wissler, C., Decorative Art of the Sioux Indians (Bulletin, American Museum of Natural History, vol. 7, part 2, New York, 1912).

Section 3—Sculpture

Boas, F., Primitive Art (Instituttet for Sammenlignende Kulturforskning, Serie B, Skrifter 8, Oslo, 1927).

Shetrone, H. C., The Mound Builders, New York, 1930.

Sloan, John and La Farge, Oliver, Sculpture (Introduction to American Indian Art, Part I, pp. 41-50, New York, 1931).

Section 4—Painting and Draughtsmanship

Armer, Laura Adams, Sand-Painting of the Navajo Indian (Introduction to American Indian Art, Part II, pp. 5-7, New York, 1931).

Ewers, J. C., Plains Indian Painting (Berkeley, 1939).

Henderson, Alice Corbin, Modern Indian Painting (Introduction to American Indian Art, Part II, pp. 3-11, New York, 1931).

Holmes, W. H., Art in Shell of the Ancient Americans (Second Annual Report, Bureau of American Ethnology, pp. 179-305, Washington, 1883).

Mallory, G., Pictographs of the North American Indians (Fourth Annual Report, Bureau of Ethnology, Washington, 1886).

Morris, A. A., Rock Paintings and Petroglyphs of the American Indian (American Museum of Natural History, The Pictograph Project, Folder, 10 pp., New York, 1930).

Newcomb, Mrs. Francis L., Description of the Symbolism of a Sand-Painting of the Sun (Introduction to American Indian Art, Part II, p. 8, New York, 1931).

Newcomb, Mrs. F. J., and Reichard, G. A., Sandpaintings of the Navajo Shooting Chant. J. J. Augustine, New York, 1937.

Shetrone, H. C., The Mound Builders. New York, 1930.

Section 5—Pottery

Bunzel, R., The Pueblo Potter (Columbia University, Contributions to Anthropology, vol. 8, New York, 1929).

Chapman, K. M., The Pottery of Santo Domingo Pueblo (Laboratory of Anthropology, Memoirs, vol. 1, Santa Fé, 1936).

Cosgrove, H. S. and C. B., The Swarts Ruin (Papers of the Peabody Museum of Harvard University, vol. 15, no. 1, Cambridge, 1932).

Gladwin, H. S., and associates, Excavations at Snaketown, vol. 1 (Medallion Papers, no. 25, Gila Pueblo, Globe, Arizona).

Guthe, C. E., Pueblo Pottery Making (Papers, Phillips Academy, Southwestern Expedition, no. 2, New Haven, 1923).

Holmes, W. H., Aboriginal Pottery of the Eastern United States (Twentieth Annual Report, Bureau of American Ethnology, Washington, 1903).

Kidder, A. V., An Introduction to the Study of Southwestern Archaeology (Papers of the Southwestern Expedition, Department of Archaeology, Phillips Academy, Andover, No. 1, New Haven, 1924).

*Section 6—*Weaving

Amsden, C. A., Navaho Weaving, Its Technique and History. Santa Ana, California, 1934.

Barrett, S. A., Pomo Indian Basketry (University of California Publications in American Archaeology and Ethnology, vol. 7, no. 3, Berkeley, 1908).

Bushnell, D. I., Jr., The Various Uses of Buffalo Hair by the North American Indians (American Anthropologist, n.s., vol. 11, pp. 401-425, Lancaster, 1909).

Emmons, G. T., and Boas, F., The Chilkat Blanket (Memoirs, American Museum of Natural History, vol. 3, part 4, New York, 1907).

Mason, O. T., Aboriginal American Basketry: Studies in a Textile Art without Machinery (U. S. National Museum, Report for 1902, Washington, 1904).

Reichard, G., The Navajo Blanket, New York.

Weltfish, Gene, Prehistoric North American Basketry Techniques and Modern Distributions (American Anthropologist, n.s., vol. 32, pp. 454-495, Menasha, 1930).

*Section 7—*Jewelry

Sloan, John, and La Farge, Oliver, Jewelry (Introduction to American Indian Art, Part I, pp. 33-39, New York, 1931).